D1064568

COURBET

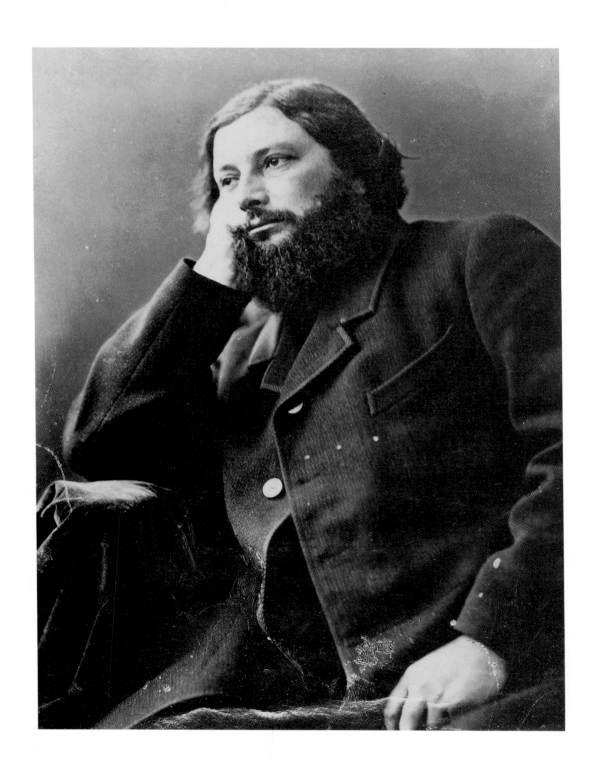

GUSTAVE
COURBET

BY
SARAH FAUNCE

HARRY N. ABRAMS, INC., PUBLISHERS

Editor: Ruth A. Peltason
Designer: Ellen Nygaard Ford
Photo Research: Neil Ryder Hoos

Frontispiece: Courbet in 1861.
Photograph by Nadar.
Bibliothèque Nationale, Paris

Library of Congress Cataloging-in-Publication Data

Faunce, Sarah.
 Gustave Courbet / by Sarah Faunce.
 p. cm.
 "Masters of art"
 ISBN 0–8109–3182–6
 1. Courbet, Gustave, 1819–1877—Criticism and interpretation.
I. Title.
ND553.C9F28 1993
759.4—dc20 92–21998
 CIP

Published in 1993 by Harry N. Abrams, Incorporated, New York
A Times Mirror Company
All rights reserved. No part of the contents of this book may be
reproduced without the written permission of the publisher

Printed and bound in Japan

PHOTOGRAPH CREDITS

Numbers refer to pages: A.C.L.-Brussels: 30 (bot-
tom); Bildarchiv Preussischer Kulturbesitz/Jorg
P. Anders: 113; Jean-Loup Charmet Archives: 42
(bottom right); Charles Choffet: 14 (bottom), 20, 31
(bottom), 61; A. E. Dolinski: 111, 127; Richard
Feigen & Co., Inc.: 12 (bottom); Flammarion: 43
(bottom); Foto Rázsó: 11; Jacques QUECQ
d'Henripret: 59; Frédéric Jaulmes: 23 (top and bot-
tom), 24, 34, 55, 57, 69, 75; Jacques Lathion: 51;
Claude O'Sughrue: 38 (top); Photographie Giraudon:
27; Photographie Musées de la Ville de Strasbourg:
30 (top); Photothèque de Musées de la Ville de Paris:
9, 13 (top), 35 (right), 53, 83, 103, 119, 121;
Rheinisches Bildarchiv, Cologne: 87; Service de doc-
umentation photographique de la Réunion des Musées
Nationaux, Paris: 10 (top right), 14 (top), 16 (right),
33 (bottom), 35 (left), 38 (bottom), 41, 62, 79, 115,
117, 123; Statens Konstmuseer: 15 (top), 33 (top), 37
(bottom); Joseph Szaszfai: 101; Ville de Nantes,
Musée de Beaux-Arts/P. Jean: 71; Elke Walford: 32

CONTENTS

Courbet

"M. Courbet has made a place for himself in the current French School [of painting] in the way that a cannonball lodges itself in a wall." Thus wrote François Sabatier early in 1851, the only one of the many critics of that year's Salon to appraise positively the works submitted by the young, relatively unknown painter from Ornans. Sabatier was confident that Courbet's work pointed in the direction that painting would go, and he had the acuity to see that nothing of such importance as *A Burial at Ornans* (plate 8) had been done since Géricault's *Raft of the "Medusa,"* comparably reviled at the Salon of 1819. This fresh and excited assessment, a single voice at the time, was proved to be accurate, and in the intervening century and a half Courbet has been part of the canon of nineteenth-century progressive painting. But his position today is more complex and ambiguous than that of his younger contemporaries. One reason for this lies in the obstructive power of those categories and *isms* that began to emerge and lead an independent life in the art world during Courbet's lifetime. Manet, Monet, Pissarro, Cézanne, all of whom understood the significance of Courbet's work for their own, would eventually be grouped (however misleadingly) under the rubric of Impressionism. Courbet is commonly defined in brief textbook terms as the champion of Realism. Between these two *isms* there is commonly felt to be a gulf, one side of which is the true beginning of modern art, while the other retains an air of the old-fashioned and traditional. Yet those painters who began to exhibit together in 1874 and received the then derogatory term *Impressionist* were in fact deeply rooted in the contemporary Realist movement, and would certainly, if pressed at that time to choose between the two labels, have chosen Realism. But the word itself has a very broad life, both upper- and lowercase, with meanings and connotations which can make it an obstacle to the understanding of how it was used in relation to Courbet and his contemporaries, and an even greater one to the understanding of Courbet's art.

The term Realism conveys meanings to the late-twentieth-century mind, aware of the whole history of abstract nonfigurative art, that are quite different from, and only very partially overlap with, the cluster of meanings attached to the word in the artist's lifetime. Today Realism, in visual representation, most often implies an uninflected, basically banal relationship between the artist and the visual facts that lie before him. It is assumed that the effort of a Realist painter is to sharpen his skills of observation and transcription of the things of the measurable world, minimizing the role of mind and feeling. This pejorative notion of literalism and lack of ideality was also a part of the reaction of hostile nineteenth-century critics of what was called the Realist School, and indeed the work of Courbet and others was condemned for appearing too factual, too close to the new medium of photography—also opposed for its apparent lack of ideality and intention. But for these critics both Realist painting and photography were seen in opposition to a form of ideality very different from that which defines the opposite of Realism today. We see it in relation not only to the pure forms of abstraction, but also in relation to the various expressive and structural manipulations of form and space which have transformed the idea of painting in the twentieth century. In the mid-nineteenth century, however, the term Realist was used to describe the growing number of painters who took as their primary subject the world around them, whether in landscape or in figure painting. Realism was seen as the opposite of the ideal, which in turn was embodied in the tradition of *peinture d'histoire,* the painting of

Fig. 1. William Bouguereau (1825–1905). *Zenobia Discovered by Shepherds on the Banks of the Araxes.* 1850. Oil on canvas, 57⅞ × 44½" (147 × 113 cm). Ecole Nationale Supérieure des Beaux-Arts, Paris

illuminating themes drawn from religion and myth, literature and history. History painting—the term which referred to all of these—was the painting which was normative, which in effect justified the career of the artist, and by which all other kinds of painting were judged.

From this perspective, Realism was at best a minor mode and at worst a dangerous one because of its potential capacity to undercut the powerful belief in art as that which should affect the viewer primarily through forms of idealized beauty and heroic actions. In this context, Courbet, whose work represented the most powerful challenge to academic ideology, was certainly the great Realist of the nineteenth century. But his was not simply a thematic innovation. Courbet's challenge did consist of making a claim to high seriousness for his paintings drawn from the life surrounding him, but it also did more; the way he went about making those paintings was an assertion of a wholly different basis for visual art in its function of cultural self-imaging. The idealization of the human figure established in the Renaissance on the basis of the art of Antiquity and variously developed in the ensuing centuries was seen by him to be not a universal continuum

but a historical phenomenon, and one in the process of coming to an end. Eventually, the forms of classicism could return to art, but only as a consciously chosen style, not as a cultural norm. In Courbet's figure paintings, meaning is generated by figures whose representation is based on empirical observation of living people known to him, uninflected by the mental schemata of academic form and proportion. It was this challenge to a powerful cultural self-image, even more than to the mythic content of the narratives of history painting, that accounted for the violence of the critical response to the emergence of Courbet's work. His Realist project had the effect of cutting off the possibility of a certain kind of historically reassuring self-identity and bringing in its place something that appeared alien and disturbing.

Courbet's art represents a profound change in our idea of the role of art and the function of the artist. The artist may be trained in his métier, but he is not to be initiated into a specific esthetic, an inherited image-world. The new territory Courbet claimed for his art was that of his own perceptions and existence, with all their rough edges: his own community and class, his own landscape, his own meaning as an artist in a world that had, without yet realizing it, left behind the old visual certainties along with the ancien régime. This claim brought with it a major shift in the direction of the subjectivity of vision. Courbet's insistence, often too vociferous for comfort, on the right of the artist to be an independent witness to the truth of his own time lies at the center of our own concept of modernity.

Courbet in the 1840s was faced with an official painting culture which continued the conventions and formulas of a Neoclassicism, which at its height had been filled with meaning, but which had become increasingly artificial and eclectic. David's *Oath of the Horatii* had had an important and effective relationship with the ideas of the late 1780s; but by the 1840s the subjects drawn from classical history or literature had become increasingly marginal and esoteric (fig. 1). The same was true, except in rare instances such as that of Delacroix, of Biblical subjects, in a society increasingly dominated in fact if not in illusion by secular and anticlerical attitudes. The works themselves took on more and more of the aspect of anecdotal genre paintings, in which stories of minor significance were told by means of a figural style which had been developed and perfected for the portrayal of ennobling themes. Even the paintings of French history which appeared at the Salons in increasing numbers, commemorations of the brave and noble deeds of French heroes from Saint Louis to Louis-Philippe (fig. 2), had lost the powerful

Fig. 2. Paul Delaroche (1797–1856). *The Takers of the Bastille at the Hotel de Ville.* 1839.
Oil on canvas, 13′1½″ × 14′5¼″ (400 × 440 cm). Musée du Petit Palais, Paris

authenticity of the work of Gros and Géricault. Crowded and populous and filled with literal detail, they were made with an eye to both royal patronage and the taste of the growing numbers of bourgeois patrons. None of this provided a model for the ambitions of the young Courbet.

The conventional path for a young man from the provinces desirous of becoming a painter was to acquire whatever training he could at home, and then go to Paris to study at the Ecole des Beaux-Arts. In Paris he would learn not only the art of painting but the sophistication of the great capital. In the attainment of these arts, both technical and social, he would shed his provincial ideas and manners. The young Courbet could very well have conformed to this stereotype. He was a child of Ornans, a small town in the Doubs region of the Franche-Comté in east central France. He came from farming stock, in a family which had acquired some property and bourgeois status as a result of the Revolution. He had gone to school locally and in the nearby provincial capital, Besançon, where his father had sent him in the vain hope of his pursuing a career in the law. Another *topos* enters here, that of the father's ambition for his son to advance in the bourgeois world, against the wishes of the son who wants to be an artist. The boy had hated the College in Besançon and spent as much time as possible studying with a local art

teacher. When in the fall of 1839 Courbet did set out for Paris, he had no intention of studying anything but painting, although he would never lose the need to justify his achievements to his father.

If Courbet was true to type in this father-son conflict, in more important ways he did not conform to the conventions of the aspiring provincial artist pursuing a career in Paris. In the first place, though he worked for a time in the studio of the painter Baron Steuben, he did not attempt to enroll in the Ecole des Beaux-Arts or to join the atelier of an established artist who could prepare him for academic success. He chose instead to work from the model at the informal Académie Suisse and to copy the masters in the Louvre. It is very likely that he also copied in the Galerie Espagnole, a collection of classic Spanish paintings formed for Louis-Philippe and made available to the public. He would certainly have known the collection, as it was the paintings by such masters as Zurbarán, Ribera, and Velázquez that he was especially attracted, as well as to those by Rembrandt, Hals, and the other Dutch seventeenth-century painters hanging in the Louvre. It was from these masters that he learned the method of painting that he never forsook: building up the canvas from a dark ground, modeling from dark into light, the classic technique which linked him with the great tradition even as he used it to realize ambitions that were essen-

Fig. 3. Courbet in 1853. Photograph by V. Laisné.
Bibliothèque Nationale, Paris

Fig. 4. Jean-Baptiste-Camille Corot (1796–1875). *Villeneuve-les-Avignon, Fort St. André.* 1836. Oil on paper mounted on canvas, 11 × 15¾″ (28 × 40 cm). The Louvre, Paris

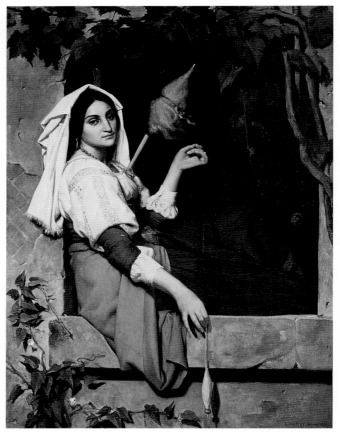

Fig. 5. Felix-Joseph Barrias (1822–1907). *A Spinner, Italy.* 1846.
Oil on canvas, 38¹³/₁₆ × 28½″ (98.6 × 72.4 cm).
The Ackland Art Museum, the University of North
Carolina at Chapel Hill. Ackland Fund

tially modern. This project of working on his own rather than through the Academy was in one sense inevitable, given the young man's temperament and rooted antagonism toward the whole apparatus of classical academic learning on which the teaching of the Ecole was based. He could see clearly the way that he did not want to go; during the course of the forties he would forge his own way.

Courbet was not unique in making this choice; neither Géricault nor Delacroix had established themselves through the academic mechanisms of the Ecole. Landscape painters such as Rousseau and Daubigny were beginning to be accepted occasionally into the Salon without benefit of official backing. Indeed, the small number of artists who in the 1830s and 1840s practiced the relatively novel form of painting out-of-doors, *sur le motif,* were grouped together by the Salon critics with the emerging painters of peasants and everyday life under the catchall category of *Ecole Réaliste.* Thus from the beginning the term Realist was packed with internal contradictions. The landscape painters—Corot (fig. 4), Rousseau, Daubigny—were the vanguard of the 1830s and 1840s. In their hands, as we can now see, the painting of pure landscape, traditionally holding a minor place in the academic hierar-

chy, would become a means of transforming pictorial vision. But with such few exceptions as Millet and Daumier, the painters of contemporary figure subjects drawn from everyday life, both rural and urban, perpetuated the pictorial conventions that derived from the academic tradition (fig. 5). Courbet's ambition, which began to clarify and declare itself by the end of

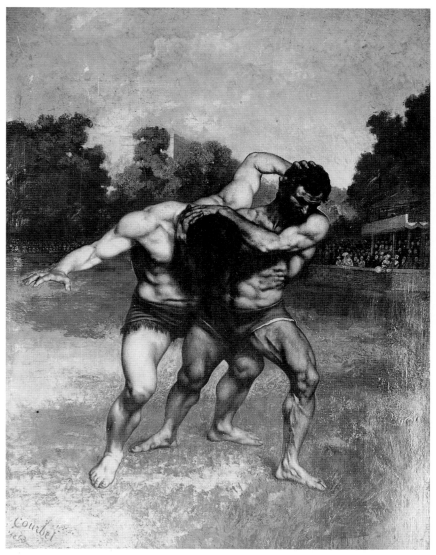

Fig. 6. Gustave Courbet. *The Wrestlers*. 1853. Oil on canvas,
99¼ × 78" (252 × 198 cm). Szépmüvészeti Múzeum, Budapest

the 1840s, was in effect to incorporate the radical
vision of pure landscape into the painting of figures
from ordinary life, conceived on a heroic scale but
without the trappings of heroism. The fact that these
figures were "of the people" was less significant than the
fact that they were not "types" drawn from the tradi-
tion of genre painting, but were representations of the
fabric of the painter's own life. In his paintings,
Courbet gave imaginative visual form to people living
in his own town and countryside. As such they were
intrinsically contemporary, intrinsically a part of that
"modern life" which was becoming a critical issue in
the 1840s.

Courbet's milieu in the formative decade of his
twenties was in part the Bohemian world of Realist
painters and writers in Paris, living precarious margin-
al lives not only because of their youth and obscurity
but because of their critical stance vis-à-vis the official

culture of eclecticism and the *juste milieu*. But the world
to which he bore witness in his painting was that of his
home, in Ornans. Early on Courbet established the pat-
tern of spending portions of each year in Ornans.
While his studies and copies were naturally made in
Paris, most of the paintings that he sent to the Salon
from 1841 to 1848 were painted in Ornans: portraits
of family and friends, self-portraits, and local land-
scapes. Much of the work of these early years is lost, or
painted over, or difficult to identify, but enough
remains to show how he experimented, changed his
mind, underwent and shed specific influences, and laid
the groundwork for the future. *Lot and his Daughters* of
1844 was not followed up by any further standard nar-
rative themes; the 1848 *Walpurgis Night*—a potent
Romantic theme—was painted over in 1853 with *The
Wrestlers* (fig. 6). Two paintings of 1844, *The Sculptor*
(fig. 7) and *The Guitar Player* (fig. 8), are solid examples

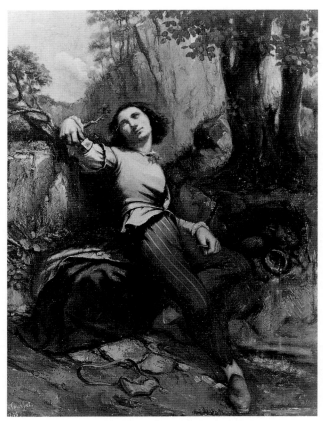

Fig. 7. Gustave Courbet. *The Sculptor.* 1844. Oil on canvas, 21⅝ × 16⅛″ (55 × 41 cm). Private collection

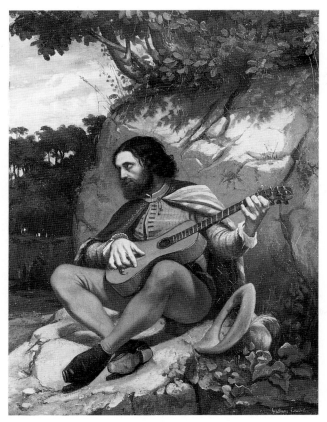

Fig. 8. Gustave Courbet. *The Guitar Player.* 1844. Oil on canvas, 21⅝ × 16⅛″ (55 × 41 cm). Collection Barbara and Thomas Lee

of the Troubadour Style, a kind of medievalizing genre painting which had emerged in the late 1820s and continued to be popular. *The Guitar Player,* with its archaic costume, its vaguely Spanish air, and its relatively high degree of finish, fulfilled the conventions of the style successfully enough to be accepted at the Salon of that year. Indeed the very subject of the wandering minstrel might well have been ironically conceived by the artist as a virtual trademark of the popular style. Also inflected by the Troubadour Style, but far more pregnant with the seeds of the future, is the wonderful *Hammock* (plate 1), now at the Oskar Reinhart Collection in Winterthur, Switzerland, refused at the same Salon. Here are gathered some of the artist's most obsessive themes: the sleeping woman, the woman surrounded by the forest, the woman juxtaposed with water, the woman with loose hair that acts, like flowing water, as a sexual metaphor.

Of equal if not greater significance for the future was the artist's concentration during these early years on portraits—of family, friends, and of himself. It might be said that as a practical matter, the obvious choice of subject for a young painter chronically short of funds would be just these. But such a remark would be both anachronistic and limited in relation to Courbet. Certainly portraiture was an established genre, and one which all painters had relied upon to a greater or lesser extent during their careers; certainly, too, young artists had practiced their skills on their immediate circle and, in many cases, on themselves. But Courbet did not turn to his sisters (fig. 9) and his close friends in order to practice the mastery of skills and conventions learned elsewhere; he turned to them in order to work out his own vision. These persons were not only his models but the subjects of his work, that which gave meaning to his art; and what he made of them would culminate in the mature works of the end of the decade, *After Dinner at Ornans* (plate 6), *The Peasants of Flagey Returning from the Fair* (plate 7), and *A Burial at Ornans* (plate 8).

The self-portraits reveal something of the way in which Courbet used what was closest to him—in this case his own person—to construct a framework of meaning. Altogether ten self-portraits (together with a few drawings) are known to have been made during the 1840s. Some, like *Courbet with a Black Dog* (plate 3) and *Portrait of the Artist,* called *Man with a Pipe* (plate 4), are direct self-images; however, most are images of Courbet in various guises. One of the earliest of these, *The Desperate Man* (fig. 10), is constructed in a rather academic manner and may be based on a traditional "*tête d'expression*" of the art schools, yet the figure with

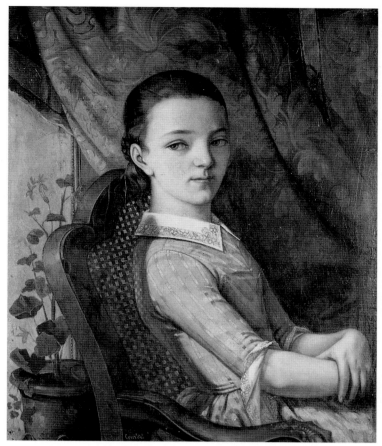

Fig. 9. Gustave Courbet. *Portrait of Juliette Courbet*. 1844. Oil on canvas,
30¾ × 24½″ (78 × 62 cm). Musée du Petit Palais, Paris

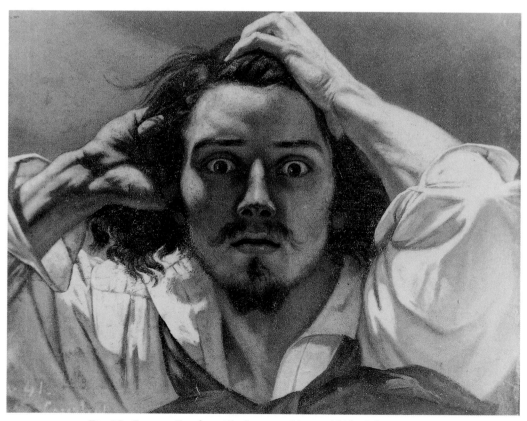

Fig. 10. Gustave Courbet. *The Desperate Man*. c. 1843. Oil on canvas,
17¾ × 21¼″ (45 × 54 cm). Private collection

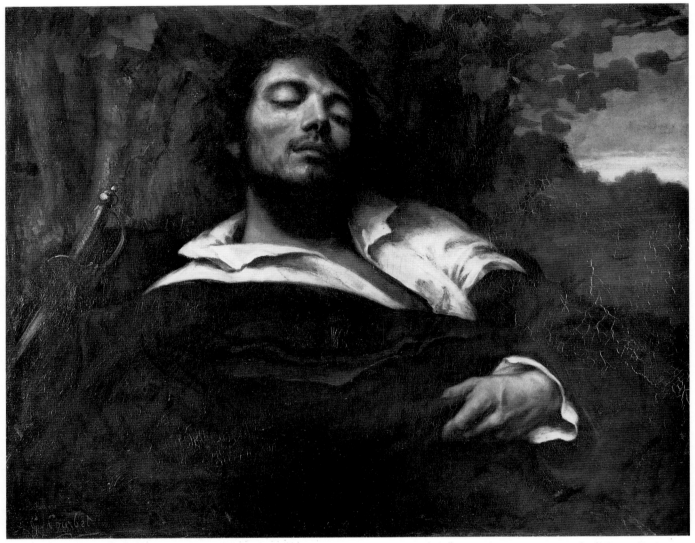

Fig. 11. Gustave Courbet. *The Wounded Man.* 1844, 1854. Oil on canvas, 32 × 38½" (81.5 × 97.5 cm). Musée d'Orsay, Paris

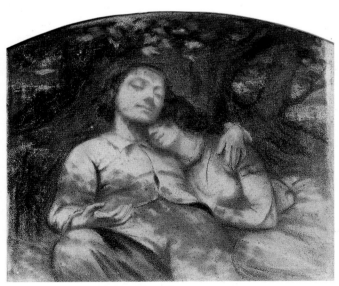

Fig. 12. Gustave Courbet. *The Country Nap.*
Early 1840s. Charcoal and black crayon on paper,
10¼ × 12¼" (26 × 31 cm). Musée des Beaux-Arts et
d'Archéologie, Besançon

its staring eyes almost hurls itself through the picture plane in a very untraditional way. In a related work, *The Desperate Man,* or *The Man Made Mad by Fear* (plate 2), the desperate figure, here full length and clad in Troubadour Style costume, is set in an unfinished landscape and appears to be on the verge of throwing himself over the edge of a cliff to certain destruction. The imaging forth of such extreme states, at the age of about twenty-two, shows not only the young man's imaginative range of emotions but also his susceptibility to the culture of Romanticism, of the *Sturm und Drang.* Another work very much a part of this culture, more from its poetic than its visual tradition, is *The Portrait of the Artist,* called *The Wounded Man* (fig. 11). Here a young man with Courbet's features lies back against a tree trunk, blood showing on his shirt, embraced by nature as he apparently breathes his last after fighting a duel, evidenced by the sword whose hilt is seen at the left. The fact that the painting presents us

with the Romantic union of love and death is revealed when we learn from X-ray examination reports that the present figure was painted over an earlier composition in which a young man lies against a tree with a young woman next to him, her head on his shoulder; this same composition is also known to us from a drawing in Besançon (fig. 12). In another, equally potent mode of Romanticism, Courbet presents himself in the *The Cellist* (fig. 13) as a musician, participating in that art which seems most intimately connected with Romantic culture. The intense sidelong gaze of the powerful, black-bearded head only adds to this cultural aura.

These evidences of a Romanticism which one might expect from a young artist working in the 1840s coexist with elements more individual and more forward-looking. The figure in *The Desperate Man* (fig. 10) seems to invade the viewer's space, while the roughly indicated gulf beneath the figure in *The Man Made Mad by Fear* (plate 2) seems to open out into that space, with the effect of pulling the viewer into the painting. Both these kinds of pictorial structures, the pressing against the picture plane of the figure and the opening out of the ground space (often in the form of water flowing toward the viewer), are consistent characteristics of Courbet's mature work. They are invented structures, derived from no compositional precedents but discovered in the course of the artist's efforts to shrink the distance between his painting and himself, and by extension all viewers. In what is perhaps the most familiar of the early self-portraits, *Man with a Pipe* (plate 4), this sense of close-up, of the almost obtrusive presence of the figure, is very powerful and very much a part of the painting's effect. The viewer is more or less forced to take account of this figure, to read the complex messages of arrogance, melancholy, sensitivity, disdain, ennui, and much else that are embedded not only in the features of the face but in the tilt of the head, the turn of the shoulders, the set of the pipe in the mouth. What begins as an artist's self-portrait, the most subjective and intimate kind of image, ends by becoming a virtual summing up of the idea of the Bohemian artist in the mid-nineteenth century.

In a letter of 1854 to his patron Alfred Bruyas, who had recently bought the *Man with a Pipe,* Courbet remarked, "I have made in my life quite a few portraits of myself, in proportion as I changed my mental situation; in a word, I have written my life." It is this kind of transformation of the material of the artist's own life into paintings of broad significance that I take to be the essential character of Courbet's painting. How he did it is a matter of continuous looking and interpretation of the work, and can never be finally summarized: that he

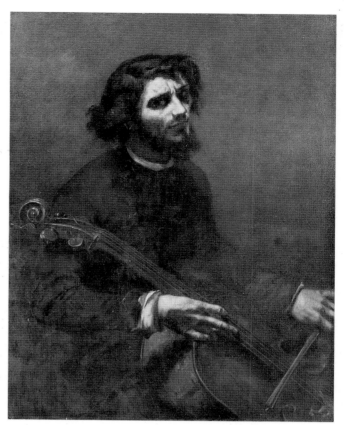

Fig. 13. Gustave Courbet. *The Cellist, Self-Portrait.* 1847. Oil on canvas, 46 × 35″ (117 × 90 cm). Nationalmuseum, Stockholm

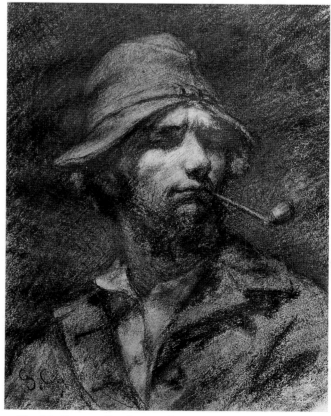

Fig. 14. Gustave Courbet. *Self-Portrait with a Pipe.* c. 1847. Black chalk on paper, 11½ × 8¾″ (29.2 × 22.2 cm). The Wadsworth Atheneum, Hartford. Gift of James Junius Goodwin

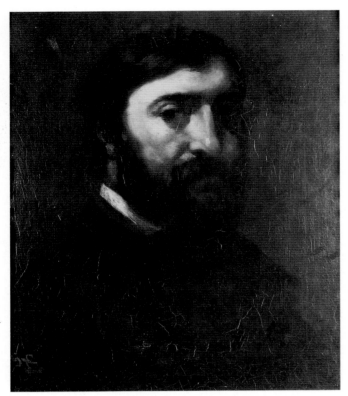

Fig. 15. Gustave Courbet. *Portrait of Urbain Cuenot.* 1846.
Oil on canvas, 22 × 18½" (56 × 47 cm).
Musée Gustave Courbet, Ornans

Ornans (plate 6), depicts three men around a table at the end of a meal listening to a fourth play the violin. It is a kind of meditation on provincial life. Courbet himself identified the figures when he registered the painting for the Salon of 1849, showing by doing so that their actuality was important to him: "It was the month of November, we were at our friend Cuenot's house, Marlet had come back from hunting, and we had asked Promayet to play the violin for my father." Regis Courbet, the artist's father at the left, and his friend Urbain Cuenot (fig. 15), seated across the table, are known from earlier portrait heads, as is Alphonse Promayet (fig. 16), another friend. Marlet (there were two brothers, both childhood friends) is seen from the rear, his dog asleep beneath his chair. The naiveté with which Courbet presented this personal information to the Salon jury is akin to the simplicity of his decision to present such a scene on a nearly life-size scale. Both are intrinsic to his Realist project. No amount of acknowledgment of the painting's perfectly apparent roots in seventeenth-century Dutch painting—at the time or since—could make it into anything but a palpable image of contemporary life. The figures are not only large but solidly painted, and placed just at

did it is a matter of history, and enables us to grasp the importance of his work to his own generation of vanguard artists and to those immediately following. We tend to take for granted the fact that Manet and the Impressionists chose their subjects from the world around them, despite the continuing preference among the rich and powerful for mythology and decoration, and the academic clinging to the concept of "genres." The crucial battles of this intellectual conflict took place in the 1840s and 1850s, and the force and ambition of Courbet's painting inevitably made him the leading figure. Courbet's work of the late forties into the fifties destroyed the idea of genre, with its implication of hierarchy and its distancing of the painter from his theme, and made it impossible for a serious painter to avoid confronting the life of his own times and finding his own meanings within it.

The life closest to Courbet at this period was that of his native town and countryside in the Franche-Comté. As to the landscapes he painted in the region, more will be said later. And as we have seen already, the figure studies focused on portraits of the self, family, and friends; single figures for the most part, or no more than two. By 1848 Courbet was ready to attempt a larger and more complex figure painting drawn from the same thematic source. The painting, *After Dinner at*

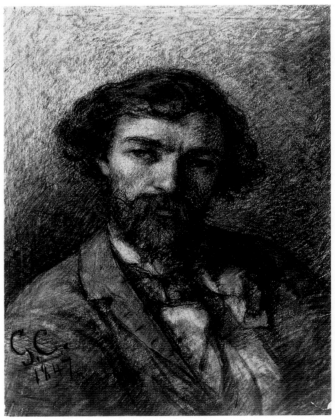

Fig. 16. Gustave Courbet. *Portrait of Alphonse Promayet.* 1847.
Charcoal on paper, 12⅝ × 9½" (32 × 24 cm).
The Louvre, Paris

16

the edge of the picture plane so that the viewer feels included in their space. The fact that the two most prominent figures are seen from the rear adds to the viewer's sense of being drawn directly into the scene. Despite our knowledge that such a large canvas could only have been painted in the studio, the painting conveys the sense of immediacy that would come from having been made inside the room depicted.

After Dinner at Ornans demanded attention and got it, both from hostile critics and admirers. One of the latter was Delacroix, who had never heard of Courbet, and who is reported to have been immensely enthusiastic and impressed that a talent so strong and so independent of precedent could have emerged so suddenly. The relatively liberal jury of 1849—the first of the short-lived Second Republic—awarded Courbet the crucial medal that would allow him free entry to future Salons, and the painting was bought by the state. The town of Ornans gave its artist son a big party, and when Courbet had recovered he set to work with enormous energy, buoyed by the knowledge that his work would certainly be shown in the following year's Salon. Over the course of the next year he produced three very large and very important paintings: *The Stonebreakers* (fig. 18), *The Peasants of Flagey Returning from the Fair* (plate 7), and *A Burial at Ornans* (plate 8), all of which were shown at the Salon of 1850. Together they comprised a kind of manifesto, of which the *Burial* was the most complete expression.

In a letter of 1854 to Bruyas, Courbet would refer to the painting as "my debut and my statement of principles." Again, Courbet's actual title is significant: *Tableau de figures humaines, historique d'un enterrement à Ornans.* There was to be no way that this twenty-two-foot-long painting could be confused with a genre painting in the traditional sense; it could only be judged in the terms of *peinture d'histoire,* possessed of a claim to high seriousness. This claim, made by a relative newcomer on behalf of this painting in the context of its two companion works at this historical moment, brought down a critical firestorm on Courbet's head. Forced to confront not only the rustic subjects of these paintings but their massive engagement with and intrusion upon the viewer's space, that is, their total lack of either pictorial or rhetorical convention, most critics reacted in self-defense. The issues raised were clarified by the strength of the challenge. "The aim of painting and sculpture must be to inspire men to beautiful thoughts by the sight of beautiful images," wrote Louis de Geofroy for the prestigious *Revue de Deux Mondes,* and this was the essential theme of many other writers. To possess beauty, a painting must not only present noble subjects but must do so with the accepted forms of grace and elegance. The entire structure both of the Academy and the established taste of society based on academic norms was in danger from this painter, who dared to present this image of a provincial funeral in place of heroic myth and to claim the validity of his seemingly raw and unmediated vision of human beings in place of the noble self-image of the classical tradition. The pain of this unacknowledged cultural wound was widely expressed by accusing the painter of being in search of deliberate ugliness.

One of the many aspects of this apparent ugliness in the *Burial* was the stiffness and blackness of the clothing, the *habit noir* of the bourgeoisie, an issue ambivalently raised in 1846 by Baudelaire. Calling for an end to the painting of historical scenes with their opportunities for flowing and colorful costumes, Baudelaire also acknowledged what he called the "heroism of modern life," which consisted of recognizing that we are the victims of that life, and our victimhood is expressed in our stiff black clothing: "We are all celebrating some burial." Another source of perceived ugliness in the painting was the complete lack of traditional composition, that is, the clear and graceful disposition of figures; also absent were the expected gestures and expressions of grief that would enable the viewer to respond in sympathy with the occasion. These stony, work-lined faces were in fact too particular, too localized, too much the portraits of the Ornans townspeople that indeed they were; the critics saw this, and deplored what they believed to be an artist who could not understand that what lay before his eyes was not the same thing as the truth of art. Courbet of course knew the difference between what he put onto canvas and the infinite messy world of visual fact. But for the critics defending an entrenched position, the "truth of art" could not exist outside of the conventions on which their world view was based. These massive figures seemingly torn from the context of their crude rural life, these rough road workers, these buyers of cattle and pigs, these impassive country mourners represented, in themselves and in the manner of their depiction, the desire to tell a new kind of truth, which was unacceptable to all but a few.

Such issues were not simply a matter of esthetic debate among critics, academicians, and artists, but were solidly embedded in politics. The Academy and the Salon were institutions of the state, and the state was in an unstable condition in these years of 1850 – 51. The fragile Second Republic was being weakened by pressures from the right and radical reactions from the left. By the end of the year, Louis-Napoleon's coup

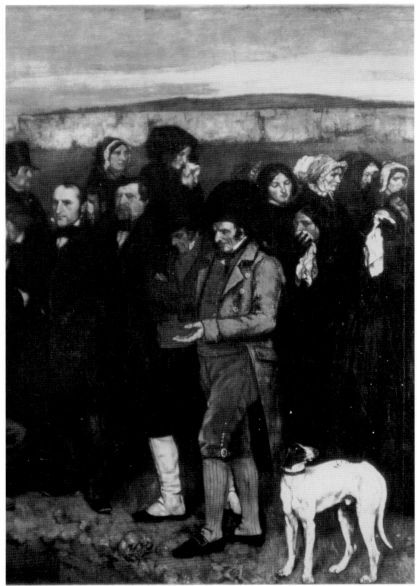

Fig. 17. Gustave Courbet. *A Burial at Ornans,* detail. 1850.
Oil on canvas. Musée d'Orsay, Paris

d'état would open the way for the Second Empire and the repression of libertarian and populist ideas. Social norms were closely linked to matters of taste, and the newly arrived members of the middle class were anxious above all for correctness, while the still powerful monarchists tended to despise all forms of modernity. As T. J. Clark has demonstrated, Courbet's paintings forced some Parisians to confront the provincial origins that they wanted to suppress, and reminded others of the solid presence of the members of the so-called dangerous classes, the working people of rural France. Under the circumstances it was no surprise that Courbet was dubbed a peasant and a Socialist. Neither epithet disturbed him. He took pleasure in maintaining his country accent and manners in the polished metropolis, and he was also aware that this local color

sharpened his public image. As for being labeled a Socialist, he was a friend of Proudhon, an admirer of the ideas of the Utopian Socialist Fourier, and a believer in the Republic and in *le peuple*; thus he was not offended by the accusation, which only added to the rather heady notoriety of the moment. What did come to disturb him was the reductive and dangerous way in which political labels were used. Toward the end of 1851, in the anxiety-wrought weeks before the coup d'état, he was publicly—and falsely—accused of attending a subversive political meeting, and he responded: "M. Garcin calls me a socialist painter; I willingly accept that description. I am not only socialist but even more democratic and republican, in a word partisan of the whole revolution; and above all *realist*. But this does not matter to M. Garcin, this is what I

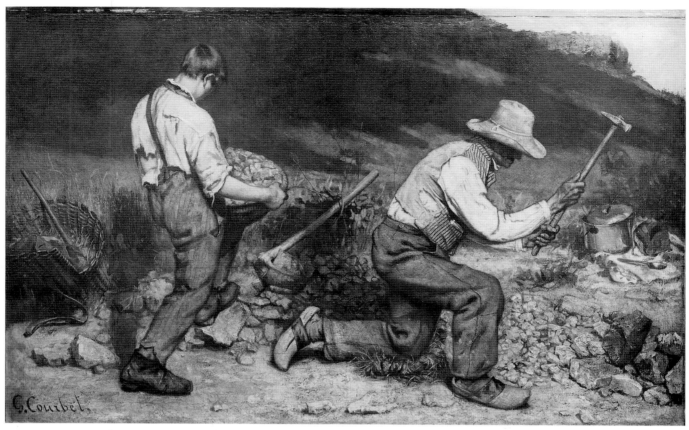

Fig. 18. Gustave Courbet. *The Stonebreakers.* 1849. Oil on canvas, 63 × 102″ (160 × 259 cm).
Formerly Gemäldegalerie, Dresden (destroyed in World War II)

insist on, because realist means a sincere friend of real truth."

The political tensions of the time may have made Courbet's work especially threatening, but the intellectual conflict in which he took so strong a stand was more profound and far-reaching than the specifics of the historical struggle. The ideas embodied in his paintings represented a genuine revolution in the way of perceiving and thinking about the world. This was a change which did not deny the validity of the art of the past, the beauty of which arose from the authenticity of its relation to the most powerful intellectual and spiritual currents of the age in which it was made. What was claimed and demanded was authenticity for the art of the present and future, and that meant an art whose driving aim was to explore the experience of the self in the world in order to gain understanding, not to serve an ulterior end, whether sacred or secular. This is what Courbet is getting at when he says that "realist means a sincere friend of the real truth." Certainly such a remark does not stand up under rigorous philosophical scrutiny, but then Courbet was not a philosopher. Nonetheless, for him painting was bound up with the aim of truth-telling, and truth-telling involved paying attention to the way life was lived in the present by

ordinary people, represented without reference to ideal norms. The whole dense matrix of figuration that was his immediate pictorial heritage—the rich and intricate mass of historical, literary, mythological characters and symbols—all of that had to be given up. That he did so willingly, and with an irritating bravado, does not detract from the fact that for a figure painter of high ambition it was a breathtaking refusal and one which required precisely the force of ego for which he was blamed throughout his life and by many critics since.

For models of figure painting Courbet chose to leapfrog the whole of the eighteenth century and look to the solid, somber paintings of the Dutch and Spanish Baroque artists. (His first trip outside France was in 1846, to Brussels, Amsterdam, and The Hague, and he wrote enthusiastically of the collections he had seen.) But there were few models among his contemporaries for what he wanted to do. Only the open-air landscape painters like Corot, Rousseau, and his own close contemporary Daubigny were doing something comparable by setting up their canvases in forests and fields and making paintings out of what they saw. In late 1849, Courbet wrote to Francis Wey, "I had taken our carriage, I was going to Château de Saint Denis to make a landscape; near Maisières, I stopped to look at two men

Fig. 19. Gustave Courbet. *Sketch for A Burial at Ornans.* 1848. Charcoal on paper, 14⅝ × 37⅜" (37 × 95 cm).
Musée des Beaux-Arts et d'Archéologie, Besançon

breaking stones on the road. It is rare to encounter such a complete expression of hardship, so the idea of a painting came to me on the spot. I made an appointment with them for the next day at my studio, and since then I have finished my painting" (fig. 18). He continues with a description of the painting, but these first few words tell us a great deal about his concerns and practices. First, Courbet too is an open-air landscape painter; he takes his gear to sites in the region he knows so well, he chooses what he will focus on, he engages in a dialogue with the shapes, spaces, surfaces, light, and atmosphere of that little piece of the world in which he is at that moment alive. Though he is on this day heading for a destination, we may suppose that as he goes along he is continually seeing the countryside as landscape, as a source for painting; when he sees the two men working, he seizes upon them immediately as a "tableau." But inseparable from his seeing them in this way, with his landscape eye, as a picture, is his instantaneous grasp of the character of their life, the grinding rural poverty which necessitates a lifetime of backbreaking tasks. This is not a sentimental view, but a factual one; facts seen with respect and understanding, even as are the facts of the surrounding landscape. Thus in these brief phrases we get a glimpse of Courbet's mind at work, generating a work of art from an experience of vision which fuses the open-air idea of unmediated perception with the passion to embody in painting the people who formed the fabric of his own rural life. In its own more complex way, *A Burial at Ornans* (plate 8) can be seen to have originated in a related manner. The painter's initial idea is in this latter case documented in a drawing, probably made not long after the funeral, which was an event of family significance to him and at which he was a mourner (fig. 19).

The final sentence of the passage quoted above sheds light on his procedure: in the case of the stonebreakers he is obviously not going to make a painting on the spot; rather, he engages the workmen as models in the studio, and makes from his studies a large painting with life-sized figures. Similarly, though over a longer period of time, construction of the twenty-two-foot-long *Burial*, which took place in his Ornans studio during the first half of 1850, was an arduous process of composing individual portraits of his family, friends, and fellow townspeople.

Like the *After Dinner at Ornans*, the *Stonebreakers* (fig. 18) looks as though it could have been painted in situ. There are the solid figures pressed close against the picture plane, the intense clarity of the foreground details, the figure seen from the rear that draws the viewer into the pictorial space. This same illusion of presence is true of *A Burial at Ornans*, where the freshly dug grave opens out toward the viewer, who looks across the length of the grave at the life-sized figures massed in a procession that could easily extend beyond the edges of the canvas. For Courbet's audience, this novel sense of having been thrust against their will into the alien company of roadworkers and rural mourners would account for some of their hostility to the paintings (and for the milder reaction to the more inviting situation of the *After Dinner*). For ourselves, this illusion of the presence on the scene of the painter, and by proxy of the viewer, provides an insight into the artist's project and its cultural affinities. In these paintings of 1849–50, Courbet is after a kind of authenticity and truth to nature which is shared by his contemporaries, such early photographers as Charles Marville (fig. 20), Humbert de Molard, and Gustave Le Gray. These pioneers of calotype produced paper prints in the late for-

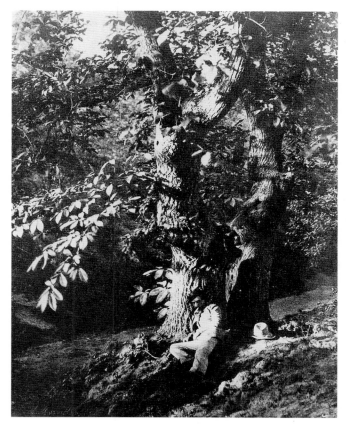

Fig. 20. Charles Marville (1816– c. 1879). *Young Man Reclining Against a Horse-chestnut Tree*. 1853. Salted paper print, 8½ × 6″ (21.6 × 15.2 cm). The Metropolitan Museum of Art, New York. Harris Brisbane Dick Fund, 1946 (46.122.3)

ties and early fifties, which even in their small scale show a distinct kinship with Courbet's vision. This kinship has nothing to do with the question of how much each may have known of the others' work, still less what specific uses may have been made of that knowledge if it existed. What they shared was a belief in the weight of reality and in the authenticity of witness. At that time, the photographer's carefully made print was a guarantee of its author's witness to the image depicted; he was *there* and this was the truth that he saw. The subjectivity of vision implied in this witnessing was observed by few, overridden by the fact that the camera was an instrument very different from the pencil or the brush; and it was not long before critics would use photography as a weapon against painters of the Realist School. (It is interesting that one of the early writers to perceive the *positive* esthetic qualities of the photographers' work of this period was Francis Wey, one of Courbet's earliest admirers.) As we know from the letter to Wey quoted above, and from the history of *A Burial*, these paintings began in an experience of witness; in the subsequent studio painting it was important to the artist to build this experience into the structure of the painting. In the interest of authen-

ticity, he created the illusion of his own presence.

The alien quality, coupled with heroic size, of Courbet's 1850–51 Salon entries established him as the leading challenger to academic norms, and as such fair game to the kind of attack and ridicule that formed such an important part of the journalistic culture of nineteenth-century Paris, particularly during the Second Empire when direct political satire was a punishable offense. By responding to these attacks with bravado rather than modesty, Courbet assured himself a permanent place in the textual and visual iconography of critical vituperation. The leading caricaturists had a field day. *The Peasants of Flagey Returning from the Fair* (plate 7) of 1850 and the large painting submitted to the Salon of 1852, *The Young Ladies of the Village* (plate 10) were both visually parodied in similar terms as stiff doll figures, as clowns and toys on wheels (figs. 21, 22). The reference was not only to actual childrens' toys but to the *images d'Epinal*, the provincial block prints that were just beginning to be appreciated as folk art by Courbet's generation, but which were widely considered by educated people to be laughably crude. But making fun of the paintings was only half the game; Courbet's reputation as a rustic with much too good an opinion of himself made a target of his own person (fig. 23). Much was made of his so-called Assyrian profile as a young man, and of his belly in middle age. An excellent opportunity arose in the form of *The Meeting* (plate 14), painted in 1854 and shown the following year. In this painting, commonly known as *Bonjour, M. Courbet*, the artist's presence within the painting made it possible to caricature the painting and the person at the same time. The Quillenbois drawing, titled *L'adoration de M. Courbet, imitation réaliste de l'adoration des Mages* (The adoration of M. Courbet, realist imitation of the adoration of the Magi) (fig. 24), is quite hilarious, concentrating rather more on the painter than on the painting as it shows Courbet flaunting his Assyrian profile while the two figures of Bruyas and his servant, and dog, go down on their knees before him.

The Meeting marks an important stage of the painter's career. In it Courbet depicts himself being greeted, under the bright sky of the Midi, by Alfred Bruyas, gentleman of Montpellier, attended by his manservant and his dog. It was painted for Bruyas to commemorate Courbet's highly satisfactory visit to Montpellier from June through September of 1854. Bruyas was the first and most significant patron of Courbet's career, and at this time their relationship was close to its peak. (Francis Wey had helped with advice and making arrangements for such matters as the Berlioz portrait commission, but he was not a collector.) Bruyas was an

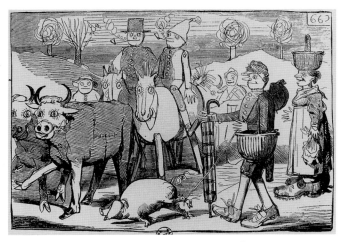

Fig. 21. *The Peasants of Flagey Returning from the Fair.*
Caricature by Bertall, in *Le Journal Pour Rire,* 1851

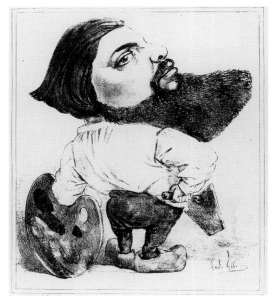

Fig. 23. *G. Courbet.* Caricature by André Gill,
in Nouveau Panthèon Charivarique, 1868

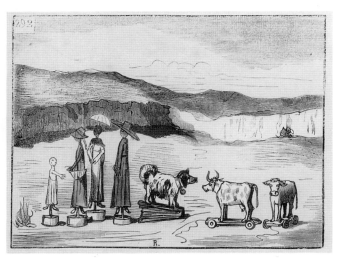

Fig. 22. *The Young Ladies of the Village.* Caricature by Bertall,
in *Le Journal Pour Rire,* 16 April 1852

Fig. 24. *The Meeting,* or *Bonjour M. Courbet.* Caricature by
Quillenbois, in *L'Illustration,* 21 July 1855

emblematic nineteenth-century man: son of a well-to-do banker, with no interest in business but with high esthetic ideals and ambitions; serious amateur, neurasthenic, often at odds with the family who controlled his funds, prone to Utopian and somewhat esoteric theories; withal, possessed of a feeling however vague for modernity and for the role of art in a changing society. He also liked to befriend the artists whose work he collected, and loved to have them paint his portrait. It is possible that he became interested in Courbet through his friend François Sabatier (fig. 25), a landowner near Montpellier, who was also an esthete and a Fourierist and who had been the only critic of the 1850–51 Salon to have written at length in favor of *A Burial at Ornans* (plate 8). From the Salon of 1853 Bruyas bought the very controversial *Bathers* (fig. 40), as well as *The Sleeping Spinner* (plate 11). Soon afterward, he commissioned a portrait of himself—the so-called *Tableau Solution* (fig. 26)—and seven other paintings were

bought or commissioned from Courbet during the following year. For Courbet, Bruyas was not simply a collector, but *the* collector, the man whose support and understanding of the artist's enterprise would, he believed, enable the painter to be free of the burdens of dealing with government bureaucrats and petty clients. His natural tendency to utopian thinking, fostered by Fourierist philosophy and stimulated to further flights by Bruyas, gave rise to an energizing euphoria. In a letter to Bruyas shortly before he visited Montpellier, Courbet wrote that he had always told his friends, "'Never fear! Even if I have to go all over the world, I am sure to find men who will understand me; even if I should find only five or six, they will make me live, they will save me.' I am right, I am right! I have met you; it was inevitable, because it is not we who have met, but our solutions."

"Solution" was a key term in the Fourierist concept of the transformation of society, used as in the title of

Victor Considerant's 1850 essay, *La Solution ou le gou-vernement direct du peuple*. In the Fourierist philosophy, art is seen not as an amenity but as essential to the development of mankind; as Sabatier wrote in his critique of the Salon of 1850–51, "Art is the highest and most complete expression of the human microcosm, the most sublime creation of social man." Ideas such as these united Bruyas, the dilettante and patron, with Courbet, the painter. Their imaginative stimulation moved Courbet to add a new dimension to his art— what he himself would later refer to as "real allegory." He used the term to describe his great canvas of 1855, *The Painter's Studio* (plate 16), but *The Meeting* (plate 14) is in some respects a foreshadowing, or first step toward that magnum opus. To the paintings generated from the life around him, primarily themes of rural activity, he added this image of a milestone in his own artistic evolution. The artist is no longer present as witness, he is present as subject, and not as a conventional self-portrait but as a participant in a figure painting, which again lays implicit claim to the status of History Painting, while presenting none of its attributes. There is no narrative involved, because with all its solid painterly conviction this is not a scene that would ever have actually taken place. The three figures (and a dog), each of them brilliant portraits in themselves, are set in the landscape in such a way as to represent the relationship among them, not an actual greeting. The patron, a man of property and intellectual sympathy, although lacking in physical strength (he goes out accompanied by a manservant carrying a shawl), is connected to life by the Realist artist, a figure of intellectual and physical power who is in turn enabled to fulfill his ambitions through the generosity and idealism of the patron. The sense of mutuality is present, but so too is Courbet's profound conviction, despite all his gratitude, of the primacy of the artist. In pictorial terms it takes two figures to match the weight of his one; tall, easy, and erect while heavily burdened, fully silhouetted against the sky, his is the figure closest to the viewer, the active figure who leads us into the space toward the static pair with their symmetrically though differently disposed hats, their bodies conjoined at the middle by the telltale shawl on the attendant's arm. The relationship figured in the painting is at once vivid and concrete, and filled with subtle complexities. It is possible to read the Bruyas/servant pair as a metaphor of dependency, set over against the free, self-sufficient figure of the itinerant artist, who himself is a representation of freedom and independence; or even as a metaphor for the Fourierist notion of the union of genius, capital, and labor in a healthy society. What is

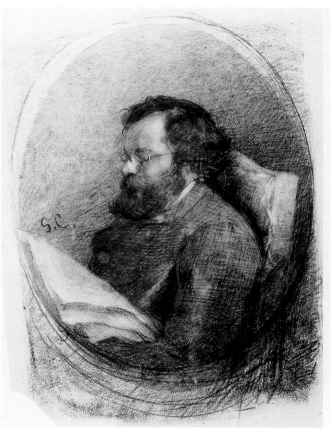

Fig. 25. Gustave Courbet. *Portrait of François Sabatier*. 1857. Conté crayon on paper, 13⅜ × 10¼" (34 × 26 cm). Musée Fabre, Montpellier

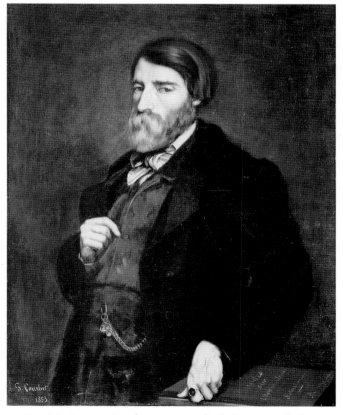

Fig. 26. Gustave Courbet. *Portrait of Alfred Bruyas*, called *Le Tableau-Solution*. 1853. Oil on canvas, 35¾ × 28⅜" (91 × 72 cm). Musée Fabre, Montpellier

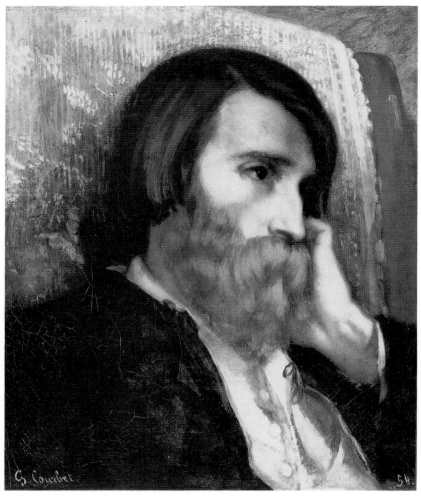

Fig. 27. Gustave Courbet. *Alfred Bruyas,* called *Bruyas III.* 1854. Oil on canvas,
17¾ × 14½″ (45 × 37 cm). Musée Fabre, Montpellier

impressive and gives meaning to Courbet's term *real allegory*, is the artist's capacity to create such an immense degree of resonance out of such private materials.

The term *real allegory* was of course a provocative one, given the fact that traditional allegory had by no means gone out of fashion. Even more provocative was the way in which the painting so described by Courbet, *The Painter's Studio* (plate 16), was first displayed to the public. Not long after the government announced its plans to organize the Exposition Universelle for 1855—a grand international show modeled on London's Crystal Palace Exhibition of 1851 and designed to demonstrate the cultural and economic strength of France—Courbet began to dream of a pavilion of his own, abutting the Exposition grounds, in which to mount a show of his own work. An important part of this scheme was to be a large new painting, which he described to Bruyas as being "the most surprising picture that one could imagine. There are 30 life-sized figures. It is the moral and physical history of

my studio. They are all people who serve me and who take part in what I do." He hoped that Bruyas would collaborate with him on this pavilion project, but the banker-father—doubtless not ready to condone the flaunting of his good name on such a manifestly subversive enterprise—refused to supply the funds. Nonetheless work on *The Painter's Studio* progressed, and Courbet, only partially scaling down his original idea, submitted fourteen major works to the Exposition-sponsored Salon. They included such new works as *The Meeting* (plate 14), *The Grain Sifters* (plate 12), and *The Painter's Studio*, and also such previously exhibited works as *The Young Ladies of the Village* (plate 10) and *A Burial at Ornans* (plate 8).

Perhaps not surprisingly, the two very large paintings, the *Burial* and *The Painter's Studio*, were refused, together with one portrait. Courbet chose to take this refusal as a political attack on his "tendencies in art." That made a good rallying cry, but it may be that what pained him most was the loss of the opportunity to show the great new "summing-up" painting to the pub-

lic, and in particular to show it in the context of his other work, beginning with his virtual opening gun, the *Burial*. In a very modern way, Courbet had a conception of his work as an ongoing project, in which individual paintings had a significant relation to one another and to the whole. He referred to *The Grain Sifters* (plate 12) as a "painting of rural customs" that belonged in a "series" with *The Young Ladies of the Village*, and he wrote of planning a painting of a gypsy mother and her children as being part of a "*serie du grand chemin*" along with *The Stonebreakers* (fig. 18). It is evidence of a new way of thinking about painting that he saw his works as both discrete objects and as providing added meaning through being seen together. In any event, the refusal of the two important large paintings revived—doubtless without much difficulty—the original idea of the separate pavilion. Friends rallied in support, and Courbet managed to have built a temporary structure close to the Exposition grounds, where he opened an exhibition of forty paintings. Thus visitors to the Exposition Universelle could if they so willed see fifty-one of Courbet's paintings; although not ideally shown because of being separated into two groups, Courbet had nonetheless achieved his dream. In so doing he helped to invent a phenomenon that we take for granted today—the one-man show/museum retrospective (such few antecedents of this event as there were in the late eighteenth and early nineteenth century were rather different, being centered around single works or themes). The building housing Courbet's forty paintings was called the Pavillon du Réalisme. In the brief preface to the printed checklist of the exhibition, Courbet discounted the usefulness of the term—"The title of realist has been imposed on me just as the title of romantics was imposed on the men of 1830"—and concluded by providing his own definition of his humanist enterprise: "To know in order to do, that was my thought. To be able to translate the customs, the ideas, the appearance of my epoch, according to my own estimation, to be not only a painter but a man as well—in short, to create a living art, such is my goal."

In this little brochure the full title of the new major work is *The Painter's Studio: A Real Allegory Summing up Seven Years of My Artistic Life*. Despite its subtitle and all of the interpretations that it has given rise to, the effect of the painting when seen in the original is to take the viewer beyond interpretation, beyond encoding and decoding, into an imaginative space which is for the time being more concrete and affective than anything in the empirical world. To say this is simply to recognize the painting as a masterpiece, as Delacroix, despite his misgivings about Courbet, did when he went to the exhibition and wrote in his journal of August 3, 1855: "I stay there alone for nearly an hour and discover that the picture of his which they refused is a masterpiece; I simply could not tear myself away from the sight of it." Through its size and the scale of its figures, the complex seriousness of its atmosphere and its absolute conviction as a painting, the viewer is aware of being brought into the company of Masaccio in the Brancacci Chapel, Raphael in the Vatican Stanze, Watteau at the shop of Gersaint. Such references have nothing at all to do with art history and certainly not with influence (Courbet was if anything antagonistic to both the Italian Renaissance and to the eighteenth century), only with an order of being in a work of art which enables it to rise above its own time and also to contain and illuminate some of the most profound ideas and attitudes of a whole age. We stand before this painting as if we were at a kind of intersection between Eternity and the middle of the nineteenth century.

Having said that, we of course want to know more. While tremendously satisfying as a work of art, a part of the power of this painting comes from its sense of enigma. We know that we are present at an artist's studio, and that the artist is Courbet, again as in *The Meeting* (plate 14) assuming the role of *the* artist in such a way as that role could not have been conceived and visualized before the nineteenth century. He takes the central place of both thought and action, the painter in the process of realizing his conception. Behind him stands a half-draped nude model, in front of him a small boy gazes up at him and his work, at his feet a cat plays, here representing the animal presence that is so frequently found in Courbet's major figure paintings. Before we have even left this central group, we are once again aware that we are present at a scene that, however immediately compelling as an observation of "reality," is far from being a literal scene. The child is an unlikely visitor, and the nude model, whose recently shed clothing makes a wonderful foreground still life, is irrelevant to the landscape painting on the easel; models were not paid to stand in chilly studios while the artist worked on something that had nothing to do with them. And of course when we take in the character of the figures which are so naturally and convincingly grouped on either side of the artist, we realize the force of the term *allegory*. Just possibly the figures at the right might represent actual studio visitors (fig. 28); with the exception of the pair of lovers in the window embrasure, these are, like the figures in the *Burial*, images of persons known to Courbet that have been constructed from his earlier portraits of them (fig. 29). But having

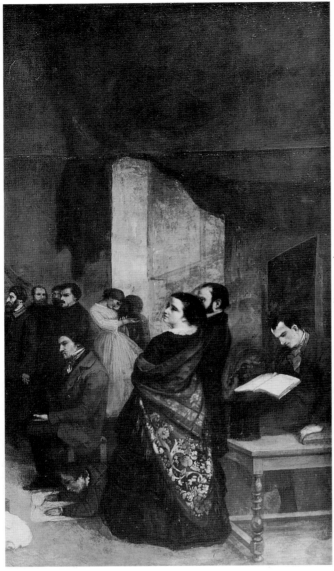

Fig. 28. Gustave Courbet. *The Painter's Studio,* detail. 1855.
Oil on canvas. Musée d'Orsay, Paris

sented, each of which is visually centered upon the figure of the artist. Even if we did not know, as for the most part we do, the identities of the figures on the right and their specific relationships to Courbet; and even if we did not know, as we do from Courbet's letters, that both groups were constructed however enigmatically to constitute the painter's conception of his own society, we would be aware that these figures were Courbet's own contemporaries and that they were in some important way a part of his life. In this sense, *The Painter's Studio* is a perfect metaphor—or allegory—of Courbet's work as a whole, and of the way he conceived of the enterprise of painting. Painting is no longer to be the concrete visualization of persons known to the mind essentially as characters in a narrative, graspable through the medium of words. Whether gods on Olympus, apostles in the Holy Land, Byronic heros, or kings of France, all, whether mythic creations, literary inventions, or figures of history past, are equally out of bounds to an art which seeks to grasp and understand the world in direct and unmediated terms. All of these personages either were originally, or had developed into, concepts, each with its history of visual embodiment in the great figurative tradition of European art. But in the mid-nineteenth century, to continue in this tradition of visualizing myth, tale, or history through

established their identities, we know that they are not in actuality a group who might have been present in the studio together, as for instance the fellow artists in Bazille's *The Studio in the rue de la Condamine* could have been. As for the figures at the left, their motley character completely does away with any idea of historical plausibility and plunges the viewer directly into the question, What do they mean? rather than, Who are they? We are here a very long way indeed from the kind of naive Realism that people often assume to characterize Courbet's art.

Reference to recent interpretive answers to the above questions are found in commentary on *The Painter's Studio* (plate 16); here I would draw attention to the significance of the way in which the painting is constructed. Nothing could be clearer than the fact that there are two separate groups of "visitors" repre-

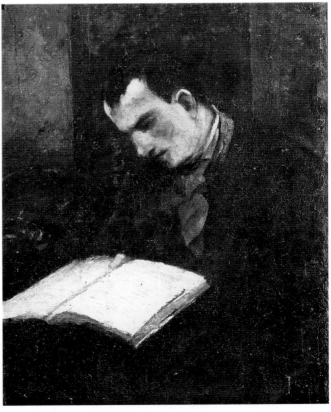

Fig. 29. Gustave Courbet. *The Painter's Studio,* detail. 1855.
Oil on canvas. Musée d'Orsay, Paris

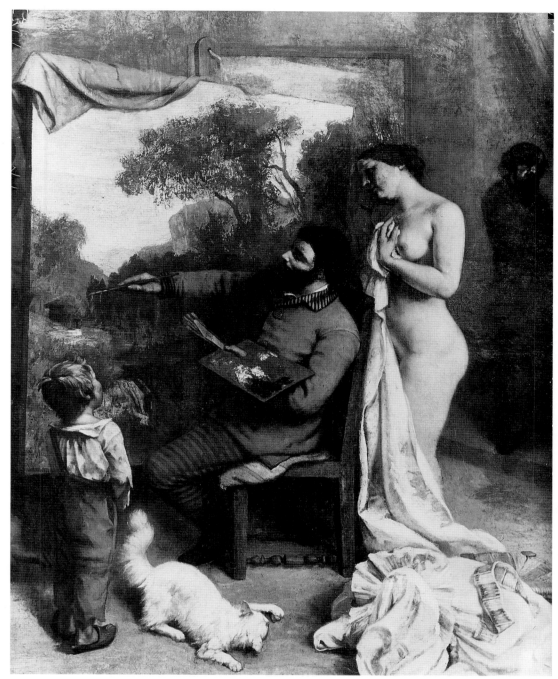

Fig. 30. Gustave Courbet. *The Painter's Studio,* detail. 1855. Oil on canvas. Musée d'Orsay, Paris

the medium of painting, was to fall into the trap of illustration and archaeology, of something static, sentimental, and heavy with meaningless detail. The painter's own direct knowledge and experience are the only valid criteria for an authentic art, and it is the task of the painter to grasp the significance of what he knows and to create a visual equivalent that will communicate that significance to others. Such was Courbet's credo, and by painting this work, intended to be seen by the large international audience of France's first Exposition Universelle, he stated it with great force and conviction.

The modernity of this credo is further implicated in the fact that in *The Painter's Studio* Courbet chose to represent himself as painting a landscape (fig. 30). The motif is clearly drawn from his region of the Doubs in the Franche-Comté, with its high chalky cliffs, woods, rivers, and falling waters. The painting is large, of a kind which can only be made in the studio, though its origin and visual structure are firmly placed in the tradition of open-air painting. Courbet, maturing in the 1840s, appropriated that tradition for himself at a time when it was approaching a mature phase. Like Realism itself, the idea of painting landscape out-of-doors is

Fig. 31. Gustave Le Gray (1820–1882). *Forest at Fontainebleau.* 1849–52. Salted paper print, 10 × 14½″ (25.4 × 36.4 cm). Gilman Paper Company Collection

now so taken for granted, indeed so relegated to the realm of convention, that it can be difficult to reimagine its first emergence into historical time and the profound significance of the ideas that were attached to and grew out of the practice. Landscape as background in figure paintings, and on-site landscape drawings and sketches in order to develop a vocabulary of motifs for figure paintings had been a part of the painting tradition since the Renaissance. But by the later eighteenth century, new attitudes toward nature were emerging, which gradually transformed pure landscape painting into an independent vehicle of meaning. The physical world itself, and not just the works of man wrought into things of beauty, became a source of conscious esthetic experience in a way it had not been before. By selecting his site, his focus, and the limitations of his pictorial field, the painter could construct a painting—that is, make an object of esthetic meaning—out of any corner of the visible world. The operating feature becomes the look, or to use a word closer to the French, the *regard*, of the artist; and the significance of that idea for the ensuing two hundred years of art history is clear enough. But this is to speak, as we cannot help speaking, from the perspective of Duchamp, Warhol, and a hundred and fifty years of photography: no such claims were articulated in the late eighteenth and early nineteenth centuries. What did occur was that the most adventurous painters increasingly made paintings in the open air, looking upon them initially as partial studies for larger finished compositions, but

over time coming to see that the qualities embodied in paintings made on the site possess important artistic meanings. The very freshness and beauty of the best of these open-air paintings, from Valenciennes' studies over Roman rooftops to the great body of landscape paintings by Corot from the 1820s onward, attest to the energy generated by the artists' sense of experiment and discovery.

Courbet would have encountered this tradition in the late 1840s in the work of Corot and the other Barbizon painters—Rousseau, Millet, the young Daubigny, and others. By the end of the decade, the painters were joined by such early photographers as Le Gray, Marville, and Le Secq, who worked alongside the painters in the Forest of Fontainebleau (fig. 31). Both painters and photographers respected each other as colleagues engaged in a common enterprise: the discovery of esthetic form in the raw material of nature. Methods of representation differed, but to the artists this seemed to be less important than the fact that the meaning of representation was shared. This meaning was many layered. Landscape as an independent genre had to be asserted against the conventional belief that only figure paintings mattered. Conservative critics of the Second Empire lost no time in linking the spontaneity and personal freedom implied in the painting of landscape to social and political subversion. The notion that meaning could be found in any corner of nature made nonsense of the prevailing belief in a hierarchy of subject matter. Against these received ideas the

painters of pure landscape had to find their way to construct a new kind of meaning out of their own direct experience of nature. The importance of the weight of witness, of being there, was common to both painters and photographers. They were not without pictorial models, in particular the Dutch landscapes of the seventeenth century, but their essential project was without precedent other than its own short tradition of open-air painting.

For Courbet, that tradition was a perfect fit both for his Realist ambitions and for his private lifelong physical love of the countryside in which he had his roots. From his earliest years he made paintings of the valleys and rivers and chalk cliffs of his own region, and though he traveled and worked elsewhere he never tired of his native landscape. As he matured, his sensuous feeling for the shapes of the land was augmented by his awareness of the larger meanings involved in landscape painting. The painting of landscape in itself represented an individual decision: a choice to move away from the inherited symbolic culture of history painting and into a realm of private sensibility and personal freedom. In Courbet's case this idea was fused with the attitudes that he shared with his fellow-citizens of the Franche-Comté, a province that was intensely conscious of its history of independence and individuality vis-à-vis the power of the capital. When Courbet paints the Château d'Ornans (fig. 32), the hamlet on one of the high cliffs overlooking Ornans, he is aware that there was once a castle there, of sufficient actual and symbolic importance to be destroyed in the seventeenth century to prevent resistance to the monarchy. Rather than dwelling on the kind of picturesque nostalgia for medieval glories that typified the Troubadour Style, Courbet sees the natural formation of the cliffs themselves as representing the idea of the castle, the harsh vertical strength and stony fortitude that he felt to be his local cultural heritage.

Indeed these geological features of his region, the region that provided the term "Jurassic" to the geological studies that were being undertaken by the painter's contemporaries, form an important thematic group in Courbet's landscape paintings. These distinctive cliffs rise beyond the frieze of figures in *A Burial at Ornans*

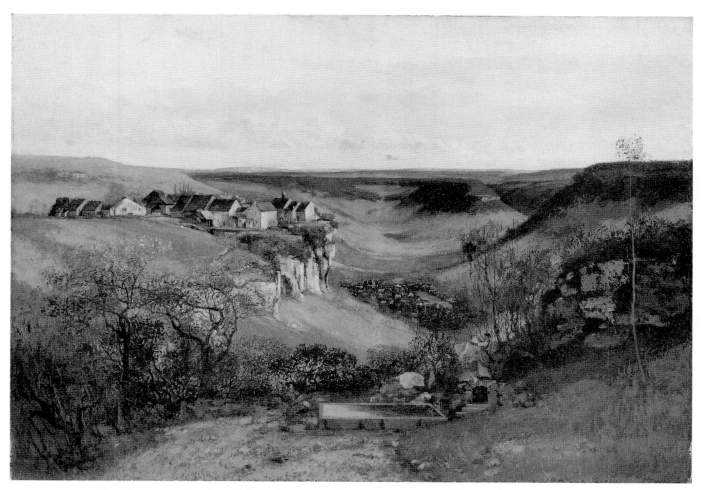

Fig. 32. Gustave Courbet. *Château d'Ornans.* c. 1850. Oil on canvas, 32⅛ × 46″ (81.6 × 116.8 cm). The Minneapolis Institute of Arts. The John R. Van Derlip Fund and the William Hood Dunwoody Fund

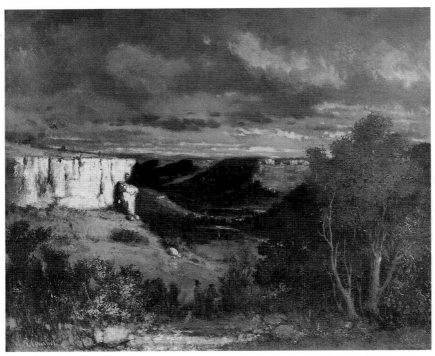

Fig. 33. Gustave Courbet. *The Valley of the Loue in Stormy Weather.* c. 1849.
Oil on canvas, 21¼ × 25⅝" (54 × 65 cm). Musée des Beaux-Arts, Strasbourg

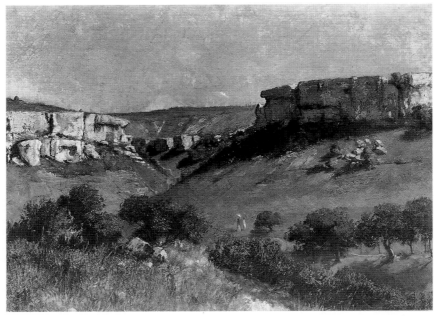

Fig. 34. Gustave Courbet. *Valley near Ornans.* 1851. Oil on canvas,
16½ × 21⅞" (42 × 55.5 cm). Royal Museum of Fine Arts, Brussels

(plate 8); the citadel-like formation at the left is in fact the same Château d'Ornans, seen here from the low valley across the Loue River, outside the town. Another major early figure painting, *The Young Ladies of the Village* (plate 10), is set in a bowl of pastureland rimmed by a group of cliffs, which Courbet studied in several related paintings. In one of these a pair of figures is so tiny as to be virtually invisible; the meaning of the painting is in its purely landscape structure, in which the cliffs play a primary role (fig. 34). They become the main theme of the painting in such a work as *The Meuse at Freyr* (fig. 35), where the high looming cliffs are pulled close to the viewer by the complex structure of brush and palette knife strokes with which they are painted. It is in these cliff paintings that Courbet first begins working on the new ways of applying paint that would become a hallmark of his landscape style: the rough, thick, scraped surfaces that define the

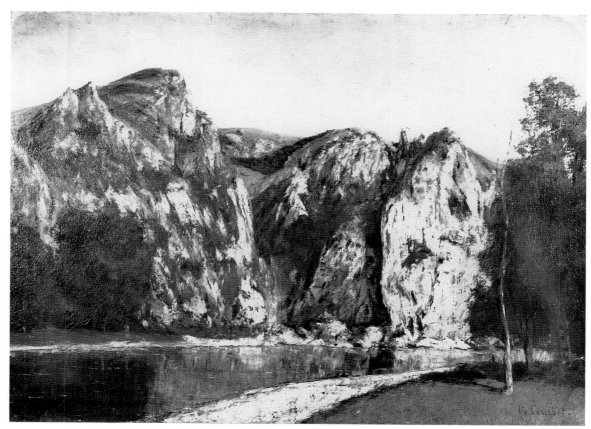

Fig. 35. Gustave Courbet. *The Meuse at Freyr.* c. 1856. Oil on canvas, 23 × 32¼″ (58 × 82).
Musée des Beaux-Arts, Lille

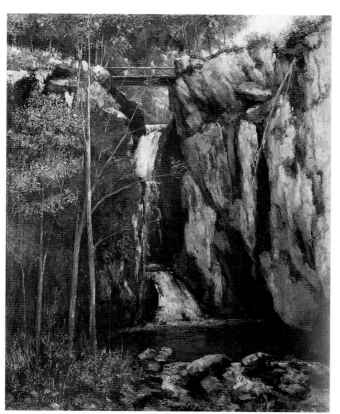

Fig. 36. Gustave Courbet. *The Gour de Conche.* 1864.
Oil on canvas, 27⅝ × 23⅝″ (70 × 60 cm).
Musée des Beaux-Arts et d'Archéologie, Besançon

chalky cliff, the pulled and scumbled openwork of pigment that conjures up foliage, the grainy mixed whites and browns that represent a snowy forest.

Another important way in which Courbet constructed symbolic meaning out of his feeling for the geological facts of his native land involved the combination of rocks and water. One of his favorite sites near Ornans was the stream of the Black Well (see plate 34), a densely forested dark pool cut deep in the high rocks which surround it like walls. In this series of paintings the water, as always flowing outward toward the viewer, is represented as a clear transparent medium. A different series theme is that of the falls and sources that are common to the region. In the high pastureland several streams and rivers have their origin, emerging out of fissures in the rocks, which themselves emerge from the earth like bony structures. In some instances a snowy waterfall or cascade results, as at the site known as the Gour de Conche (fig. 36). In the case of the Loue, the river that runs through the middle of Ornans, the water rises out of a cavelike opening in the massive boulders. At this site, with its flowing waters and dark mysterious opening, Courbet found a compelling theme with powerful sexual overtones that he was to treat in four major paintings (fig. 37, plate 26). In this

31

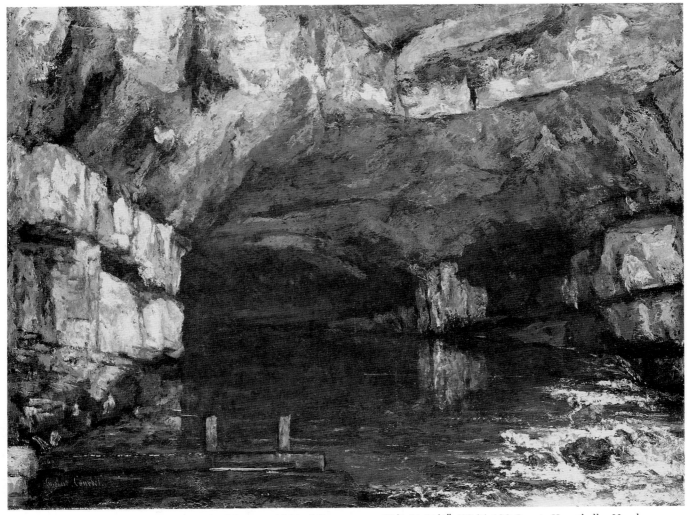

Fig. 37. Gustave Courbet. T*he Source of the Loue.* 1864. Oil on canvas, 38⅝ × 51⅜″ (98 × 130.5 cm). Kunsthalle, Hamburg

series of paintings, the landscape is represented without reference to human habitat; nature is witnessed for its own sake. Where there are implied metaphors, Courbet constructs them without in any way falling into the trap of anthropomorphizing the natural shapes and structures. Rather he operates, as in his figure paintings, by bearing witness both to the solid presence of what is before him and to the implications generated in the artist's mind by that presence.

When Courbet's landscapes of the late fifties and sixties are populated, it is usually by hunters and/or the forest animals that are their prey. As with the landscape itself, the painter's relation to the theme of the hunt grows out of his own practical experience as a native of the countryside and the way in which this experience resonated in his mind. His treatment of the hunt theme was equally far removed from the heroic tradition of Rubens and Delacroix and from the conventional treatments of the current Salon painters, who were concerned primarily with handsome costume and fine horseflesh, with the hunt as social sport and play.

Courbet grew up in a rural society in which hunting was and had been for centuries a means of sustaining life. Boar and venison were winter staples, and the barnyard had to be protected from foxes (fig. 38). As often happens in such societies the world over, the hunters feel a deep respect for the animals who challenge and sustain them. Courbet was no exception, and to this respect he added his powerful visual consciousness, which enabled him to grasp both the particular surface and the essential character of each animal that he represented. When he wrote to Francis Wey in April 1861 about his *Battle of the Stags* (fig. 39) he spoke of his witnessing of these creatures in terms that are both exact and admiring: "The battle is cold, the rage deep, the thrusts are terrible and they seem not to touch each other. That is easy to understand when one sees their formidable defense. With that, their blood is as black as ink and their muscular strength makes them able to cover thirty feet in one leap, effortlessly, something I saw with my own eyes." This kind of empathetic observation, combined with his painterly powers,

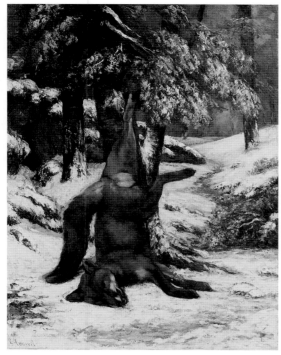

Fig. 38. Gustave Courbet. *Fox Hanging from a Tree in the Snow.* 1860–65. Oil on canvas, 52¾ × 39⅜″ (134 × 100 cm). Nationalmuseum, Stockholm

made of him, without intention or the kind of "animal genre" specialization typical of the period, probably the most convincing and sympathetic animal painter working in the nineteenth century. To modern urban eyes, the subject matter of the animal paintings may appear archaic, but in fact when Courbet began to paint hunting themes in the late fifties he did so as a logical outgrowth of landscape painting, with congruent implications of the freedom and independence conferred by the exploration of the natural world of the wild forest and its denizens.

The other theme intimately linked with landscape that did retain a certain archaic character in Courbet's work was that of the Bather, the female nude in a forest setting. It was a theme that attracted the artist early in his career, and which he never wholly managed to separate from its history in idyll and myth. His first major statement of the theme, the famous *Bathers* (fig. 40) in the Bruyas collection in Montpellier, was the most radical. It contained all the contradictions that made it an object of critical scandal in the Salon of 1853: a figure that ought by tradition to be a youthful, idealized

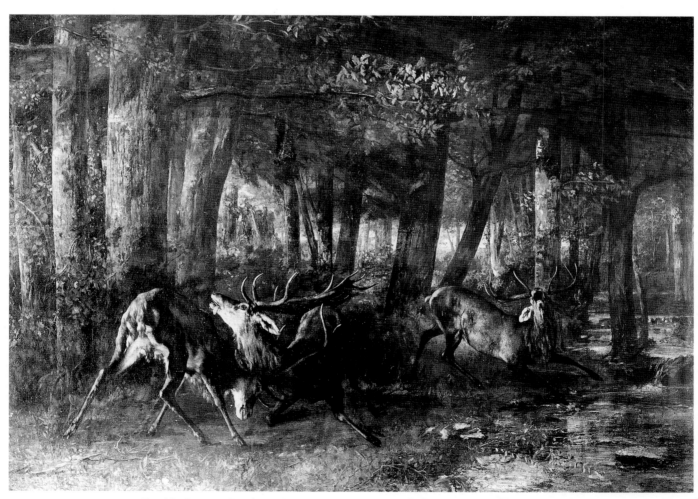

Fig. 39. Gustave Courbet. *The Springtime Rut: Battle of the Stags.* 1861. Oil on canvas, 9′11¼″ × 16′6¾″ (355 × 507 cm). Musée d'Orsay, Paris

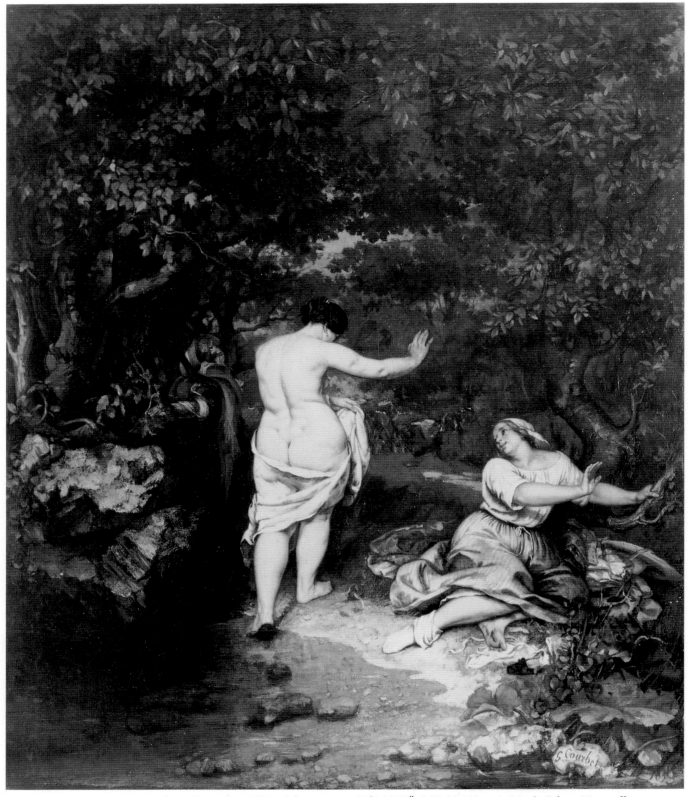

Fig. 40. Gustave Courbet. *The Bathers.* 1853. Oil on canvas, 89⅝ × 76″ (227 × 193 cm). Musée Fabre, Montpellier

nymph, is presented as an ordinary provincial woman revealing her avoirdupois by shedding her clothes; the rhetorical gestures of the nude figure and her companion (attendant?) seem to belong to some other story, some ancient tale of denial and revelation incongruous-ly set upon the bank of the Loue River. There was too much everyday actuality in the painting to suit conventional taste, and at the same time narrative and dramatic expectations were aroused, but not met. Subsequent paintings of this particular theme, in which a single

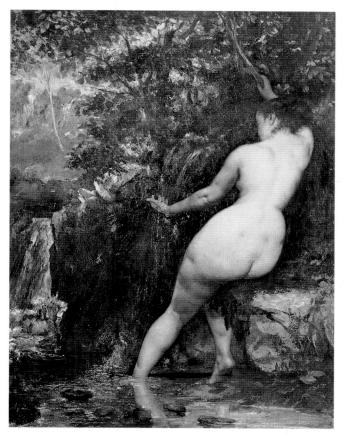

Fig. 41. Gustave Courbet. *The Source*. 1868. Oil on canvas,
50⅜ × 38″ (128 × 97 cm). Musée d'Orsay, Paris

tensions and scenarios, which may or may not have been consciously present to Courbet's mind. The likelihood is that at least some of them were, in view of the fact that in this same period of the late sixties Courbet painted his great masterpiece of the painting of the female nude, *The Sleepers* (plate 36), in which the figures of the two women have cut all ties with the sylvan world of nymphs, and lie embracing on a Parisian bed.

It was Manet who in the *Déjeuner sur l'Herbe* delivered a fatal blow to the convention of the bather in the forest by turning her into a picnicking artists' model; but his painting was in part an homage to Courbet's not quite so thorough subversion of the convention in his painting of 1853. By the mid-sixties, Courbet had adapted his own critique of the theme to another kind of conjunction of the female nude and water, this time that of the sea. In *The Woman in the Waves* (fig. 43) the nude assumes one of the standard poses of the academic model, with her arms clasped behind her head. The pose serves to focus attention on the breasts and underarms, whose flesh and hair are painted with a sensual vision remote from academic convention. The figure appears to rise from the sea like Venus, yet the sea is marked as contemporary by the presence of the boat at

nude is variously placed in a sylvan setting, have fewer contradictions and are less forceful as a result. However strong and voluptuous the figures, the paintings seem not to have quite arrived at some threshhold of authenticity present in the artist's other work. It is as if the theme were on the one hand too loaded with private sexual significance, and on the other too tied to tradition to enable Courbet to break entirely through the veil of mythology. One painting that approaches this point is the *Three Bathers* in the Petit Palais (fig. 42). Here the central figure is flanked by one nude and one clothed figure; but there is no question here of calm symmetry. The body of the central figure is painfully torqued as she both stretches down to the water with her foot and reaches with her arm up around the shoulders of the clothed companion who is herself precariously perched. The solidly seated nude at the right, with her brilliant golden hair and gentle gaze, is sharply contrasted to the upper supporting figure, who is black-haired and gypsy-like, with an ambiguous expression. These figures, opposite in every way, together with the strained, openly vulnerable figure between them, virtually cry out for an allegorical reading in the traditional sense. At the same time, to the modern mind the painting is rife with potential sexual

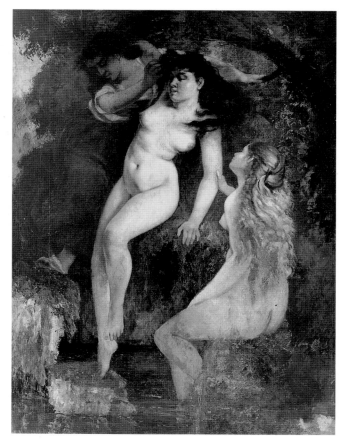

Fig. 42. Gustave Courbet. *The Three Bathers*. 1868. Oil
on paper mounted on canvas, 49⅝ × 37¾″ (126 × 96 cm).
Musée du Petit Palais, Paris

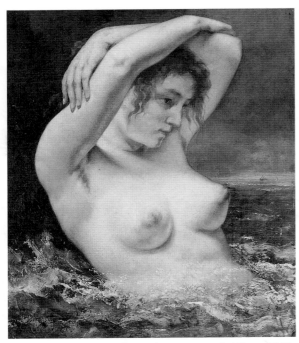

Fig. 43. Gustave Courbet. *The Woman in the Waves.* 1866
(signed and dated 1868). Oil on canvas, 25¾ × 21¼″
(65.4 × 54 cm). The Metropolitan Museum of Art,
New York. Bequest of Mrs. H. O. Havemeyer, 1929.
The H. O. Havemeyer Collection

the horizon. In the well-known *Birth of Venus* of 1863 by
Cabanel, everything is consistent: the pink and desex-
ualized flesh of the nude, her charming bed on the
waves, the wafting putti. Courbet subverts this image
with the up-front presence of a fully sensual creature.
The inconsistencies, the contradiction between the
realities and the unrealities in the painting are its sub-
ject—at least in part. Coexisting with the irony of
Courbet's critique is the naiveté of his passion for the
female flesh and for the sea.

Despite the magnificence of the painting of the
female nude to be found in *The Sleepers* (plate 36) and
The Woman in the Waves, despite the solidity of *The
Woman with a Parrot* (fig. 44) and even the extraordinary
painterly daring of *The Origin of the World* (fig. 45), the
expression of Courbet's affinity for the female was not
limited to this traditional theme of the nude. The nude
per se was only one of the ways in which he construct-
ed his sense of the power of women and of the force of
female sexuality. *The Sleepers* has to do not simply with
the beauty of female flesh but with sexual transgres-
sion, and with the vulnerable abandon of sleep.
Arguably the greatest of his paintings of female somno-

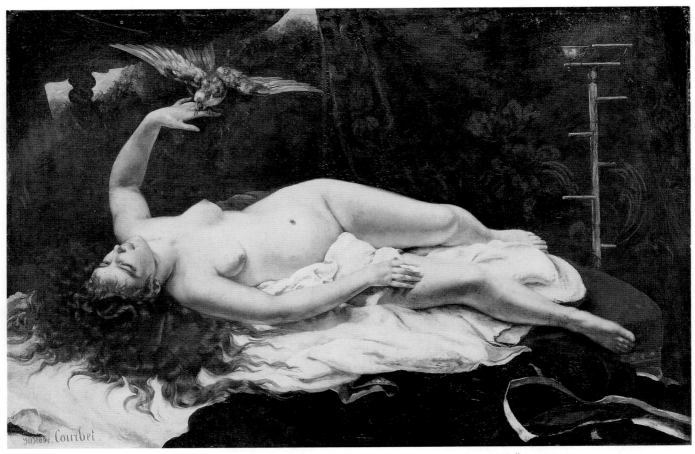

Fig. 44. Gustave Courbet. *The Woman with a Parrot.* 1866. Oil on canvas, 50¾ × 76⅞″ (129 × 195 cm).
The Metropolitan Museum of Art, New York. Bequest of Mrs. H. O. Havemeyer, 1929. The H. O. Havemeyer Collection

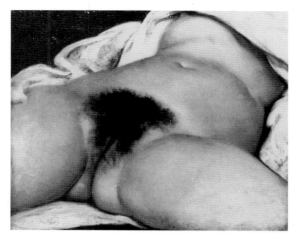

Fig. 45. Gustave Courbet. *The Origin of the World.* 1866.
Oil on canvas, 18⅛ × 21⅝" (46 × 55 cm).
Private collection

lence, attraction, and desire is *The Young Ladies on the Banks of the Seine* (plate 18), in which much of the meaning of the painting is generated through the impassioned painting of the costume and decoration and other still-life accoutrements of the clothed figures. Among the most important of his paintings of provincial life are themes of specifically women's tasks: spinning, sifting grain, giving alms, laying out a dead body. The painter constructs metaphors of female force and fecundity in his paintings of the source of the Loue, and of female vitality in the rhyming of curling, flowing hair with the ripple of streams and the flow of the waves of the sea. Coming out of his experience of the sea are three of his most original figural images: the portrait of Jo with her electric tresses (fig. 46); *The Girl with Seagulls* (plate 30), whose canopy of hair joins the natural world of birds' feathers; and the wonderful modern Venus, *The Woman in a Podoscaphe* (plate 29), who is not born from the sea but who masters it with her energy and skill. In these images and metaphors we see a conception of woman very different from that of the Symbolists later in the century, who transformed the theme of long flowing hair, for example, into a sign of mortal danger. The notion of woman as alien and fearsome does not enter into Courbet's art, which conceives of women as an intrinsic part of working humanity and of female sexuality as an intrinsic part of the natural world in which the painter has his deepest roots.

The sea in question above is that of the English Channel off the coast of Normandy. Courbet had visited there earlier, but he first spent an extended time at Trouville in the summer of 1865. He had painted seascapes before, though only occasionally, on his two visits to his patron Bruyas in Montpellier in 1854 and 1857. From the first trip comes the well-known *Seashore at Palavas* (fig. 47), in which the Mediterranean shore south of Montpellier becomes the setting for a self-portrait that expresses the artist's new sense of glory and optimism for the future. The horizon line in this work is striking, a straight line of dark blue dividing sea and sky into equal areas. This sharp clarity born of the southern light is absent from the many seascapes painted at Trouville in the summers of 1865 and 1866. Here the continuously changing weather and misty light of the Channel coast are felt in the paintings. Courbet was especially drawn to two opposing moods of the sea: the calm sea at low tide, where wide stretches of reflecting sand extend out to the water's edge, and the stormy sea, where dark waves rise to pound upon the shore. In both types, it is the elemental facts of sand, sky, and water that become the subject of the painting. Indications of humanity are confined to an occasional tiny boat or two on the horizon or an empty one on the beach. The palette of the low tide paintings is light, unusually so for Courbet; the sense of vast space is compelling even while the thick, often knifed impasto brings the solidity of the paint to the surface (see plate 32). The paintings of the rising waves are dark, with both the water and the clouds painted with such gestural activity and materiality of pigment that they seem to surge into the viewer's space (fig. 48). Both types are alike in their extraordinary lack of human referent, in their resolution of pure natural elements into the elements of pure painting, in their witnessing of the separate being of the natural world.

In going to Trouville in 1865 Courbet was hardly a pioneer. Boudin had made his career there and in the neighboring Deauville, both towns part of the bur-

Fig. 46. Gustave Courbet. *Portrait of Jo, the Beautiful Irish Girl.* 1865(?). Oil on canvas, 21¼ × 25⅝" (54 × 65 cm). Nationalmuseum, Stockholm

Fig. 47. Gustave Courbet. *The Seashore at Palavas.* 1854. Oil on canvas,
15⅜ × 18⅛″ (39.1 × 46 cm). Musée Fabre, Montpellier

Fig. 48. Gustave Courbet. *The Stormy Sea,* or *The Wave.* 1869 (signed 70). Oil on canvas,
46 × 63″ (117 × 160 cm). Musée d'Orsay, Paris

Fig. 49. Gustave Courbet. *Three English Girls at a Window (Trouville)*. 1865. Oil on canvas, 36⅜ × 28½" (92.5 × 72.5 cm). Ny Carlsberg Glyptotek, Copenhagen

geoning resort culture developed during the Second Empire. The young Monet, a native of Le Havre, painted there and along the coast and by the mid-sixties had produced a solid body of work. What Courbet joined there was a kind of summer society, of people devoted either to the pleasures of play and sociability or, like his painter friends and colleagues, to the pleasures of work in a fresh and stimulating setting. He found it wonderfully productive. Not only was there the fascination of the sea, there were ladies—and even gentlemen—who commissioned portraits as part of their recreational program. He made portraits of a countess, of two debonair brothers, of three young sisters (fig. 49), and many more; he even made a portrait of the two fine greyhounds belonging to his host, the Count de Choiseul (fig. 50). But though he enjoyed the sociability and the income, unlike Boudin he never incorporated the beach life of the resort into his paintings of the coast and the sea. With few exceptions, these remained, in his paintings, as inviolate as the sky. On the other hand, elements of the sea as structural forms found their way into the figure paintings, most particularly in the intense focus on the abundant, freely wavy hair of such subjects as the young women of *Three English Girls at a Window, The Girl with Seagulls* (plate

Fig. 50. Gustave Courbet. *The Greyhounds of the Count de Choiseul*. 1866. Oil on canvas, 35 × 45¾" (89 × 116.2 cm). The Saint Louis Art Museum. Gift of Mrs. Mark C. Steinberg

Fig. 51. *Courbet: Avant la lettre.* Caricature by André Gill,
in *L'Eclipse,* 2 July 1870

30), and the *Portrait of Jo* (plate 31), all begun or completed in Trouville.

Though his dream of the "solution" to be provided by his patron Bruyas did not come true, the 1860s on the whole were satisfying years for Courbet. His paintings of forest and sea and the hunt were easier for the critics to admire than the massive figure paintings of the fifties had been; the circle of collectors who wanted his paintings grew, so that in addition to making works for exhibition in the Salon he was sending paintings to dealers in Brussels and Amsterdam as well as in Paris. His work was invited to exhibitions in a number of French cities and in London, Brussels, Amsterdam, The Hague, Munich, and elsewhere. These new distribution systems, which worked through the channels of dealers and of local artists' groups who organized exhibitions of contemporary work they admired, were phenomena which evolved during the course of Courbet's career. Courbet's own contribution to this process of change was the organization of his own one-man shows: the Pavillon du Réalisme in 1855, and an even larger retrospective of his work mounted at the Place d'Alma during the Exposition Universelle of 1867, where Manet too organized his own show. These various new methods, though not yet providing a real alternative to the official state Salon system in the sense of making the latter obsolete, were different enough from

the official system to make Courbet welcome their emergence. This was especially true in the case of the locally organized exhibitions, which enabled artists to present their work directly to the public without the intervention of an official controlling institution. Courbet often traveled himself to these exhibitions, particularly to those in the Low Countries and in Germany, where the progressive younger artists admired both his work and his ideas. In the fall of 1869 he went to Munich to accept from King Ludwig II of Bavaria the Order of Merit of St. Michael. Courbet allowed himself to accept this royal gesture with pleasure because it came at the request of the local artists rather than from a state agency and because it was made specifically in recognition of the paintings that he had contributed to their exhibition. He wrote to his agent in Brussels, where a medal had also been awarded to him, that he was "very delighted with this custom of medals given by artists. It proves that it is not necessary to be Napoleonist, as in France, to do painting."

Matters were quite different when it came to the award of the Légion d'Honneur by the French government of Napoleon III. After years of conflict and contention with Count Nieuwekerke, Napoleon's powerfully reactionary minister of fine arts, and with the emperor himself, Courbet was presented in June of 1870 with a potentially awkward situation: the offer of the decoration by a new and more liberal minister. Courbet used the opportunity to write a letter to the minister in which he gave his reasons for refusal: essentially, that however open-minded the new minister was, it was not possible to accept an award from the Imperial government, which had proved itself so antagonistic to the genuine art of the age. Honors received from an establishment so incompetent to judge art would be dishonoring. He made his refusal in the name of remaining a free man, and ended the letter with the resounding words: "when I'm dead, let this be said of me: He belonged to no school, no church, no institution, no academy, least of all to any regime but that of liberty." The letter was published in the *Siècle* of 23 June 1870, and Courbet was immediately denounced both for his lack of respect to the state and for having made a public issue of his refusal. Once again, as throughout his career, the artist's willingness to make himself the center of controversy brought down accusations of vanity. But because Courbet enjoyed the uproar centered upon himself does not mean that he generated the controversy out of motives of vanity. On the contrary, it was important to him to use this occasion to make the political issues clear. The news of the refusal of course generated a new crop of caricatures, the best of which,

by Gill (fig. 51), shows the artist lighting his crude country pipe with the ribbon of the Légion d'Honneur. This was amusing, but less so was the fact that the police file on Courbet (begun in 1868 when he was seen attending an anniversary of the funeral of the Socialist thinker P.-J. Proudhon), was swollen with newspaper clippings, largely hostile, about the affair of the refusal, thus helping to build an image of the artist as a dangerous subversive. This image, fused with the image of Courbet as a bombastic egoist, created a mental caricature which was regularly fed by the actual caricatures printed in the daily and weekly journals of the period. The resulting stereotype had much to do with the events that determined the final years of the artist's life.

The episode of the Légion d'Honneur took place only weeks before the outbreak of the Franco-Prussian war. Courbet was not alone in considering the war to be a wrong-headed adventure on the part of Napoleon III, and like many other believers in the Republic he was not sorry to see the emperor defeated at Sedan on 2 September. The Republican government set up immediately in the wake of the downfall of the Imperial government was devoted to the defense of the country against the Prussian Army. This defense very soon became the defense of Paris, and Courbet not only stayed in Paris to take part in this effort but was active as the head of a commission given the responsibility for protecting works of art in and around the capital city. Ministry papers in the National Archives show Courbet reviewing such projects as the packing of porcelain collections of the Manufacture de Sèvres for storage in mushroom cellars as protection from the vibration of the cannons, and converting the Versailles museum into a hospital for the wounded in order to protect it from destruction. Late in October, as winter neared and the siege settled ominously in, Courbet did an extraordinary thing. He wrote and had printed a short pamphlet entitled *"A l'Armée Allemande et aux Artistes Allemands"* (To the German Army and German Artists). At a moment dominated by fear and hatred of the German Army, he addressed himself to the ordinary soldiers, the rank and file among whom were his young artist friends and companions, serving in Bismarck's army. Courbet's message was a simple one: their fight against the French Emperor may have been valid, but now that he was gone they were destroying the Republic of the French people, and in this they were destroying themselves. As German people, they should cast off the tyranny of their own emperor and join hands with the people of France in Republican brotherhood. Courbet called for the abolition of frontiers,

the destruction of the fortresses in the endlessly war-torn lands of Alsace and Lorraine; he spoke of those on both sides of the border who have a "horror of national chauvinism" and proposed that the two peoples join in a toast: "To the united states of Europe!"

The political naiveté of such a statement at such a time is obvious; but what should be equally noted is its generosity of spirit and its prescience. These ideas were of course not Courbet's alone—they were part of his Fourierist milieu—but the pamphlet was his alone and its ideas were anathema to ardent nationalists. The final image described in it is that of a Krupp cannon—envisioned as the last one, after all the rest have been melted down—standing as a monument in the middle of the Place Vendôme, its mouth covered by a Phrygian bonnet. This will be, he says, our column, "the column of the peoples, the column of Germany and of France forever federated." Such an image would have made instant enemies of people who otherwise knew and cared little about Courbet. There were plenty of people in Paris, followers of the fallen emperor, who despised the fledgling Republic; plenty more who, with the German Army at the gate, could only read such an image as at best defeatist, at worst treasonous. And apart from the concept of Franco-German brotherhood expressed, there was the notion of replacing the column that already stood in the Place Vendôme. It was the story of that column, its symbolism and its destruction, which now intersected with Courbet's life and determined the course of his last years.

It is a story that perhaps has more resonance now than it might have had only a short time ago, before the citizens of Eastern European countries and the Soviet Union began to destroy, first a wall, and then the obtrusive monuments of repressive and hated regimes. The Place Vendôme of the twentieth century, situated in the center of one of the most elegant quarters of

Fig. 52. The destruction of the equestrian statue of Louis XIV. c. 1792. Pen and ink drawing, by Jacques Bertaux. The Louvre, Paris

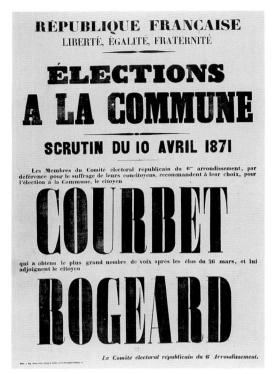

RÉPUBLIQUE FRANÇAISE
LIBERTÉ, ÉGALITÉ, FRATERNITÉ

ÉLECTIONS
A LA COMMUNE

SCRUTIN DU 10 AVRIL 1871

Les Membres du Comité électoral républicain du 6ᵐᵉ arrondissement, par déférence pour le suffrage de leurs concitoyens, recommandent à leur choix, pour l'élection à la Commune, le citoyen

COURBET
ROGEARD

qui a obtenu le plus grand nombre de voix après les élus du 26 mars, et lui adjoignent le citoyen

Le Comité électoral républicain du 6ᵉ Arrondissement.

Fig. 53. Commune election poster, 10 April 1871. Bibliothèque Nationale, Paris. Collection de Vinck

Paris, seems remote from political passions. But it had a history of political symbolism. In 1792 an equestrian statue of King Louis XIV was toppled (fig. 52); Napoleon I filled the void with a column encased, in the manner of the Column of Trajan in Rome, with metal reliefs depicting the victories of the French Army under his generalship. A statue of Napoleon in the guise of a Roman emperor was placed at the top. With the restoration of the Bourbon Monarchy in 1814, this statue was removed and melted down. In his effort to placate the Bonapartists, Louis-Philippe in 1831 commissioned a new statue of Napoleon to be placed atop the column, this time in his normal military attire. But this did not satisfy Napoleon III, who in 1863 commissioned yet another sculpture which would restore his uncle to the lofty realm of Roman emperorship—toga, laurel wreath, and all. He then proceded to make of the monument a personal symbol of his own regime, gathering his forces in the *place* around it at an annual military ceremony. Thus by 1870 the column had a rich symbolic history and had become, during the Second Empire, a rallying point for the Imperial government and an object of antagonism for the opposition.

It caused no particular stir, then, when soon after his appointment to the art commission in September 1870, Courbet officially called for the removal of the column, on the grounds that it is "a monument com-

pletely devoid of artistic value, tending to perpetuate . . . the ideas of wars and conquests which are in the imperial dynasty, but which deny the feelings of a Republican nation." He asked that the government authorize the dismounting of the column and the removal of the materials to the Mint. The term he used for dismounting, "*deboulonner*," was not in the dictionary and was immediately given the negative interpretation of "demolish"; Courbet became known as the *deboulonneur*, not such a terrible thing in the Republican euphoria of September 1870, but devastating in the aftermath of the Commune in the late spring of 1871. By March of that year the Republican "Government of National Defense" had failed, a new quasi-monarchist Assembly had set itself up as the legitimate government in opposition to Paris, and the Prussian forces were victorious. In Paris, however, the National Guard and a significant part of the populace refused to admit defeat, either by the German Army or by what appeared to them to be a false and hardly Republican government in Versailles. On March 18 the Paris Commune was set up. Courbet was an elected participant from his arrondissement (fig. 53), again working on the protection of works of art and—in a more utopian vein—on projects for the reform of the system of artistic education and exhibition. Once again public anger rose against the column, and this time no care was taken to dismount rather than to destroy. The monument was toppled into pieces on 15 May (fig. 54). Though he registered no objections to the action, Courbet had not been part of the decision or the arrangements. Because he carried with him, however, the label of *deboulonneur*, the pamphleteers lost no time in associating his carica-

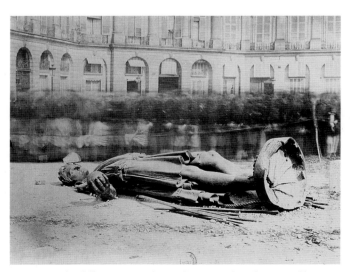

Fig. 54. The fallen statue of Napoleon I in the Place Vendôme, May 1871. Anonymous photograph, 1871. Musée Carnavelet, Paris

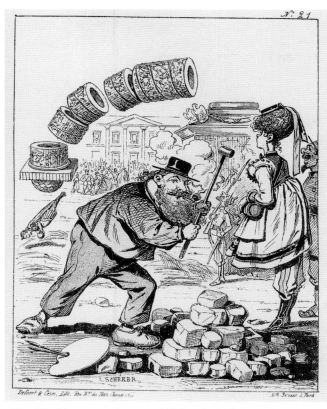

Fig. 55. *L'homme qui était appelé à démolir la Colonne devait commencer par être casseur de pierres.* Caricature by Léonce Schérer, in *Souvenirs de la Commune*, 14 August 1871

tured figure in myriad satirical manners with the destruction of the column (fig. 55). As Napoleon III had personally symbolized the Empire, as the column had become a personal symbol for the Emperor, so the persona of Courbet symbolized the fall of the column.

The Commune lasted only until 28 May. After the "Bloody Week" in which the forces of the Versailles government succeeded in destroying it, any participant or sympathizer who survived was in danger of imprisonment, deportation, or execution. Courbet was arrested on 8 June, following a week of rumors and denouncements, which duly found their way into the Police archives. People who had always hated his ideas and the intrusive honesty of his work rejoiced in an orgy of spite; Alexandre Dumas *fils* demanded, "In what hothouse, by the use of what dung, as a result of what mixture of wine, beer, corrosive mucus and flatulent bloating, can have grown this hollow hairy gourd, this aesthetic belly, this imbecile and impotent incarnation of the Ego?" Courbet had his defenders, too, people like his friend the critic Castagnary and others who first tried to pull strings to get him out of prison and then failing that went to Versailles, where he was interrogated after two degrading months of prison (fig. 56), to testify on his behalf. Much time and ink was spilled in

Fig. 56. Gustave Courbet. *Les grandes écuries à Versailles: les fédérés.* 1871. Charcoal on paper, 6⁵⁄₁₆ × 10⁵⁄₈″ (16 × 27 cm). The Louvre, Paris

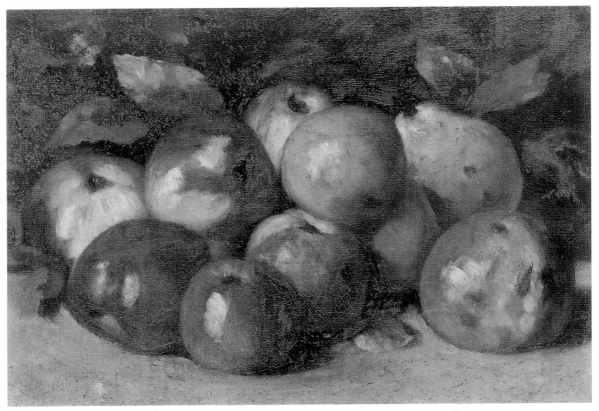

Fig. 57. Gustave Courbet. *Apples and a Pear.* 1871–72. Oil on canvas, 9½ × 12⅞″ (24 × 32.5 cm).
The Philadelphia Museum of Art. The Stern Collection

trying to establish the degree of responsibility that Courbet did or did not have for the actual overturn of the monument. The accused made hopeless efforts to distinguish between the kind of dismantling he had had in mind and the actual destruction that took place; but he might have saved himself the trouble. In the end, considering the vengeful attitude of the victors, he was not too badly treated—six months in prison, half of which were spent under house arrest at a clinic where he was sent to be operated on for severe hemmoroids. It was by far a lighter sentence than the executions and deportations inflicted on other Communards; but it was nonetheless a terrible ordeal, both physically and psychically.

When he was able to work again after his release, Courbet made paintings that attest to the experiences he had been through. In the paintings of flowers and fruit—especially the fruit—some of which were painted before he left the clinic, we sense the intensity of feeling of a man who is looking at simple apples and pears (fig. 57, plate 40) as if he had never seen them before. The energy of his feeling for these natural gifts, which are the antipodes of darkness and void, is made palpable in the painting. These are *natures mortes* which embody a fierce grasp upon the works of life. In some of these paintings, Courbet underlined his sense of the

meaning of this imagery by inscribing on the canvas "Ste.-Pélagie"—the name of the prison where he had served the first part of his sentence, compared to which the clinic where he painted these solid rounded forms was a kind of paradise. In the summer of 1872, back in Ornans to recuperate and to work freely, Courbet painted a different kind of still life, which he made even more specifically into a kind of "real allegory" of his experience. Though he had obviously fished many times before, he had never used fish as a theme as he had other game. Now, struck perhaps by the reality of the fish as a creature who is *caught* and who struggles vainly against his captor, he paints them: first in a more traditional way, as dead game, and then even more strikingly as a kind of self-portrait, inscribed with the phrase *in vinculi fecit* (made in chains) (fig. 58).

Though free of his chains, Courbet was not free of the consequences of his involvement with the Commune and especially with the affair of the column. While in prison, paintings that he had stored had been stolen, adding to the pressure to produce for income. A show organized at Durand-Ruel in March 1872 sold well, but the Paris police refused him permission to mount a private exhibition of his works. Despite the fact that he had shown regularly at the Salon for years, he was punished with refusal by the jury of the 1872

44

Fig. 58. Gustave Courbet. *The Trout*. 1872–73. Oil on canvas,
21⅝ × 35″ (55 × 89 cm). Kunsthaus, Zurich

Salon (with only two dissenting votes, those of J. Robert-Fleury and Eugène Fromentin). Already in early 1873, his friends began to advise him to start protecting his paintings from possible seizure by the government; and with the fall in May of the government of Adolphe Thiers, who knew and respected the artist, the situation grew more dangerous. The new administration officially decided to reconstruct the Vendôme column, and the general assumption was that Courbet would be made to pay the entire cost of the project. (The final figure owed, not fixed until mid-1877, was 323,001,68 francs.) Some of his possessions were confiscated, and he feared that the next thing to be seized would be himself. Having taken precautions to protect his paintings and his family property, Courbet fled to Switzerland in late July of 1873, settling eventually in the village of la Tour-de-Peilz, near Vevey on the eastern end of Lac Léman. There he would live for the next four and a half years, prevented by the impossible debt imposed on him from safely returning to France before his death on the last day of December 1877.

He found a warm welcome in Switzerland, and his old friends supported him, but he was not able to construct a new life cut off from his personal and artistic roots. Imprisonment and illness had weakened him, too much wine took its toll, and much of his energy

went into managing efforts to seek an official pardon that would clear him of the debt and the fear of capture should he set foot in France. His mind turned to the past, to happier days, and to the effort of self-justification. To a great extent, his painting output was done for the market, in the form of landscapes and marines whose motifs were remembered ones drawn from Ornans and Trouville, rather than from the direct experience that had been the essence of his life work; and even these were often only finished off by the master, having been prepared by his assistant Cherubin Pata. When he did turn to local subjects, he made of them a personal statement by concentrating mainly on two motifs: the nearby Château de Chillon, the gloomy medieval dungeon made famous by Byron; and the silent lake, its horizon blocked by the mountains. From la Tour-de-Peilz Courbet could look southwest across Lac Léman to the range of Mont Blanc: the Alps of France, his native land from which he was cut off. He kept up his spirits by beginning in 1877 a large painting (fig. 59) that he hoped to be able to submit to the Exposition Universelle of 1878. It was a panoramic view of the Alpine landscape, a large canvas now in the Cleveland Museum of Art, which though not finished possesses much of the energy of painterly attack that is found in his earlier work. But the year brought him

Fig. 59. Gustave Courbet. *Grand Panorama of the Alps, the Dents du Midi.* 1877. Oil on canvas, 59½ × 82¾" (151 × 210 cm). The Cleveland Museum of Art. John L. Severance Fund, and various donors by exchange, 64.420

increasingly ill health from edema, and increasingly depressing news about his future. In May the government of Jules Simon—the minister for whom he had worked in the fall of 1870—fell, and with it his hopes for an official pardon. In late November the sale he had dreaded took place: the paintings seized by the government in 1873 were sold at auction, for far below their market value. By early December he was gravely ill; by the end of the month he was dead.

Many people, even some who were supporters of his work, were critical of what they saw as Courbet's naiveté and—once again—vanity in becoming politically involved in the Commune and in attempting in his trial to avoid the consequences of that involvement. But the naiveté was generous in spirit, and the consequences—the exorbitant financial reprisals that forced him into exile—were vengeful and cruel, a fact implicitly recognized by the amnesty of the Communards declared in 1879 and the decree of the following year relinquishing all financial claims upon them. By 1881 the new minister of the arts, Antonin Proust, was buy-

ing Courbets for the state. Much of what Courbet and his fellow artists of the Commune had proposed by way of reforming the system of artistic training and exhibition eventually occurred, by the actions of artists over a period of years rather than by decree, beginning with the first Impressionist exhibitions of 1874. After the war the official Salon, Courbet's lifelong arena and *bête noire*, was—in fact if not in perception—a moribund institution. He had devoted his life until the war to making a kind of art that was defiantly anti-official, which asserted the significance of his own witness to what he defined as real: the life of the people emerging into consciousness and the intrinsic values of the natural world. He was also a lifelong believer in the Republic, and when the opportunity came to carry out his principles, he took it. His legacy remained to those practitioners of the New Painting to whom he had shown the way. All those who followed, and who sought roots for their experience of modernity, could turn to his paintings and to the meanings they continued to generate.

COLORPLATES

1. THE HAMMOCK

1844. Oil on canvas, 27½ × 38⅛" (70 × 97 cm).
Sammlung Oskar Reinhart, "Am Romerholz," Winterthur, Switzerland

The Hammock has been identified as the painting entitled *La Rêve*, which was unsuccessful-
ly submitted to the Salon of 1845. Like *The Guitar Player* (fig. 8), the one painting that was
accepted that year, *The Hammock* is an example of Courbet's use of the Troubador Style,
here on a more ambitious scale than that of the successful painting. In fact this is surely
Courbet's most impressive venture in that popular mode of medievalizing genre, a paint-
ing in which the young artist declares himself the master of its techniques while at the
same time creating a mood that shifts right away from its anecdotal conventions. The fig-
ure is something out of a fairy tale, a *princesse du pays lointain*, with long golden hair and a
tight-waisted gown, as fast asleep as any Beauty awaiting the Prince's awakening kiss; yet
she is pulled out of the innocent mode by the erotic frankness of her filmily bared breasts.
The striped fabrics of her dress and shawl are delicious, as are the yellow booties on her
Romantically tiny feet, clinging as closely as gloves and bringing to mind the tight yellow
gloves of the foreground figure in *The Young Ladies on the Banks of the Seine* (plate 18) of
twelve years later. This is not the only reminder of later work, for the painting is filled
with motifs and themes that are central to the painter's entire oeuvre. The thick, flowing
waves of the red-gold hair are virtually a presentiment of Whistler's mistress-model Jo,
subject of one of Courbet's most obsessive series of paintings. The theme of the female
figure in a forested setting is one that continues throughout his career. Invariably in these
paintings there is the presence of water, felt always in Courbet's work as a kind of female
force; in this painting it flows directly beneath the laden hammock only inches from the
figure's delicately clad feet. The beauty of the bosky setting is enhanced by the deep space
at the center, where the sunlight pours into an open clearing, and by the opulence of the
foliage surrounding the figure. The cascade of roses pouring over her like gold over a
Danae represents a kind of flower painting that Courbet took up again in the early 1860s.
Finally, the theme of the sleeping woman, powerfully erotic in her unconscious openness,
is one that he explored in some of his finest masterworks.

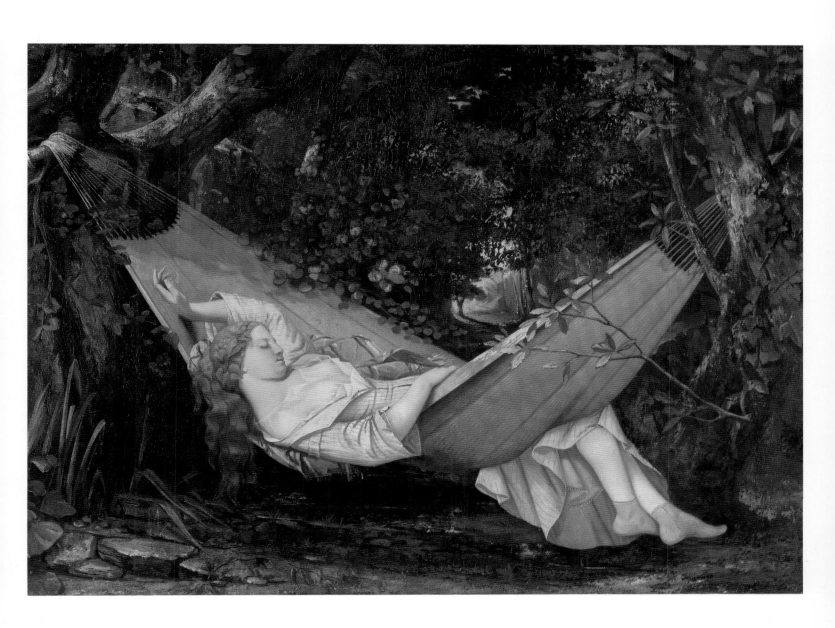

2. THE DESPERATE MAN, OR THE MAN MADE MAD BY FEAR

c. 1843–44. Oil on paper mounted on canvas, 23⅞ × 19⅞" (60.6 × 50.5 cm).
Nationalgalerie, Oslo

This remarkable work is closely related to *The Desperate Man* (fig. 10), a somewhat smaller and more finished painting on canvas that is recorded as having been with Courbet in the last years of his life in Switzerland. Both present the image of the artist as a man deranged, staring wildly out of the pictorial space. Hélène Toussaint has noted the connection of this image with the tradition of Lavater's *Physiognomies*, still alive though in decline in the 1840s. For Géricault, a generation earlier, the idea of facial features as a kind of book in which to read character was already more a question than a theory. He chose a type of insanity—monomania—in which to explore the question. Courbet's vision of madness is neither so particular nor so searching, but is far more theatrical. Indeed the wild stare and the clasped head almost constitute a recipe or stage direction for the expression of a deranged state. In this way the image can be related, as Toussaint does, to the *Têtes d'expression*, which were available to art students as a kind of grammar for making an image of fear, anger, grief, and so forth. But the young Courbet is not exploring or expressing an actual mental state; rather he is using an available convention to create a persona for himself, a role in which a self-portrait can be cast. Unlike *The Desperate Man* of the same theme, in which only the head and grasping arms fill the entire field, here we have the whole figure, set against—rather than in—a landscape recognizable as that of the Franche-Comté. The medieval dress is drawn from the Troubadour Style, but there the resemblance ends. Rather than the genteel Romanticism of the contemporary medieval revival, we see the genuinely Romantic concern with extreme states of being and feeling—again calling to mind Géricault, who saw ferocity and terror in obscure corners of daily life as well as in battles and contests. The painting is unfinished, even as a study, and the foreground is ambiguous. It appears to depict a kind of cliff on the edge of which the figure kneels, thrusting his body toward the void and oblivion. The rough, bold slabs of color in this area, as well as the simple drawing with paint of the unfinished leg, show us the kind of painterly attack Courbet was developing during these formative years.

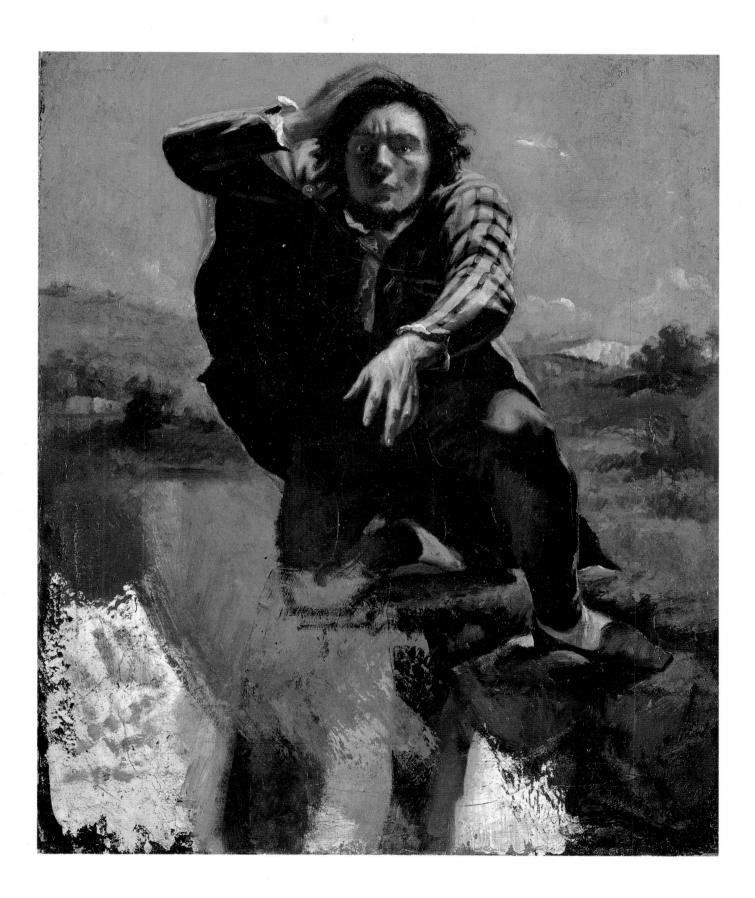

3. SELF-PORTRAIT, CALLED COURBET WITH A BLACK DOG

1844 (signed 1842). Oil on canvas, 18⅛ × 21⅝" (46 × 55 cm).
Musée du Petit Palais, Paris

The young Courbet presents himself here in one of the several different personae by means of which he explored both his own self-image and the pictorial and cultural traditions that were available to him during the early 1840s. Here the figure of the young man is the picture of poised self-containment. His elegant clothes (the coat carefully turned back to reveal the dashing yellow lining), his fashionable English spaniel, and the lofty perch from which he can cast a rather superior gaze down upon the world beneath him identify him quite clearly as a dandy. Originating in the style and manners of Regency England, the image of the dandy in France became not only a model of superior fashion but a concept rich in implication for everything from social posture (Stendhal) to poetry (Baudelaire). For the young man from the rustic country of the Doubs, new to Paris, it would have been a new and very sophisticated notion, and a fascinating one to explore in relation to his own selfhood. Here Courbet places the figure of a debonair young man in a landscape of his native countryside, seated against an outcropping of its familiar steep, chalky rock. The image of the dandy is fused with that of the country boy that Courbet in fact was, the fellow who goes on long tramps in the woods and fields with his faithful dog and his briar stick, taking a rest now and then to enjoy his pipe. But this fellow is also yet another character, for he has long, flowing hair, protected by a wide broad-brimmed hat, and he takes his walk with a book. Knowing that the subject is a painter, we might assume this to be a sketchbook; but there is nothing to tell us so, and it could as easily be a volume of poetry. In either guise he plays his role as the image of the young Romantic, poet or painter or painter-poet, centrally situated in the midst of what Romantic culture was making into a fundamental theme of art—the landscape. Perhaps because of its qualities of stylishness (though one can never really second-guess a Salon jury), this self-portrait was accepted to be shown in the Salon of 1844—one of three paintings accepted out of the twenty-four submitted by Courbet between 1841 and 1847. The date of 1842 on the painting is considered questionable, as are many of the dates on the paintings of an artist who often signed and dated his works when they were going to be sold or exhibited. In this case, a small portrait with the same black spaniel, dated 1842 and now in the Town Hall of Pontarlier, provides a point of comparison. While both paintings show a similar long-haired youth, the Petit Palais work is markedly more sophisticated in pictorial development. Laboratory study at the Louvre has revealed more than one campaign of painting, and it is reasonable to assume that it was worked on over a period of two years.

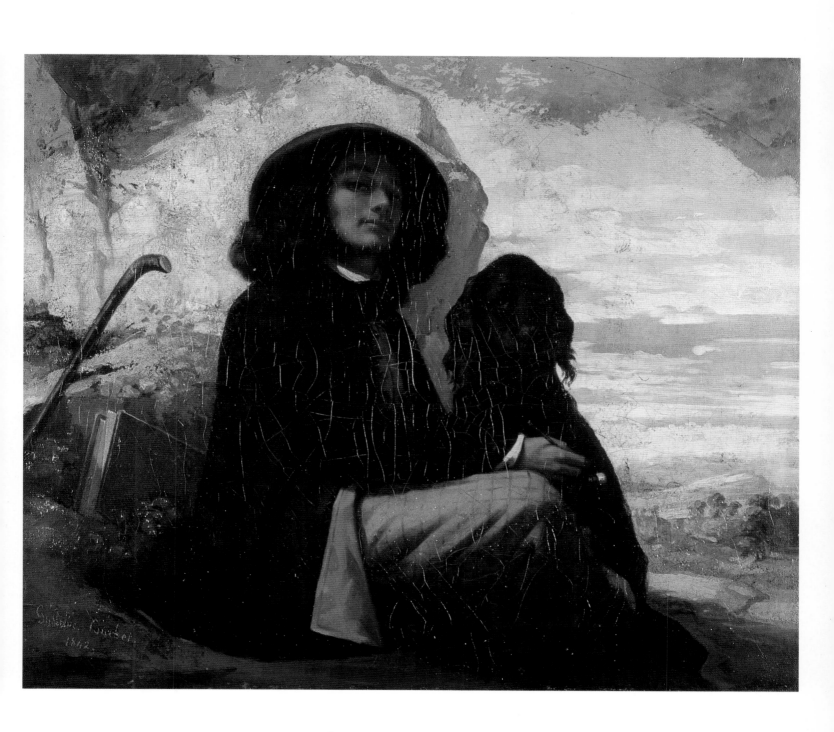

4. PORTRAIT OF THE ARTIST, CALLED MAN WITH A PIPE

c. 1848–49. Oil on canvas, 17¾ × 14⅝" (45 × 37 cm).
Musée Fabre, Montpellier

Of all the open or disguised self-portraits of Courbet's first decade as a painter, *Man with a Pipe* is the best known. It was well received from the beginning, despite its being shown at the Salon of 1850–51 in the company of the radically disturbing *Stonebreakers* (fig. 18), *A Burial at Ornans* (plate 8), and *The Peasants of Flagey Returning from the Fair* (plate 7). Courbet's great patron, the Montpellier collector Alfred Bruyas, bought it from the artist in 1854, the year following his first Courbet purchases. In a letter to Bruyas of that year the painter described the work as "the portrait of a fanatic, an ascetic . . . of a man disillusioned with the stupidities that have served as his education, and who seeks to establish himself in his principles." This is a remarkably accurate perception, particularly for a young artist to make about his own self-image, and it reveals the growing maturity of Courbet's mind. As Philippe Bordes remarks, fanaticism and asceticism accurately describe the intensity of the young painter's project, which could only succeed through absolute conviction and the willingness to withstand temptations to compromise. The image he presents is in its details that of Bohemian Paris: the artist with his thick and rather wild hair, scruffy beard, pipe, and casual dress. But these are held together by something much more complex and more difficult to describe: the expression of the face, which is a map of the artist's mind. The head is close, it is thrust aggressively into the viewer's space, yet while physically close it is mentally remote, its energies focused within, on the content of the gaze. Of all the exploratory self-portraits of the 1840s, this one is both the least theatrical and the most ambiguous. One is tempted to say that in this painting the self is presented not as playing a role (as in *The Cellist*, fig. 13) or as fusing cultural identities (as in *Self-Portrait*, plate 3), but as the man Courbet had become after nearly a decade of work, sustained essentially by his own belief in his Realist project.

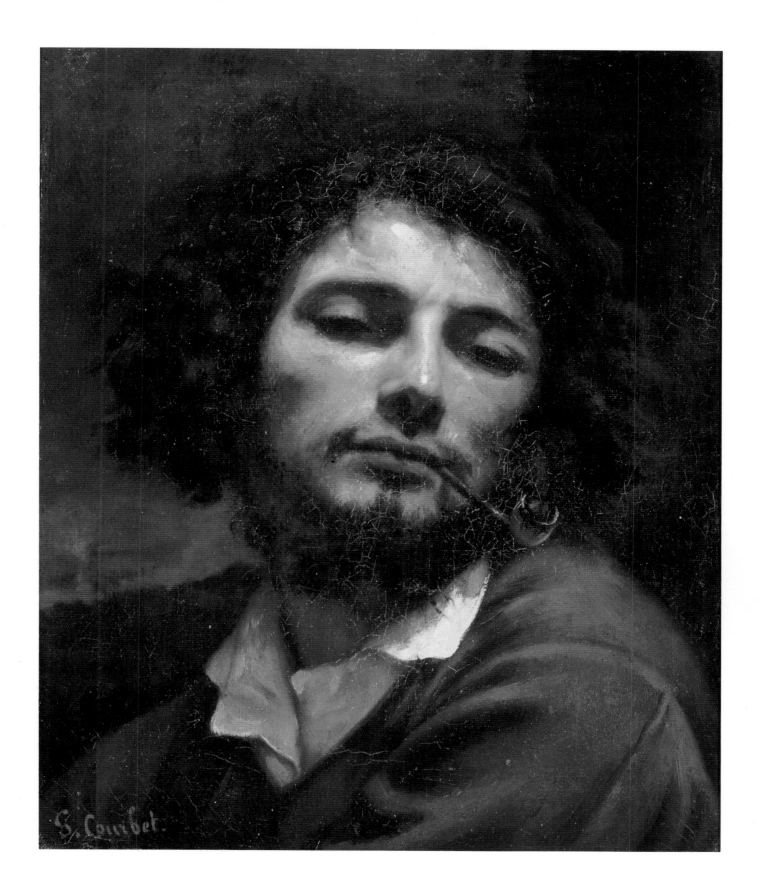

5. PORTRAIT OF BAUDELAIRE

c. 1848. Oil on canvas, 20⅞ × 24" (53 × 61 cm).
Musée Fabre, Montpellier

Baudelaire and Courbet were close contemporaries, both in their late twenties when they met sometime in the late 1840s through such mutual friends as the Realist writer Champfleury and the worker-poet Pierre Dupont. The Parisian milieu of artistic *bohème* in which they met had taken shape during the late 1830s and 40s: Courbet was a part of it by choice, conscious of the fact that in order to succeed at his project he would have to live a kind of gypsy life, marginal and therefore free in relation to the bourgeois establishment. Baudelaire was forced into it by his family's financial restrictions, and he suffered from the lack of means to live as a true dandy, incorporating style and beauty into his daily life. His interest in visual art led him to write pamphlet-length reviews of the Salons of 1845 and 1846. In both these publications he called for a new kind of painter, one who could grasp the "heroism of modern life" and who could enable the public to see the epic side of the lives of men who wore "cravats and shiny boots." He and Courbet collaborated on the issuing of a short-lived revolutionary journal in the early days of the 1848 uprising, but Baudelaire soon moved away from the Realist circle, in part out of distaste for the issues of socialism and democracy that were central to the discussions of the group. It may have been this political divergence that prevented the poet from seeing that his young friend Courbet was actually initiating the kind of painting he had called for, bringing into imaginative reality the men and women of modern life. The portrait is from the days of friendship, casually intimate, loosely painted with all the freedom of an initial study. Champfleury claimed that the painter said he was not able to finish the portrait because the poet's face was always changing. But it needs no further finish to make it a perceptive study of the poet, young and intense, his hand poised as if ready to lift himself up, yet his gaze concentrated on the text he is reading, the light catching the rounded surface of his already high forehead. He is represented with the essentials of his life: a comfortable chair and a writing table, books, papers, pen and ink. Later portraits of Baudelaire may be more tragic or more glamorous; this early one gives us youth and intellectual intensity, bathed in a warm ruddy light. It is not known why Courbet kept the portrait; it was bought a decade later by Baudelaire's editor and friend Poulet-Malassis, and later still by Courbet's patron Bruyas for his collection in Montpellier.

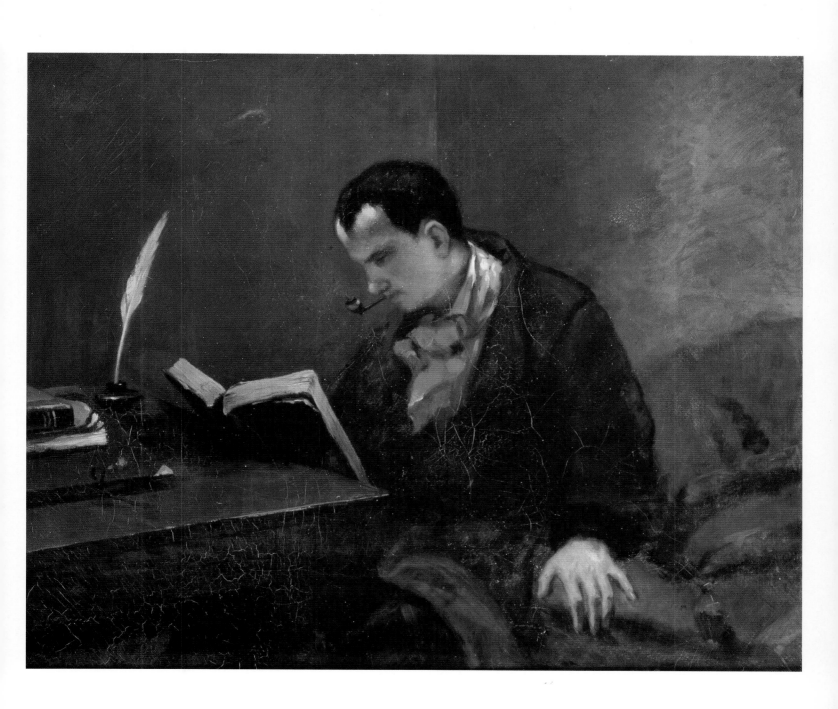

6. AFTER DINNER AT ORNANS

1848–49. Oil on canvas, 76¾ × 101⅛" (195 × 257 cm).
Musée des Beaux-Arts, Lille

This is the first painting in which Courbet announced his project of presenting particular observations of provincial life on a scale and with a sense of importance commensurate with that of academic history painting. The life-sized figures grouped around the small country dining table are engaged in no activity that could be translated into narrative or dramatic terms; each is focused on his own inner consciousness of that which they have in common, the experience of music. Yet the solidity and scale of the figures and the seriousness of their joint nonaction, their mutual inwardness, can carry the conviction that this is a painting that commands the highest attention. It has moved beyond the familiar realm of the Dutch interiors, which certainly contributed their share to its conception. The more perceptive of its early viewers testified to its originality. Francis Wey, a fellow Franche-Comtois and man of letters who became Courbet's friend, saw the painting at his first meeting with the artist, when he was taken to his studio by Champfleury in the winter of 1848. He wrote in his memoir of Courbet (preserved in a manuscript copy in the Bibliothèque Nationale) that he could not remember having ever been so unexpectedly astonished; everything about this work of an unknown artist seemed fresh and at the same time accomplished, its qualities unlike those of any known school. Wey had a grasp of the genuine esthetic of emerging Realism; in a very few years he would be writing some of the first serious criticism of early calotype photography. Also in his memoir he writes of Delacroix meeting him in front of the painting on exhibition at the Salon of 1849 and expressing a similar amazement at this revolutionary who had burst upon the scene so suddenly, without precedent. Even not knowing the identities of the figures (which we do from Courbet's specific Salon notes) to be the painter's father and three close friends, we would know that they are not types, not the boors or innkeepers or soldiers or gentlemen of Dutch genre, but individual men living in a particular time and place. At the same time there is nothing literal about them, no niggling surface traits or tics of personality. Because of the way they are conceived and set into the space and surrounded by objects, they are both individual and emblematic of a corner of French provincial life. Everything in the painting is realized: the stone floor, the sleeping dog, the wooden chairs and white tablecloth, the wineglasses and plates, the plaid cap casually hung on a nail above the table. There is no distance between ourselves and this painting; when we stand before it, we are in the room, listening. It was such a sense of lived truth that so astounded its first viewers, and despite its darkened pigments can do so still.

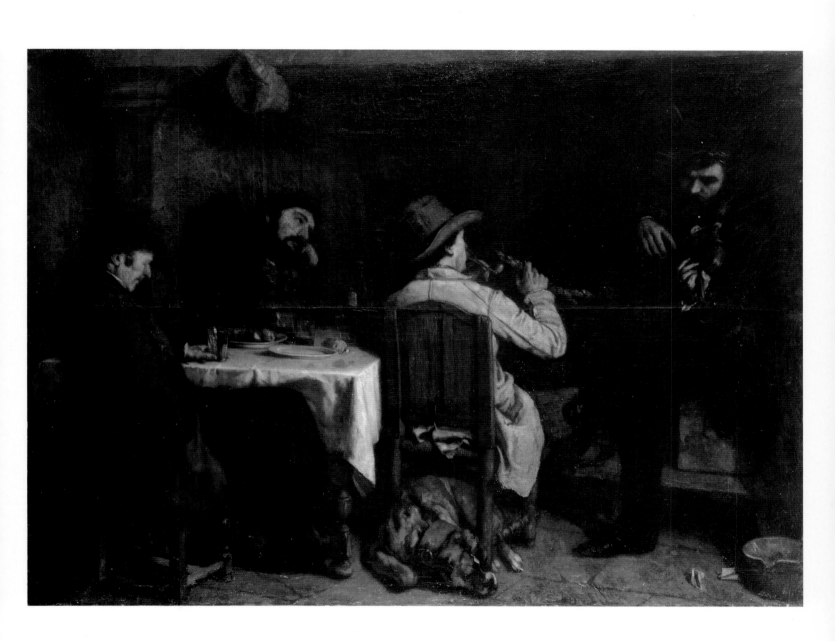

7. THE PEASANTS OF FLAGEY RETURNING FROM THE FAIR, ORNANS

1850, 1855. Oil on canvas, 81½ × 109½" (206 × 275 cm).
Musée des Beaux-Arts, Besançon

Along with *A Burial at Ornans* (plate 8) and *The Stonebreakers* (fig. 13), this was one of the three large and ambitious paintings of local life that stirred up so much critical furor at the Salon of 1850–51. The *Burial* drew most of the hostile fire, but the other two came in for their share. One critic wrote that *The Peasants of Flagey* was a picture that would go a long way toward curing Parisians of their pastoral fantasies, and make them cherish the asphalt and macadam of their urban boulevards. A favorite distinction among some of the critics who prided themselves on their advanced taste, such as the poet Théophile Gautier, was the one made between "le peuple" (good) and "la canaille" (bad: low life, riffraff, etc.) "Le peuple" were to be seen in the deserving and pitiable victims in a painting like Antigna's *The Fire;* Courbet's straightforward depiction of country people going about their business with their beasts was a representation of "canaille." (To which Courbet responded in a letter to his friend Francis Wey, "Il faut encanailler l'art! For too long it's been made of good taste and pomade!") What was troubling to the critics was not the representation of peasants as such, for there was already a lively tradition of well-composed imagery depicting young and attractive people working in the fields or celebrating the harvest, which fed into the urban pastoral fantasy; however, a work such as *The Peasants of Flagey* did not. The figures here are the real farmers of the Doubs, owners of land, able to buy and sell livestock at the fair, but also able to live and work among their animals on an intimate basis that appeared ridiculous to Parisians. Such apparently lowly figures as a man carrying his goods on his back and walking a sow on a string and a woman bearing a basket on her head are presented with the scale and dignity that asserted their intrinsic significance. Also aggravating to the art-critical eye was the stiffness and seeming rigidity of the figures; only the horseman on the left turns his body and head, while the others are firmly vertical. This perceived deficiency (always an occasion for caricaturists to portray Courbet's figures as wooden toys) arises from the painter's conscious awareness of the qualities of traditional folk imagery, a hitherto ignored aspect of art that was beginning to be looked at with a new seriousness. He sensed that the directness of this imagery, the naive verticality of its figuration, had the power to counteract the sinuous ease of academic composition; and he could see that its character was closer in feeling to the actual conditions of rural life and work than were the graceful groupings by more conventional painters of peasant themes. Also at variance with these more pastoral works is the imposing presence of the farm animals: the great oxen, one of whom gazes out at the viewer in a searching way, and the lovingly painted sow, in the center foreground of the painting. The fact that Courbet changed the composition of the painting between its first showing in 1850–51 and its next in 1855 is revealed by a caricature which shows that the woman with the basket on her head was originally situated on the right side of the painting rather than toward the middle where she now appears, making a female pair to echo the pair of male riders. The vegetation and the distant couple cover the traces of the original figure, but where the paint lightens in the sky, the ghost of the original basket appears.

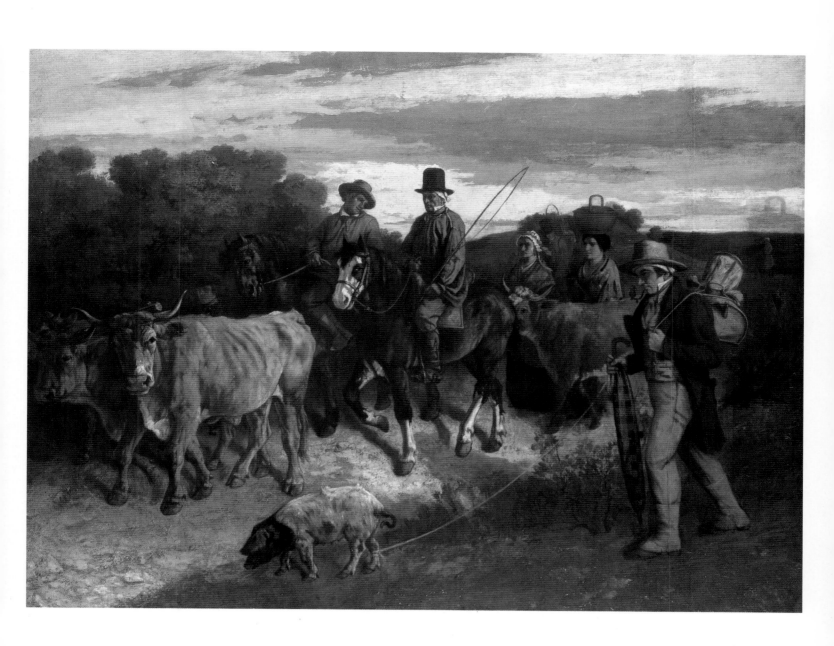

8. A BURIAL AT ORNANS

1849–50. Oil on canvas, 10'3½" × 21'9" (314 × 663 cm).
Musée d'Orsay, Paris. Gift of Miss Juliette Courbet, 1881

In a letter to his patron Alfred Bruyas, Courbet would refer to this painting as "my debut and my statement of principles"; and though reviled at its first exhibition in the Salon of 1850–51, it has remained central to our understanding of Courbet's art. On an unmistakably heroic scale, the painter represents neither heroes nor anti-heroes, but the living citizens of a provincial town engaged in the most inevitable ritual of their communal life. The vast procession of figures, their plain stoical faces emerging starkly from the field of black, was constructed over many months by means of portrait studies of family, friends, fellow-citizens, and local officials of Ornans—the very people who, together with the painter himself, had attended the funeral that is represented. The painting is thus an image of witness: titled *"tableau de figures humaines, historique d'un enterrement à Ornans,"* it subverts that title by its conception as a gathering of living people, witnessed by the artist. Recent archival research by Jean-Luc Maynaud and Claudette Mainzer enables us to know not only the identities of the mourners and officials but that of the person whose funeral is being observed: Claude-Etienne Teste, Courbet's great-uncle and brother-in-law of the artist's maternal grandfather, Oudot. Courbet was very close to his grandfather, whom he admired for being a Republican of the Revolution, one of the "men of '93." Teste had also been an early Republican, and Courbet prominently places at the center front of the painting two surviving men of that generation and political heritage, dressed in the style of that earlier period, not in bourgeois *habit noir.* He also, interestingly enough for an artist who was continually accused of painting only the most literal facts that lay before his eyes, included his grandfather Oudot, whose head, known from other portraits, is seen at the extreme left, immediately behind the casket. But the grandfather had died just a month before his brother-in-law; Courbet includes his symbolic presence as a tribute that was both personal and political. The same mix of motives lay behind Courbet's choice of this particular burial to be transformed into a painting. Teste's burial was the inaugural event of the new municipal cemetery, finally opened on the outskirts of Ornans after years of controversy between the Church, which wanted to retain control of the function, and the more liberal and secular of the townspeople who pushed for compliance with the Napoleonic directive that for health reasons burial grounds should be placed away from population centers. The long-delayed opening was a victory for the liberal faction (including Courbet, who was completely aware of the issue) in a year—1848—when opposition to clerical conservatism ran high. The new location, with its view out over the countryside to the cliffs surrounding the town, provided Courbet with a setting in which he could rhyme the dark spread of the procession with the wide, looming stretches of pale rock: the townspeople with their enclosing landscape. The mass of black and white is punctuated by the red robes of the beadles, whose homely country faces were singled out for ridicule by the press. In a characteristic way Courbet has featured in this sombre gathering two young boys, the only faces to reveal open feeling, and a fine, tensely posed dog. Also characteristic is his placement of the grave, recently dug by the kneeling man. It is just at the center, and we see only the far end of it. Between ourselves and the life-sized figures who compel our entrance into the pictorial space yawns the length of the gaping grave.

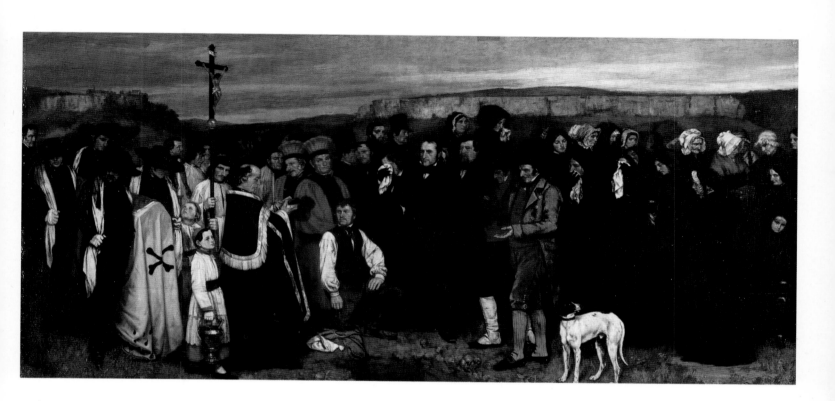

9. THE HOUSES OF THE CHATEAU D'ORNANS

c. 1853. Oil on canvas, 38 × 48" (96.5 × 122 cm).
Private Collection, Switzerland

Not far outside Ornans rises the chalky escarpment of the Château d'Ornans, one of the limestone cliff formations typical of the Doubs region and a favorite painting site for Courbet. Its profile can be clearly seen at the left horizon of *A Burial at Ornans* (plate 8). In *Château d'Ornans* (fig. 32), at the Minneapolis Institute of Art, the site is part of a panoramic view down over the town and out across the valley of the Loue River. But here the painter approaches more closely the little group of stone houses that had been constructed out of the ruins of the castle that gave its name to the hill. Built in the thirteenth century by the powerful dukes of Burgundy, who held the region in fief to the kings of France, the castle was destroyed in the seventeenth century by Cardinal Richelieu, acting to protect the authority of Louis XIII against the independent and unreliable nobility of the region. Local people had built a small hamlet out of the ruins of the castle. The historical connotations of the Château d'Ornans—the tough independence of the Franche-Comté vis-à-vis central government, and the sturdy survival of its ordinary people—were thus of a kind to enrich Courbet's spontaneous visual and physical appreciation of the site. This painting is interestingly atypical in that it focuses on the structure of buildings. Courbet was not a painter of towns, and he is more likely to treat the verticality of the local cliffs as a kind of castle made by nature to oversee the land and thus act as a metaphor for the strength of its people. But having chosen this view, coming upon the hamlet from the back, so to speak, he responds powerfully to the geometry of the structures, to the way in which the larger forms are interlocked with the smaller ones. One associates the motif more with Corot, but Courbet treats it in his own manner. The forms are built up in layers of actively applied paint that respond variously to the light just as the actual plaster-covered rough stone walls would do. That same activity of paint application, with palette knife as well as brush, escalates in the construction of the vegetation and the trees. The depth and richness of the foliage is especially striking, as is the quality of the light emanating from the pigment of the sky. We see in this painting one of the best examples of Courbet's contribution to the landscape tradition that was being developed in his time: the liveliness and energy of the act of painting, which in turn communicates the larger idea of spontaneity and freshness of perception.

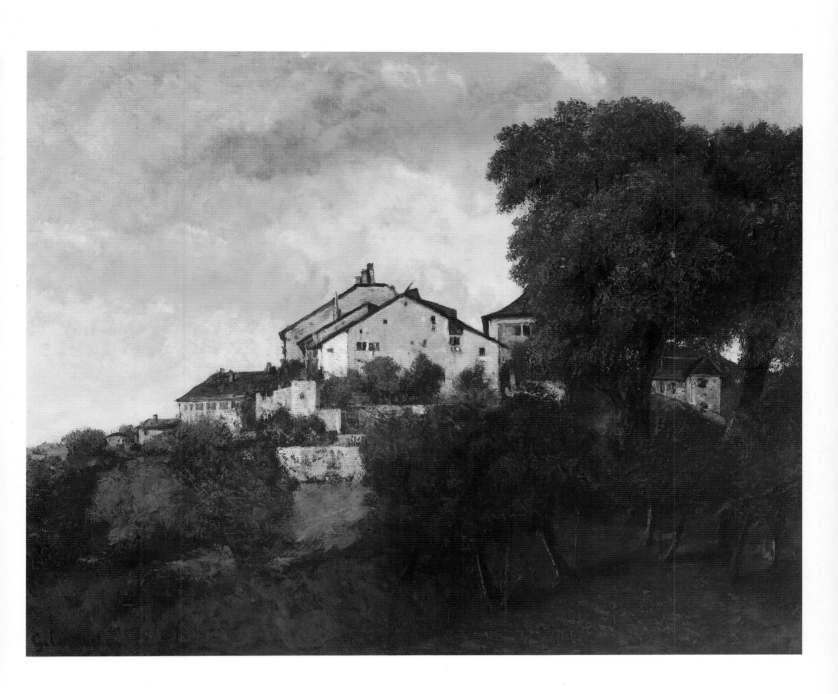

10. THE YOUNG LADIES OF THE VILLAGE

1851–52. Oil on canvas, 76¾ × 102¾" (195 × 261 cm).
The Metropolitan Museum of Art, New York. Gift of Harry Payne Bingham, 1940

Writing to Champfleury about the new large painting that he would be sending to the Salon of 1852, Courbet claimed to have done something that would confuse the Jury, to have made "something gracious." He was implying a contrast with the Salon of the previous year, in which *A Burial at Ornans* (plate 8), *The Stonebreakers* (fig. 18), and *The Peasants of Flagey* (plate 7) had caused such a critical scandal. In theory, the painter's subject—three sisters taking a Sunday walk in the country—might be supposed a harmless, "gracious" activity, but it is nonetheless likely that Courbet's remark was tongue-in-cheek. To begin with, the very title given to the painting was bound to cause offense. *Les Demoiselles de Village* was, in terms of French society, almost an oxymoron. The term *demoiselle* implied a fairly high social standing, too high as to be appropriate for members of the newly emergent rural bourgeoisie. Parisian audiences may have been ignorant of the fact that the three young women in their Sunday best were actually modeled on Courbet's sisters, but they could recognize that they were not "young ladies" in the sense in which the term was socially understood. The action of the group—the giving of a charitable treat to a ragged and barefooted peasant girl, with her cows in close attendance—only underlined what Parisians saw as vulgar pretentiousness. The painting is one that has, for Courbet, an unusual number of smaller related works, whether studies or not is often difficult to tell. The very small Brussels painting of the site (fig. 34), with figures barely visible, may be an initial idea. In a painting at Leeds with the same title, all the elements of the final work are in place, but the figures are relatively small, so that it appears to be a landscape in which some conventional, possibly "gracious" bit of genre activity is taking place. But in this final large-scale work—although the figures are more distanced from the viewer than is usual in Courbet's work—their character and action are perfectly clear. This is the first of his series of major paintings of local life in which the landscape takes an equal role with the figures. It is a classic Ornans setting of rough pastureland articulated by chalky cliffs, in which the sensuous surfaces of the rocks pull them toward the front of the picture plane despite their assumed location in deep space. They are shaped so that the curving central section acts as a kind of bowl to contain the figures, both animal and human. The pair of cattle, a young bull and heifer, are also the subject of a separate painting and seem to act for Courbet as a kind of Edenic couple.

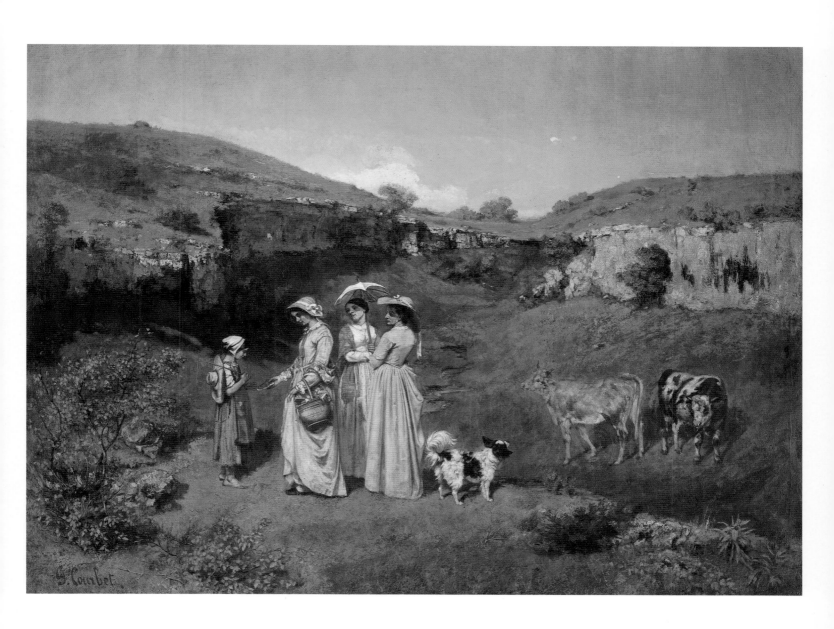

11. THE SLEEPING SPINNER

1853. Oil on canvas, 35⅞ × 45¼" (91 × 115 cm).
Musée Fabre, Montpellier

Courbet returns here to a theme first explored in *The Hammock* (plate 1) of 1844, that of
the sleeping woman. The differences in context and style mark the artist's painterly devel-
opment and the increasing specificity of his Realist project. Since the *After Dinner at Ornans*
(plate 6), he had been embarked on a series of paintings that constituted a kind of wit-
nessing of the realities of the life around him: the work, the leisure, the rituals of a provin-
cial community in which, as elsewhere in France, a former peasant class was becoming
self-aware and laying a claim to political, social, and cultural attention. As a member of
that class himself, refusing to disavow and rise above it as so many had done, he took his
subjects from the life he knew, for it was by means of the activities of these actual persons
that Courbet could express the meaning of his witness; his purpose was not to record indi-
viduals per se (though he did that in portraits). Thus, the often debated question of
whether the model was one of Courbet's three sisters or another local woman is of little
significance compared to the fact that the figure is defined by her physical type, her set-
ting and clothing, and the activity that has been interrupted by sleep. She is depicted as a
solid, cushiony sort of woman, strong and heavyset (tropes for "peasant"), but dressed in
a comfortable and attractive middle class way and seated on an upholstered chair. The fab-
rics of the dress, shawl, and chair, together with the spinning wheel and its accou-
trements, are painted with the kind of sensual energy that almost always characterized
Courbet's painting of still life. The lively treatment of the hairlike raw wool on the distaff
and its placement on the figure's lap lends some credence to specifically sexual interpreta-
tions, but these are secondary to the primary sexual fact that we are in the immediate
presence of the woman's sleep and thus implicated in her private unconscious being.
Toussaint has called attention to the remarkable quality of the hands, delicate yet heavy
in the relaxation of sleep—a motif seen again in that great image of female somnolence,
The Young Ladies on the Banks of the Seine (plate 18). Like the other paintings of this period,
with their focus on daily life, *The Sleeping Spinner* has been related to Dutch painting,
specifically to the tradition of moralizing paintings of women whose sleep is represented
as the neglect of household tasks; but Courbet was not attracted to moralizing either
by temperament or in relation to his overall project, that of giving imaginative reality to
his own people. On the other hand, an awareness of the craft of hand spinning as being on
the verge of extinction could very well have been in his mind in selecting this theme.

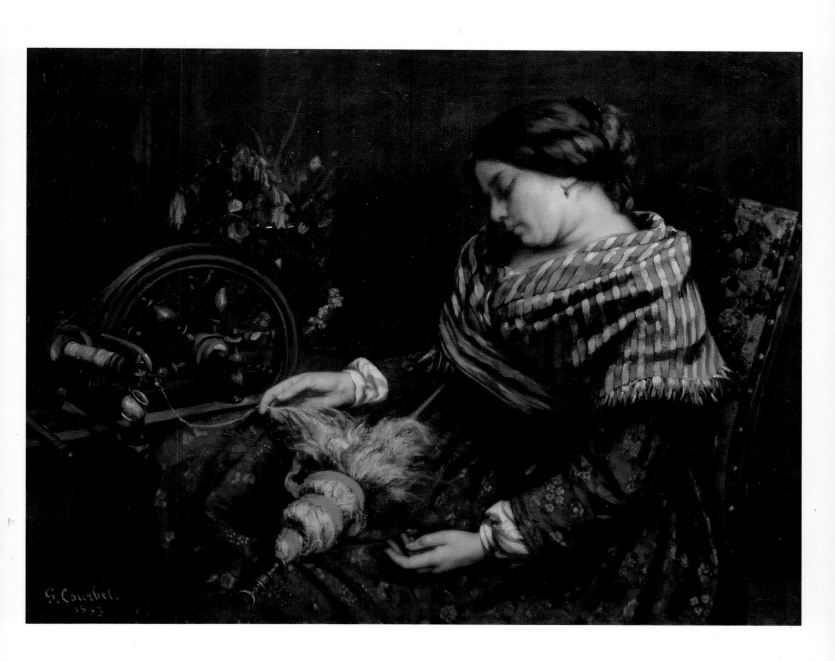

12. THE GRAIN SIFTERS

1854–55. Oil on canvas, 51⅝ × 65¾" (131 × 167 cm).
Musée des Beaux-Arts, Nantes

Courbet saw this painting as "un tableau de moeurs de campagne" (a picture of rural customs) and referred to it as being in the same series as *The Young Ladies of the Village* (plate 10), which, he writes in a letter to Champfleury, is also a "strange picture." It is this latter kind of cryptic comment that makes the interpretation of Courbet's paintings persistently enigmatic; but the grouping of the two paintings under the rubric of "rural customs" is not such an opaque remark. The fact that both paintings take the artist's sisters as models is an obvious factual link, but this can be of only generic significance. Courbet observed the living people of his native region, whether family, friends, or workmen along the road, and made their actuality the basis of his Realist project of bringing a large and hitherto obscure class of human beings into public consciousness. In the two paintings mentioned in the letter to Champfleury we see two different aspects of the life of women in a small country town. In *The Young Ladies of the Village*, they are represented at what might be called the peak of their *embourgeoisement*, wearing good clothes and in a position to give charity to a child laborer. But although such families had acquired productive land as a result of the cosmic shifts of the Revolution and were thus able to distance themselves from agricultural labor, there were still hard tasks to be done, many of them by women and by means of artisanal work. It was still a time when raw wool was spun into thread by hand, as in *The Sleeping Spinner* (plate 11); or when grain for baking the family bread was refined, also by hand, as in *The Grain Sifters*. (I read the confined, domestic atmosphere of the painting to mean that this particular sifting is a domestic task, not the more massive job of sifting grain for the market, which would be done by agricultural laborers.) Domestic or not, the hard work depicted—that of shaking the large sieve—is clearly demanding. Courbet creates a figure that represents in an unforgettable way the essential strength of a young female body. The powerful working arm—a rival in exaggerated length to those of Ingres's women, but muscular rather than svelte—the wide shoulders and slender waist, the full hoops draped in thick, ruddy cloth, the soles of the big clogs facing us like the bare feet of some kneeling Caravaggioesque saint: all these fuse into an image of remarkable force and energy. Characteristic of Courbet is the fact that the major figure is seen from the back, as in *After Dinner at Ornans* (plate 6) and *The Bathers* (fig. 40). It imposes itself and draws the viewer into this bare chamber, where only the boy (curious and exploring) and the cat (sleeping) are freed from the demands of work. In this figure Courbet creates an image of the woman as worker that casts aside the elements of personal charm and/or submissive humbleness, which were intrinsic to this type of rural subject in the work of such contemporaries as Breton and Millet.

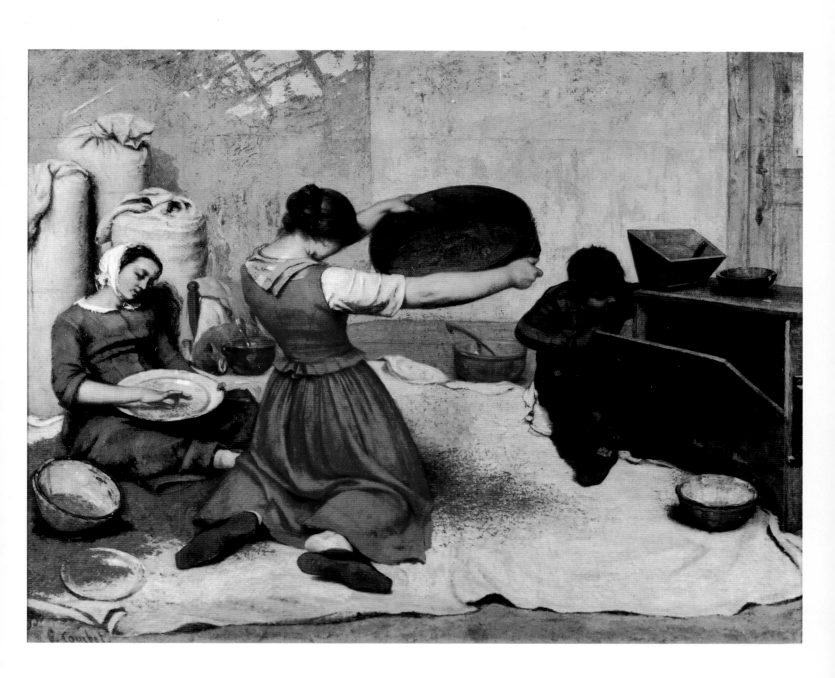

13. DRESSING THE DEAD GIRL

Mid-1850s. Oil on canvas, 74 × 99" (188 × 251.5 cm).
Smith College Museum of Art, Northampton, Massachusetts

When this large unfinished canvas first came to public attention in the 1920s, it bore the title *La Toilette de la Mariée, Dressing the Bride*. Later studies, based on documents and on the painting itself, have persuasively demonstrated that the scene is not one of preparation for a marriage but for a wake. Crucial to this radical change in interpretation was the radiographic examination of the central figure, the young woman seated in the chair being tended by her companions. This revealed a nude figure, both arms hanging down, her head leaning against her left shoulder. The awkwardness of the overpainting makes it highly probable that this change was made not by the artist but by another hand at a later date, to permit the painting to be given a more cheerful theme for the sake of the market. That the painting should be concerned with the rituals of death rather than of marriage is also borne out by some of the activities portrayed, such as washing the young woman's feet and the concentration of the group in the background on their prayerbooks. Even though incomplete, the painting takes its place in the series of what the painter calls "*tableaux de moeurs de campagne*." In that series Courbet specifically mentions *The Grain Sifters* (plate 12) and *The Young Ladies of the Village* (plate 10), both of which are also concerned with rural customs enacted by the local women of Ornans, his sisters and others. It is worth noting that all three of these paintings—and one could add a fourth, that of the spinner interrupted at her task of spinning by sleep—take as their subject the activities of women. Considering the size of the painting, it was doubtless originally intended as a Salon picture which would expand Courbet's Realist project of elevating themes of provincial life to the status of serious art. It is not known why the painting was left unfinished. Impressive, however, is the powerful atmosphere created even in this state. It is a painting that commands attention at a great distance, by its somber tonality, its strong planar construction, and the dignity of the figures as they are woven through the somewhat ambiguous space. The work reveals both the artist's traditional method of building the canvas up from light to dark, and his very unacademic method of constructing form by drawing with color and tone, establishing the basic character and feeling of the painting from the early stages.

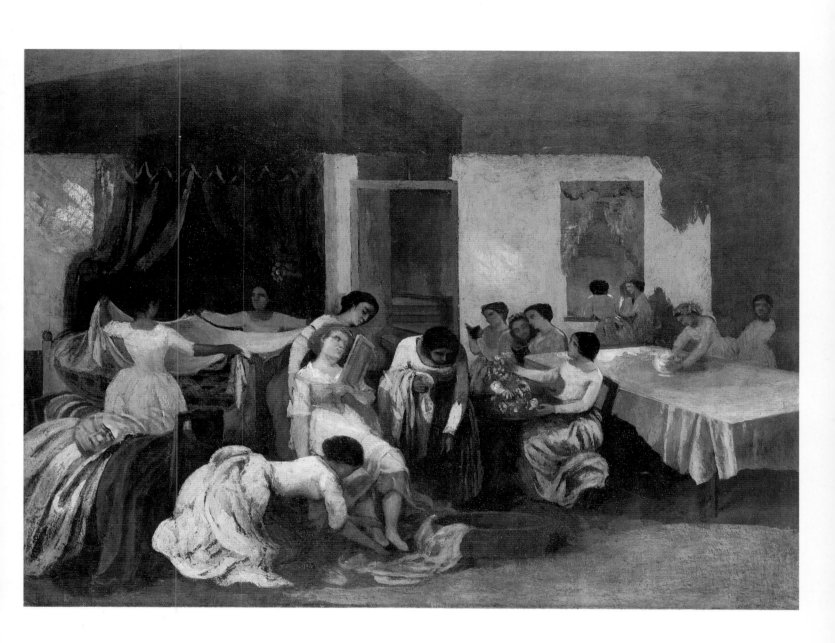

14. THE MEETING, OR BONJOUR, MONSIEUR COURBET

1854. Oil on canvas, 50¾ × 58⅝" (129 × 149 cm).
Musée Fabre, Montpellier

This is one of the best-known and best-liked of Courbet's paintings. One reason for that, apart from the apparent sociability of the theme, is the high key of the palette and the brilliance of the light. Here the artist is painting from his experience of Mediterranean light, seen on his first trip to the south of France in May of 1854. The occasion was the much anticipated visit, prolonged through September, to the artist's first and most important patron, Alfred Bruyas of Montpellier. Bruyas had first encountered Courbet the year before, when he bought both *The Bathers* (fig. 40) and *The Sleeping Spinner* (plate 11) from the Salon of 1853. Before the end of 1854 he would have commissioned or bought from the artist seven additional works, which joined his extensive collection of works by contemporary painters, which he had been forming since the mid-1840s. *The Meeting* was commissioned and possibly begun in Montpellier, and finished in Ornans. Courbet knew of Bruyas's interest in befriending the artists whose work he collected and he knew that Bruyas wanted from him a painting that would commemorate the relationship between himself and his new patron. He was happy to attempt this out of his enthusiasm for Bruyas and his euphoric belief that here was a man who could help to provide not only a Fourierist *solution* to the future of modern art and society, but the more specific solution to the problem of Courbet's own career as a painter. To make such a painting—the portrayal of actual persons in order to communicate a larger idea—was in any case perfectly commensurate with his Realist project. The result was a profoundly successful painting, which had the added advantage of pleasing his patron. True to its nature as a "real allegory" rather than an anecdote as was long thought, the painting is not a record of an actual event, Courbet's arrival in Montpellier and greeting by Bruyas and his manservant. As Philippe Bordes notes, Courbet traveled to the city not by coach but by the new railroad line, and in any event there would have been no occasion for him to be met out in the open countryside. The painting is rather an interpretation of two mutually interested and interdependent characters who represent two different social strata and two different but interrelated roles in society. Bruyas is the gentleman patron, his caste figured in his demeanor and in his manservant, without whom one feels he may not be able to function. (In fact, Bruyas was neurasthenic and seldom went out without the servant and his protective shawl.) This doubled figure faces outward toward the figure of the artist, powerfully erect, tall and striding, carrying his painting box and folding canvases on his back, head high and "Assyrian profile" well on view. One can see why the word *vanity* sprang to the lips of its first viewers; but one can also see the narrowness of such a response. The artist who tilts back his head to gaze seriously at his host, aware of his own power to produce what the other wants but also aware of his own need of the other's support, is not a creature of vanity but of pride. The artist, whose role it is to wander the world and have no settled niche in society, is presented as fully equal to, and in some ways stronger than, the man of wealth and social position.

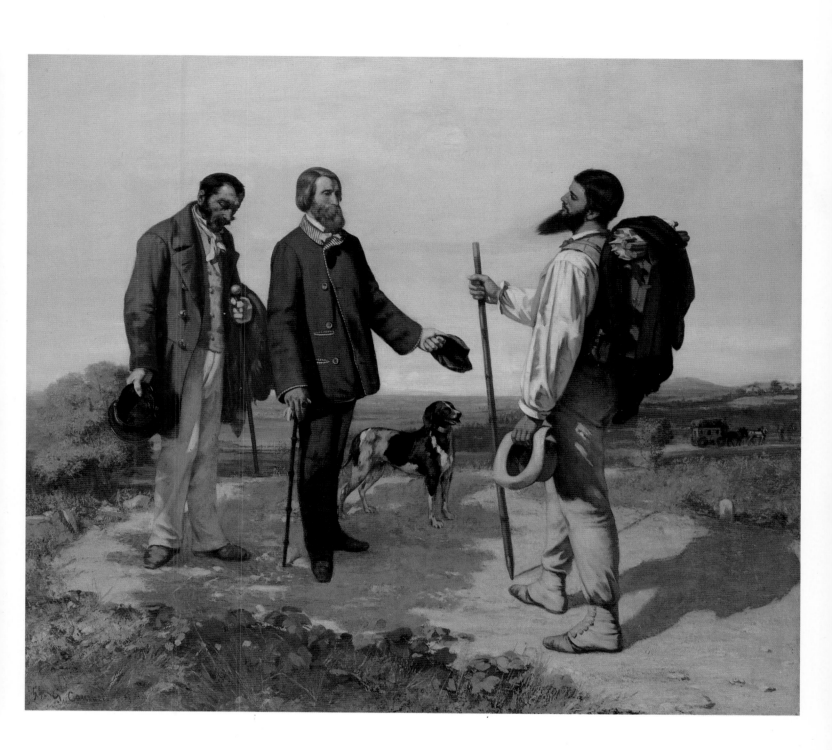

15. THE HOMECOMING

c. 1854. Oil on canvas, 31⅞ × 25¼" (81 × 64 cm).
Private collection

The Homecoming is probably identical with the *Autoportrait Saluant*, which was owned by the painter's sister Juliette and sold at the sale of his work in 1882. The French title, *Le Retour au pays*, is a logical one to have become attached to it, given the fact that the figure is a traveler and that the character of the landscape is that of the Doubs countryside. The details of the clothing, the salutation with the hat, the backward tilt of the head, all relate the figure to that of the artist in *The Meeting* (plate 14). In this way the image can be read as that of the artist as wanderer, having no fixed interests to protect but nonetheless rooted emotionally in the particular land of his childhood, which is also the source of his art. However far or often he may go, he always returns here, to the rough and unspoiled countryside of the valley of the Loue. It is through Courbet's construction of these landscapes and the people who live in harmony with them that he has been able to realize his ambition to "make a living art," as he wrote in the catalogue of his 1855 one-man show. The strong masculine body fills the pictorial field. The limbs—or three limbs and a stick—make a modified X shape, wider at the top, which gives the figure a sense of being rooted in the landscape like a tree, bringing to mind the painter's self-identification with the great oak of Flagey. Once again, as in the case of such various contemporaneous works as *The Bathers* (fig. 40) and *The Grain Sifters* (plate 12), the viewer is drawn into the pictorial space by a figure seen from the back. In this instance Courbet has achieved a kind of tour de force of expressiveness without any sign of the face. The exaltation felt by this man as he greets his native turf is conveyed entirely by the act of saluting, the disposition of the (unfinished) head, and the bend of the knee. One senses the painter's understanding that the deepest feelings are those that resist facial expression in the static art of painting. Michael Fried's ideas about the structure of beholding apply here, for this painting is all about beholding, and it is the sight of the land that brings forth the salute. The viewer is drawn into a complex structure: the painter's presentation of himself as a viewer, responding to that which is the emotional force of the image and yet is hidden from our own view.

16. THE PAINTER'S STUDIO

1854–55. Oil on canvas, 11'10" × 19'9" (359 × 598 cm).
Musée d'Orsay, Paris

By setting up an unprecedented gallery of his own work called the Pavillon du Réalisme, Courbet aimed to demonstrate, to the vast international audience that would attend the Exposition Universelle of 1855, the validity of a new kind of art that could act as witness to the realities of its own time. The one-man exhibition was a manifesto, and within it this large and ambitious canvas was a manifesto painting. It was subtitled *A Real Allegory, summing up a period of seven years of my artistic and moral life.* It presents the artist's studio, not in the descriptive genre manner typical of the period, but as an image of the significance of art in human society. Again, as in his major paintings since the *After Dinner at Ornans,* the painter has made use of persons known to him to act in the world of the painting both as themselves and as vehicles of broader meanings. The figures on the right side of the canvas, among them Baudelaire with his book at the far edge; the Realist writer Champfleury seated toward the foreground; the poet Max Buchon and the patron Alfred Bruyas in the group of supporters at the back; are described by Courbet in a letter to Champfleury as "the people who live on life . . . the friends, the workers, the people who love the world of art." In their midst, by the window, he places a pair of lovers, unique on this side in not being specific individuals but emblematic of what the artist means by "living on life." On the left side of the painting the sense of enigma, noted by Klaus Herding as being an essential feature of the work, deepens. Here are a group of figures described by Courbet as representing "the other world of trivial life, the people, misery, poverty, wealth, the exploited and the exploiters, those who live on death." These are not individuals known to him but are contemporary types ranging from a rug merchant to a ragged woman nursing an infant. The black-clad *croque-mort,* the *undertaker's mute,* reinforces the sense of living on death in direct opposition to the pair of lovers on the right side of the painting. Featured in the foreground is the seated figure of the *braconnier,* a trainer of hunting dogs who was frequently a poacher. This figure is the key to recent interpretations of the painting. Toussaint argues the case for identifying it as Napoleon III, figured in the waxed moustache, the self-absorbed smile, and especially in the prominent boots; forbidden to be the subject of caricature in the press, the Emperor was often symbolized by booted creatures or even a boot alone. Certainly the depiction of Napoleon III as a poacher, included among those who "live on death," would be consistent with Courbet's attitude toward the Emperor. Herding, while not accepting all of Toussaint's further identifications, concurs in this one, and for him the painting becomes the artist's plea to the Emperor on the great international occasion of the Exposition for peace, reconciliation, and the well-being of the people. It is clear from the construction of the painting that art, and the serious love of art, are essential to that well-being. Those who "live on life" are ranged behind the artist at work; he is watched over by a noble nude and admired by a young boy, while another child lies on the floor drawing, emulating the work of the artist. On the easel is a landscape, made to convey the meaning of that natural world which Courbet saw as a model for human life. Above all of the figures stretch the high walls of the studio: a place represented here as being at the center of the world. This centrality of the artist's studio was conceived not in the egocentric sense read into it by Courbet's contemporaries, but as being the locus of the life of the imagination, which has the power to see beyond the exploitations and inequities of mankind.

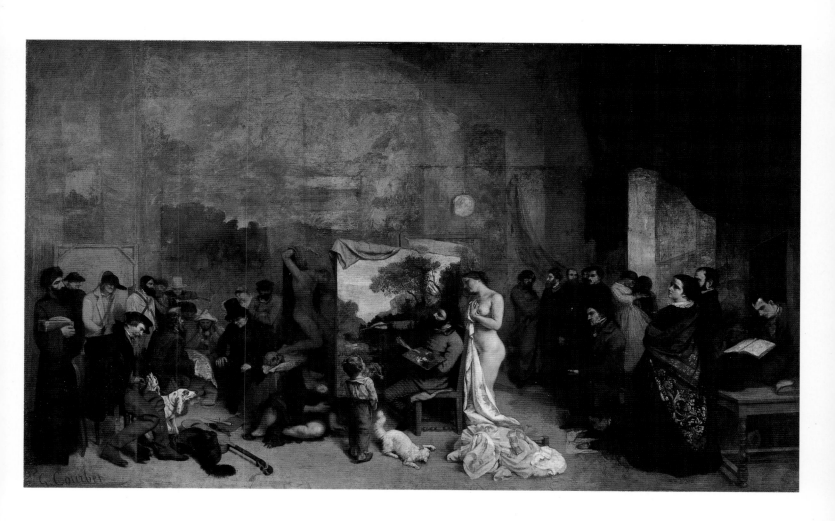

17. MÈRE GRÉGOIRE

1855. Oil on canvas, 50¾ × 38⅜" (128.9 × 97.5 cm).
The Art Institute of Chicago. Wilson L. Mead Fund

This robust painting of the quintessential *patronne* of a Parisian café is one of the infrequent themes of urban life undertaken by Courbet. As in his great series of paintings based on the people of Ornans, the figure selected to bear his meaning is drawn from the petit bourgeoisie—the vast class of artisans, small traders, and shopkeepers on whose activities Paris depended for its attractiveness and prosperity. The café—or bistro or cabaret, depending on the relative proportions of food and entertainment in the place—was an essential part of the bohemian culture that was emerging during Courbet's early years in Paris. These establishments were devoted not only to food and drink and private conversation, but to lively discussions of art and politics and to the performances of popular singers. During the whole turbulent period from the Bourbon Restoration through the Second Empire, they were favored centers of dissent and popular opposition to the ruling powers. As Robert Herbert has demonstrated, the title of the painting, given to it by the painter, shows us its relation to this lively dissident culture. "Madame Grégoire" was the title of a cabaret song of the 1820s by the popular poet Pierre-Jean Béranger, whose reputation as a spokesman of the people was subject to particularly strong right-wing attack in the mid-1850s. The song celebrates, in the person of a lusty widowed *patronne*, the kind of independence and disregard of conventional sexual morality that both attracted Courbet and frightened the government censors, who in fact were closing down thousands of cafés in the early 1850s in an effort to control dissent. The painting is as strong and ample as its subject. The perceptive critic Thoré-Burger remarked that he would like to see it in the Antwerp Museum, next to the Rubens there. It is a splendid example of Courbet's powers as a painter of both the solidity of flesh and the delicacy of flowers. The details—of marble counter and the coins and ledger upon it—are convincing without being literal. There is a certain mystery in the depth of the gaze directed at the implied customer and in the gesture of holding the little flower, which does not appear to have come from the vase at the figure's other side. The painter avoids the obvious device of having the woman look directly out of the picture; the viewer is made to feel very much present in the pictorial space, but off to one side.

18. THE YOUNG LADIES ON THE BANKS OF THE SEINE (SUMMER)

1856–57. Oil on canvas, 68½ × 78¾" (174 × 200 cm).
Musée du Petit Palais, Paris

Without doubt one of the most delicious of Courbet's paintings, *The Young Ladies on the Banks of the Seine* is rightly much admired in our own day. The painting of the fabrics alone is a tour de force: the subtly variegated tones of white, the texture of the creamy cashmere shawl in relation to that of the thin lacy muslin, the handling of the decorative patterns (pale blue dotted among the white ruffles, Indian red in the border of the shawl), the pale pink ribbon . . . and then there are the flowers, the carpet of tiny wild flowers and grasses painted with the delicacy of a Pisanello, the lush bouquet on the lap of the further figure, the rich mixture of flowers and ribbon on the hat that lies abandoned by the tree. Any viewer capable of enjoying the pleasures of painting will be drawn into this one and will succumb as well to its atmosphere of somnolent sensuality. Before we know anything further about this work, we know two things immediately: the artist is a magnificent painter and no puritan. The figure in the foreground, she of the satisfied, seductive gaze, is clearly dressed in her underclothing, however prettily charming it may be. The skintight pale yellow short gloves on her relaxed and curiously delicate hands virtually beg to be slowly peeled off. Her companion appears to be both more complaisant and less interested, which generates another level of erotic charge. The moored boat containing a man's hat signifies the temporary—soon to be renewed?—presence of the male. Courbet, as a lover of women, must have delighted in this painting, but he must have suspected too that it would cause an outcry at the Salon. The very use of the term *Demoiselles* in the title again was a deliberate provocation; these women are as far from being proper young ladies, though in a different direction, as were Courbet's sisters on their Sunday walk. By using the honorific Courbet was not putting down either set of women; on the contrary, he was attacking the rigidities of class and asserting the validity of such different kinds of actual working women as subjects for serious painting. This alone would—and did—cause annoyance, but the more serious disturbance came from the presence of such open sexuality represented in such pointedly contemporary terms. For the Salon public, sexuality could be safely encoded in nudity, such as the polished nudity of Venuses and Dianas and allegorical or exotic figures; it could not be presented in terms of social truths close to home. Thus this painting, with all its richness of cloth and decoration, flowers and foliage, and its scarcity of bare flesh was perceived as more sexually disturbing than the nudes of conventional art. That young working women in Paris—often recent arrivals from country villages—made themselves available to gentlemen who could pay for the pleasures of a Sunday along the Seine outside the city was not a truth to be openly acknowledged in polite society, still less to be embodied in a work of art with a serious claim to public attention. Only a few years later, the equally frank but more urbane sexuality of Manet's *Déjeuner sur l'Herbe* would be greeted with similar fierce denial.

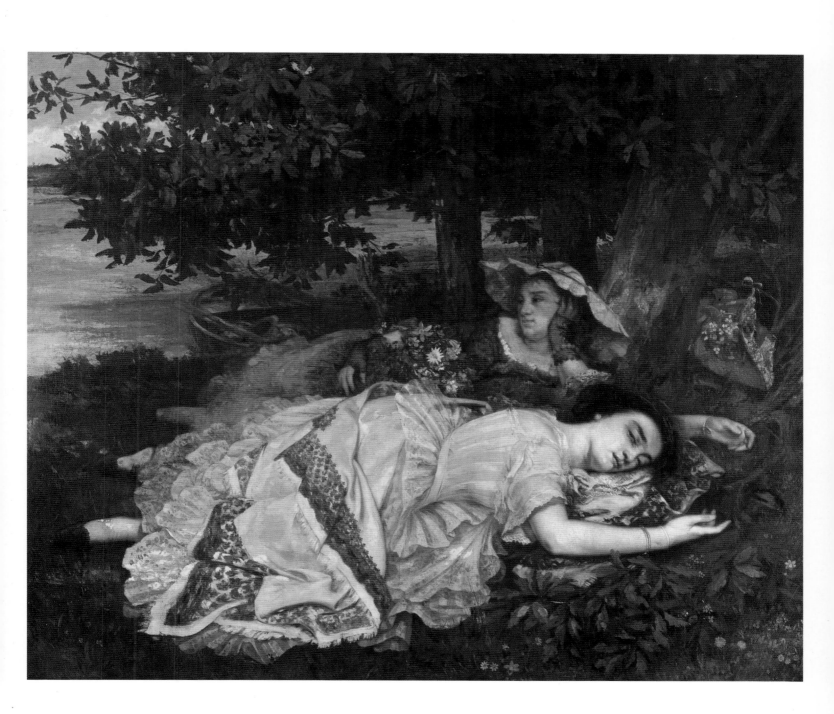

19. THE QUARRY

1857. Oil on canvas, 82¾ × 72¼" (210.2 × 183.5 cm).
Museum of Fine Arts, Boston. Henry Lillie Pierce Fund

Shown at the same Salon of 1857 as *The Young Ladies on the Banks of the Seine* (plate 18), this was the first of Courbet's paintings on the theme of the hunt. (It was also the first of his paintings to go to America, having been bought in 1866 by the Alston Club in Boston.) Unlike the *Young Ladies*, it was favorably received by the critics: huntsmen and their animals were a fixed and traditional theme of painting, not offensive to social or critical sensibilities. Indeed, the motifs of the pair of hunting dogs and the hanging deer can be related to the tradition of the eighteenth-century painters Desportes and Oudry; but there is nothing traditional about the way in which the different elements of the painting have been put together to create an atmosphere of enigma and mystery. The lively tension between the two dogs, justified in the Metropolitan Museum's painting of the same pair, who compete for possession of a dead hare, is here unmotivated. The French title of the painting, *La Curée*, is a term that refers to the unleashing of raw appetite, when the hunting dogs are allowed their share of the freshly killed game. But here that moment is long past, and the body of the deer has become an object of beauty and contemplation rather than of violence. The young man dreamily blowing the horn, the traditional *sonneur*, whose function it is to call the other huntsmen in at the death, is in yet another time frame. Leaning against a tree in a self-enclosed posture, withdrawn and meditative, is the figure of the artist-huntsman. Composed as a self-portrait, the figure is at the actual and metaphorical center of the painting. Courbet the countryman accepts the reality of the hunt as part of what today we would call the food chain; Courbet the painter rejoices in the vitality of animals, in the beauty of their structures and their surfaces; Courbet the man understands the melancholy of their fate. Thus once again the painter constructs a "real allegory" out of his witness to the realities of the life around him. The painting as it was shown at the Salon was lower and narrower than the one we see now, enclosing the figures with greater density. At the request of the dealer who bought it from him in 1862 and who wanted more "air" in the composition, Courbet attached additional canvas to the left side and to the top of the original. There is a small study for this expanded composition.

20. THE LADY OF FRANKFURT

1858. Oil on canvas, 41 × 55¼" (104 × 140 cm).
Wallraf-Richartz Museum, Cologne

Courbet came to Frankfurt in the fall of 1858, after a year in which almost nothing is known of his whereabouts. He had gone to Brussels, where his paintings were being shown, in the previous autumn and stayed for some unspecified period, reportedly spending much of his time enjoying the pleasures of the taverns. It was a strange and unproductive year, and one can only speculate that it may have represented a crisis of confidence brought on by the awareness that some of his utopian dreams were not capable of realization. Bruyas's patronage—neither so euphoric nor active as in the beginning—would in any case not ever enable him to bypass the reactionary officials and hostile juries of the Salon system. In this context, the eagerness of artists' groups in Brussels to show his work prompted a strong response, and he was there again—or perhaps still—in the summer of 1858. Courbet was equally pleased by his reception in Frankfurt, where he was given a studio in which to work on large canvases. In addition, he had the good fortune to be introduced through his friend the photographer Carjat into the family of the banker Emil Erlanger. Through these social connections he was also able to take part in the grand stag hunts of the Black Forest, which proved to be an energizing source of ideas and motifs. Yet despite all this, he wrote to his family in December of 1858 that he had not written to them because "I could only write insignificant things, full of unhappiness, nothing very interesting. I ramble through foreign countries to find the independence of mind that I need and to let pass this government that does not hold me in honor, as you know." In *The Lady of Frankfurt* this strain of melancholy in the midst of pleasant surroundings makes itself felt. The subject is apparently simple: a lady, finely but not formally dressed, is taking a comfortable cup of tea on her terrace, overlooking a spacious park. The model is undoubtedly either Madame Erlanger or one of her friends, but the painting is not conceived as a portrait. Its somewhat mysterious mood emerges in part from the sense of inwardness and self-absorption of the figure, who appears to be waiting for someone or something. This waiting becomes apprehension in the tense figure of the elegant dog. The impression given of capturing a magical, evanescent moment is also caused by the openness and transparency of the paint handling in this not fully finished work, and by the fact that the artist's changes in composition have become apparent to the viewer. The male figure originally seated at the little table was painted over with a *tempietto* in the park, but now looms ghostlike next to his companion, who in any case is gazing far beyond him. The terrace, once extended to the edge of the canvas, now ends in steep steps which provide a view out over a body of water. The light of the evening sky sifts through a mix of dark fir and autumnal foliage, scribbled in with the kind of spontaneous, feathery touch of which Courbet was the master.

21. THE FOX IN THE SNOW

1860. Oil on canvas, 33¾ × 50⅜" (85.7 × 128 cm).
The Dallas Museum of Art. Foundation for the Arts Collection, Mrs. John B. O'Hara Fund

Fox in the Snow was one of four paintings on the theme of the hunt and wild game which were critically acclaimed at the Salon of 1861. In the mid-sixties it was in the collection of Khalil Bey, the noted Turkish collector resident in Paris who commissioned from Courbet both *The Sleepers* (plate 36) and *The Origin of the World* (fig. 45). Connoisseurs of painting responded immediately to Courbet's gifts as a painter of animals. Without exaggeration or anthropomorphizing, he was able to grasp their intense vitality both in action and in repose. Here he portrays the fox in the act of devouring the rodent he has just caught, his body concentrated on feeding and at the same time tensed enough, with haunches raised, to race away if threatened. His painting of the fox's fur is masterful; without literalism and while retaining the qualities of paint, he renders a virtually tactile sense of the depth and texture of the animal's pelt. The painting communicates a sense of Courbet's deep identification with the animals he painted and hunted. Here the fox, proud and strong, is itself the predator rather than the prey. In such a painting we can see the artist's clear and unsentimental understanding of the natural world: his respect for wild animals, their habitat and their means of survival. Such a view was becoming rare in a world going headlong into technological revolution, with all its malign consequences for wild nature; the image speaks to us anew in our own life among these consequences. The setting of the fox in a snowy landscape is one of the early instances of what was to become something of a specialty of Courbet's; landscapes painted with the neutral palette imposed by snow were not common at the time, and collectors often asked specifically for a snow scene from his hand.

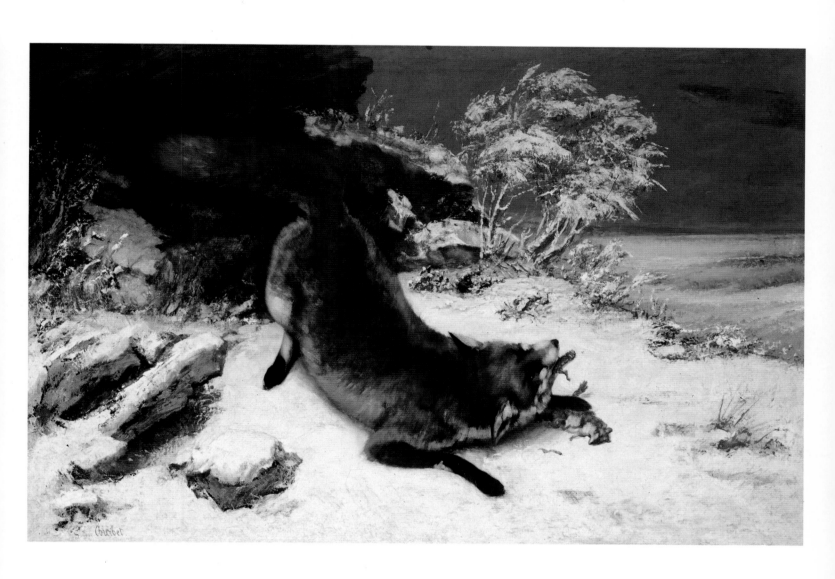

22. THE TRELLIS, OR YOUNG WOMAN ARRANGING FLOWERS

1862. Oil on canvas, 43¼ × 53¼" (110 × 135 cm).
The Toledo Museum of Art, Ohio. Purchased with funds from the Libbey Endowment.
Gift of Edward Drummond Libbey

In 1862 Courbet's young friend, the critic Jules Castagnary, introduced the artist to Etienne Baudry, a landowner from Castagnary's native province of the Saintonge in western France. Attracted by Courbet's work, Baudry invited him to come and stay at Rochemont, his estate near Saintes. Courbet went to Saintes in May of 1862 and stayed for a year, though not all of the time at Rochemont. He found the place and the people in Baudry's circle agreeable and conducive to work. Baudry was an intellectual, a liberal, and a supporter of the arts who took a great interest in botany and was a serious gardener. The gardens at Rochemont were extensive and equipped with fine greenhouses, and Baudry possessed a large botanical library as well. All of these elements combined to exert a positive influence on the painter. He had painted small flower still lifes as part of a larger composition, as in *Mère Grégoire* (plate 17) or *The Young Ladies on the Banks of the Seine* (plate 18), but here in Saintes for the first time he focused on the painting of flowers for their own sake. In so doing he placed himself in a tradition going back to the seventeenth-century Dutch painting that he had long admired and taken as a model in his youth. At the same time he put his own particular imprint on that tradition. *The Trellis* is the largest and most ambitious of the Saintes flower paintings. Two-thirds of its area is taken up with a cornucopia of richly painted summer flowers, their petals all opened out toward the space of the viewer. Traveling by eye through this mass of finely articulated shape and color is an intensely pleasurable experience. Reversing the usual order that obtains between still life and the human figure, the painting is dominated by the floral profusion, while the young woman is off to one side. Her dark dress with its discreet small floral print pattern is a lightly ironic gloss on the tumbling mass of large living blossoms. The figure of the young woman herself, her slender youthfulness and good cheer unusual in the artist's repertory of female subjects, is a mark of the lightheartedness that he was permitted to experience in Saintes. The painting was widely admired when it was shown in the exhibition that Courbet and his local friends organized in Saintes in January of 1863.

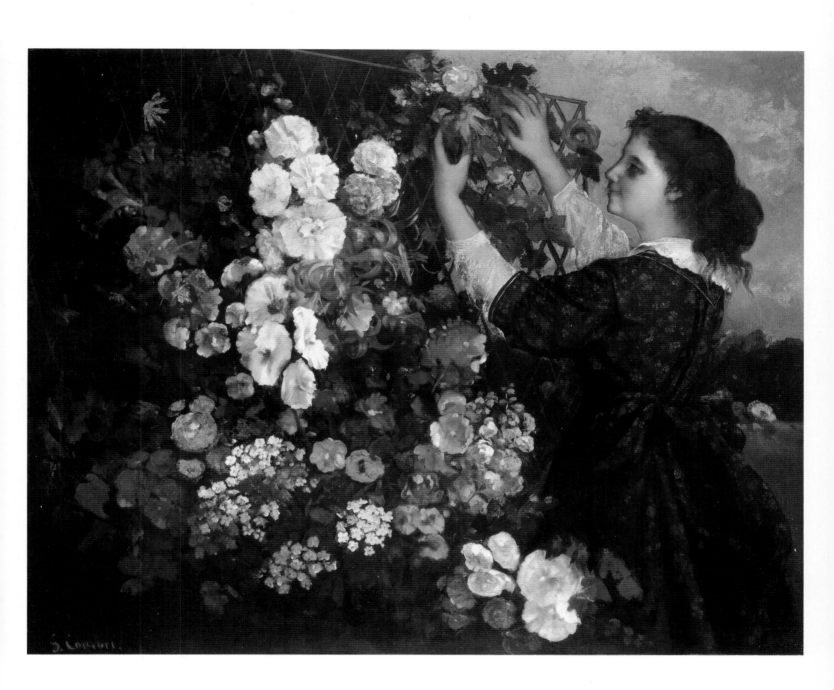

23. BASKET OF FLOWERS

1863. Oil on canvas, 28¾ × 42⅞" (73 × 109 cm).
Kunsthalle, Bremen

This magnificently painted bouquet forms a kind of *pendant* to the *Flowers in a Basket* in Glasgow, a work of almost exactly the same dimensions. Both were painted in the Saintonge, under the beneficent influence of the artist's patron and host Etienne Baudry. The gardens at Rochemont provided the artist with a whole range of flowers, unfamiliar in the Franche-Comté, to study and enjoy, and the hothouses enabled him to combine blossoms from different stages of the season, such as early magnolias and later-blooming daylilies. Such a profusion of models, together with his own powerful visual memory, would have enabled Courbet to combine flowers as he pleased. This type of grand floral painting did not depend, any more than it had in the Dutch tradition, on the transcription of a specific "arrangement." The question of a possible allegorial or symbolic intention in Courbet's Saintonge flower paintings cannot be answered in relation to the paintings of Bremen and Glasgow; but it is known that in two other small paintings he did, by inscribing a verse on the back of the canvas, the works enter the realm of symbolism. These two works, one of them a *Still Life with Poppies and Skull*, were made specifically for Baudry's friend Phoedora Gaudin. Gaudin was a local lawyer and Republican politician sufficiently activist to have been forced into political retirement by the Imperial government the very year of Courbet's visit to Saintes. The artist would inevitably find such a figure sympathetic and would have gladly indulged his new friend's interest in the symbolism of flowers. As for *Flowers*, it is a painting whose sheer beauty—of touch, of color, of evocation of the vitality of these brilliant works of nature—requires no alternative or concurrent reading.

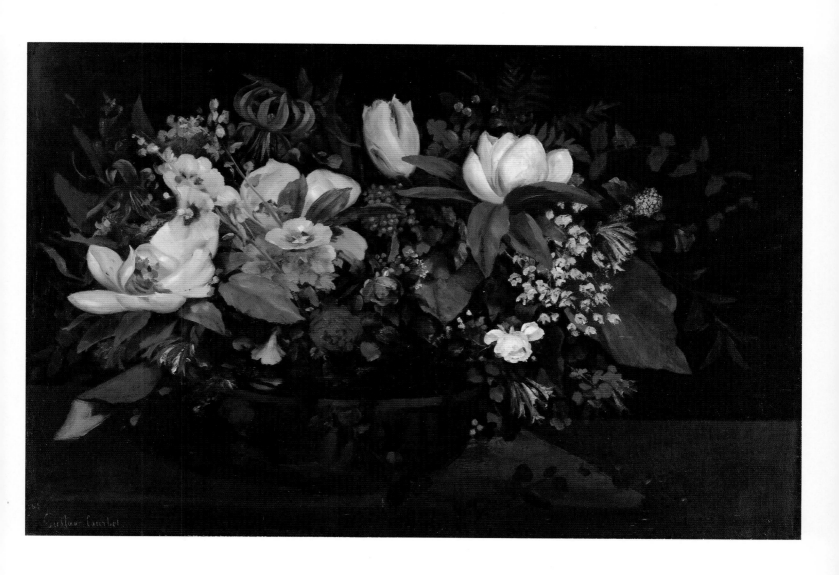

24. ROCKS AT MOUTHIER

Early 1860s. Oil on canvas, 30½ × 46⅛" (77 × 117 cm).
The Phillips Collection, Washington, D.C.

This painting is a simple and powerful statement of one of Courbet's recurrent landscape themes, that of the high steep cliff structure of the region around Ornans. Like Cézanne's Mont Ste. Victoire, the cliffs of the Doubs region had an ancient existence in fact, but only became a part of the visual imagination of the culture through the work of the artist. As a painter of landscape in his time Courbet took on the burden of choice; it was up to him to decide where he would focus his gaze and in what way he would compose the elements on the surface of the canvas. He was drawn to these rock formations for a number of reasons. It was among them that he had grown up, played, walked, and hunted from his earliest years. As he matured and became aware of the history of his own region, Courbet saw them increasingly as symbols of its rugged strength and fortress-like independence, the very qualities that he was absorbing into the concept of his own role as an artist. The endless variety of their chalky surfaces, the way they revealed the cuts and scumbles of historical time, were a stimulus to the invention of new techniques of paint application with which to build a pictorial equivalent of their fractured mass. Petra Chu has documented further sources of Courbet's interest in these ancient geological structures, which were the subject of scientific study at the time by local friends and colleagues. Chu argues convincingly that Courbet's paintings of rocky caves and cliffs reveal his profound awareness of their long history and the way in which time has shaped the landscape. This evolutionary understanding of the land, emerging in the later eighteenth century and gradually becoming established among men of learning in the early nineteenth, formed the basis of the science of geology and in turn for the later development of Darwinian theory. Courbet was no scientist, but he had a natural affinity for these ideas because of their application to his beloved cliffs and because they provided a philosophical underpinning for his own deep attachment to the local landscape. In his early paintings, he takes a more panoramic view; *Rocks at Mouthier* is characteristic of his mature work in that the motif, regardless of the space depicted, is brought close to the picture plane. This intense awareness of presence derives from the way in which the paint is handled and by means of the remarkable composition, in which the looming cliffs are made to nearly squeeze the sky out of the upper right edge of the canvas. The site has been identified as that of the Rochers de Hautepierre, behind the village of Mouthier-Haute-Pierre, about ten miles to the southeast of Ornans.

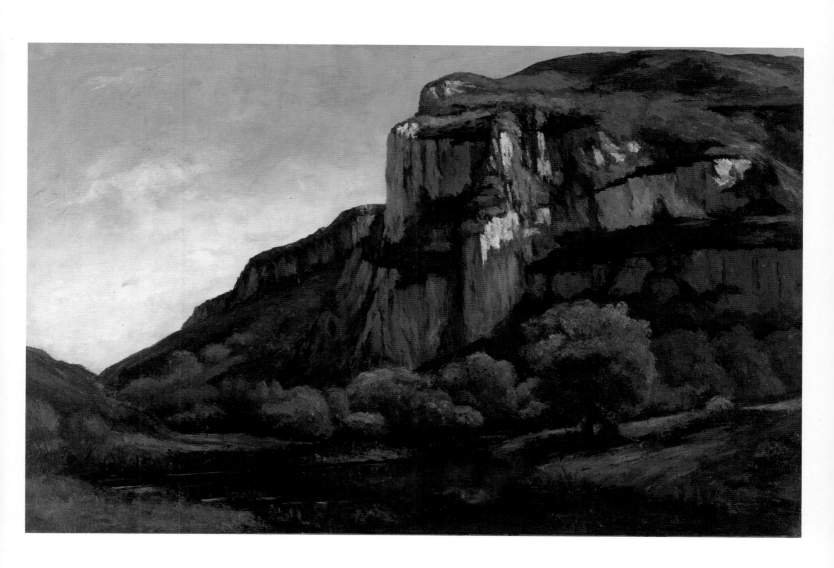

25. THE OAK AT FLAGEY, KNOWN AS THE OAK OF VERCINGETORIX

1864. Oil on canvas, 35 × 43⅜" (89 × 111.1 cm).
Murauchi Art Museum, Tokyo

In this painting of the giant oak near his father's native village of Flagey near Ornans, Courbet makes use of every device to convey the sense of the strength and massiveness of the great tree. Rooted in the absolute center of the canvas, the thick gnarled trunk moves up and out into a maze of leafy branches, whose thick foliage covers the upper two-thirds of the pictorial field with a mass of active brushstrokes that are cut off by three sides of the canvas. The ancient, still growing tree pushes way beyond the borders of the painting. Thick, dark, brooding, and powerful, this is visibly not an Impressionist tree: its meaning does not lie in dappled light or in the civilized pleasures one might enjoy beneath it. The painting has been interpreted as a self-portrait, and this is not unreasonable, given the significance of the tree and Courbet's capacity for psychic identification with the objects that he painted. The oak tree had an intrinsic symbolism of long duration in transalpine European culture: it is the tree of the Druids, of the ancient pre-Roman past. The reference to Vercingetorix in the title brings this symbolism to a specific focus on the culture of the Gauls, whose leader he was. The idea of the Gauls as being the true ancestors of the French people emerged during the course of the 1789 Revolution. They were constructed as the Ur-population, *le vrai peuple* repressed by Romans and later by the Frankish founders of feudal aristocracy, finally in the modern world rising to throw off the yoke of servitude. Vercingetorix became a popular hero, the brave warrior who fought Caesar's great armies and was finally defeated in A.D. 52 at the battle of Alesia. Around the time this painting was made, there was a controversy, archaeological with strong political overtones, in which the location of the site of the ancient battle was disputed. One possible site was in the neighboring Côte d'Or; the other was near the village of Alaise, close by Flagey, where Courbet's father was born. Courbet's subtitle mentions not only Vercingetorix but "Caesar's camp near Alesia, Franche-Comté." Local feeling ran high in favor of the Franche-Comté site, the more so as Napoleon III, author of a study of Julius Caesar, was in favor of the Côte d'Or location. The latter won, but *The Oak of Vercingetorix* remains. It is characteristic of Courbet that he entered this controversy, and that he did so not by falling into the literalism of illustrating the historical past but by portraying a great and ancient tree.

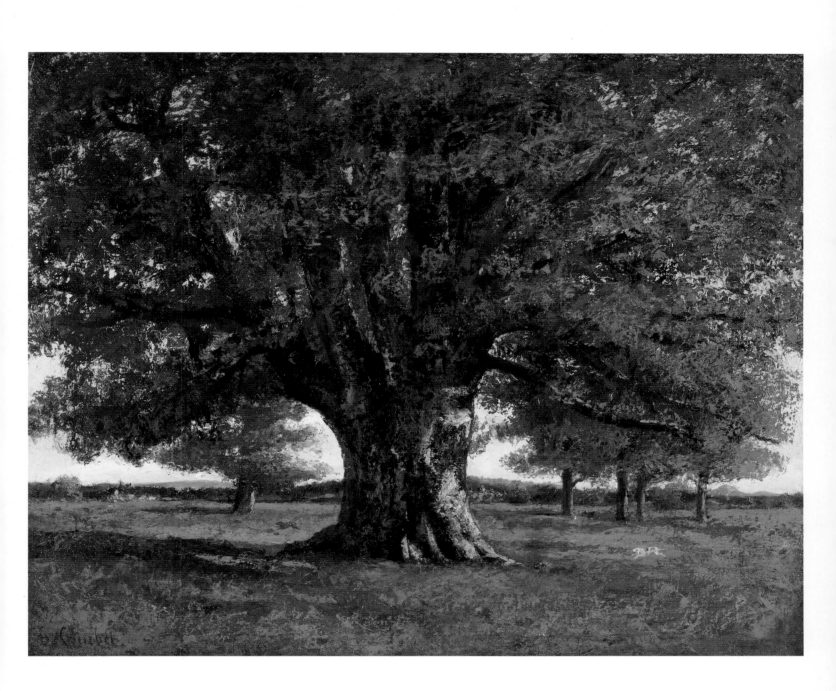

26. THE SOURCE OF THE LOUE

1864. Oil on canvas, 42¼ × 54⅛" (107.3 × 137.5 cm).
The Albright-Knox Art Gallery, Buffalo. George B. and Jenny R. Mathews Fund, 1959

One of the noteworthy geological features of the region of the Doubs, located in the eastern part of the Franche-Comté close to Switzerland, is the occurrence of underground streams, formed by the porous limestone of the Jura plateau, which then rise through the rock to form the rivers of the area. Some of these streams, like that of the Lizon, emerge from a high ledge, creating one of the several waterfalls in the region. Others flow out from deep caves in the limestone rock. The beautifully clear small Loue River that runs through Courbet's town of Ornans is one of the latter. It emerges from an opening in the heavy rock in the initial form of a still pool, which abruptly becomes a rapid before settling down into the swift but quiet waterway seen under the bridges of Ornans. Courbet spent most of 1864 in the Doubs region, either in Ornans or staying with his friend, the poet Max Buchon, in nearby Salins. One of the landscape sites he focused on with particular intensity during this year was the source of the Loue. Characteristically, he chose not to see it from the picturesque distance, which would include the full shape of the cliff, the surrounding trees, and a stretch of the foamy water. Instead he moves in so as to give us the impression of being at the point of falling in. We are brought close enough to the cave opening to experience palpably its dark mysteriousness. The looming rocks are painted in a building up of rough planes of color that convey an immense material presence, while at the same time calling to mind Cézanne's "building blocks" of color. The sense of fascination conveyed by this close-up view of the source is borne out in the fact that Courbet painted at least three other known versions of the theme, each with slight variations, but all of them fully realized works of art. In them Courbet's attraction to dark, enclosed spaces, also seen in the paintings of *The Stream of the Black Well*, is given a specifically sexual inflection. These dark openings, from which waters pour out, are clear metaphors of female sexuality, derived, like the motif of wavy flowing hair, from the depths of natural processes. Courbet's paintings of buxom unidealized women placed near forest pools, one of which has the title *The Source* (fig. 41), were one way of resisting the classical authoritarianism of Ingres's famous painting of that name; but it is in these landscapes, these actual sources which are part of an entire natural system, that the painter has found the most serious and convincing "real allegory." By painting the theme of the source in the way that he has done, Courbet has constructed a metaphor in which female sexuality is seen in terms not of male fear or ideality but in terms of natural process, identified with the forces of the earth.

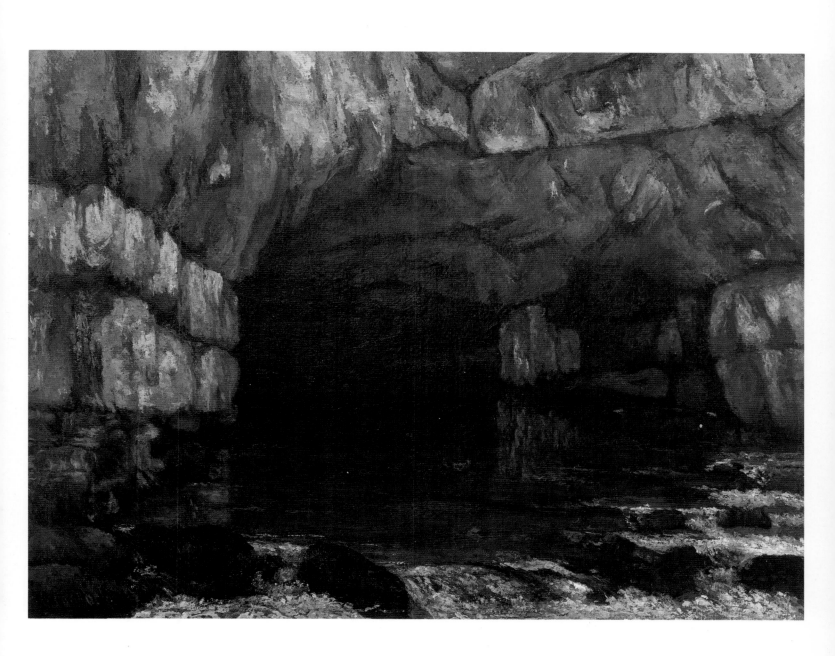

27. HUNTER ON HORSEBACK, RECOVERING THE TRAIL

1864. Oil on canvas, 46⅞ × 38" (119.4 × 95.3 cm). Yale University Art Gallery, New Haven.
Gift of J. Watson Webb and Electra Havemeyer

Like *The Woman in a Podoscaphe* (plate 29), *Hunter on Horseback* is not a finished painting—despite its size Courbet listed it under "studies and sketches" in the catalogue of his 1867 exhibition—but it is a complete and striking image. Both works represent pictorial ideas that only Courbet would have conceived: the modern Venus, discarding the suave femininity of Neoclassicism to conquer the sea under her own steam; and in a minor key, the male hunter, no victor with his trophy but a man unsure of his way, a man who does not control his animal but is fused with him and depends upon him to find the path. Both paintings run counter to the active stylistic and gender conventions of Courbet's time; and in our own day they have not lost the power to critique the stereotypes that yet remain. In *Hunter on Horseback*, the stark triangular form of the man/horse is centrally placed so as to fill the whole field of the snowy, mountainous landscape. The fact that the pigments have darkened and sunk into the canvas in the lower part of the man's body blurs the distinction between man and horse. But even without this fortuitous effect, the two would be seen as essentially part of one overarching shape, in effect as one creature. The man is identified with the animal, who is helping him to recover his way. This is a country hunter, in soft hat and old clothes, far from the decorative splendor of the hunt undertaken as aristocratic sport. The figure of the horseman is generally accepted as a self-portrait, akin to that of the meditative central figure in *The Quarry* (plate 19). The twist of the body with the hand placed affectionately on the horse's flank, the angle of the head with its gaze of poignant melancholy, combine to produce an image that shows an aspect of the artist's psyche quite at odds with the boisterous stereotype created by critics and caricaturists. In his early self-portraits Courbet presented his youthful self in different roles, such as a musician or as a personification of panic. In his maturity the self-image ceases to be a type and becomes instead his own figure as "real allegory" embodying complex meanings. When he appears as a painter, as in *The Meeting* (plate 14) and *The Painter's Studio* (plate 16), the image is one of power and confidence in the importance of the kind of art he is making. The hunt paintings introduce an ambivalence born of the tension between grandeur and violence implicit in the act of hunting and killing animals that are respected and admired. Depicted in the paintings, Courbet as hunter is a figure of introspection, uncertainty, and self-doubt—experiences which he did not show directly to the world. This does not mean that he was simply confident about his art and equivocal about hunting, but rather that the hunter image itself provided a means of figuring these darker, troubled feelings. In *Hunter on Horseback* the touches of red paint on the white make it clear that the lost way will be recovered through a trail of blood; the painter/hunter both accepts and mourns the fatality of nature.

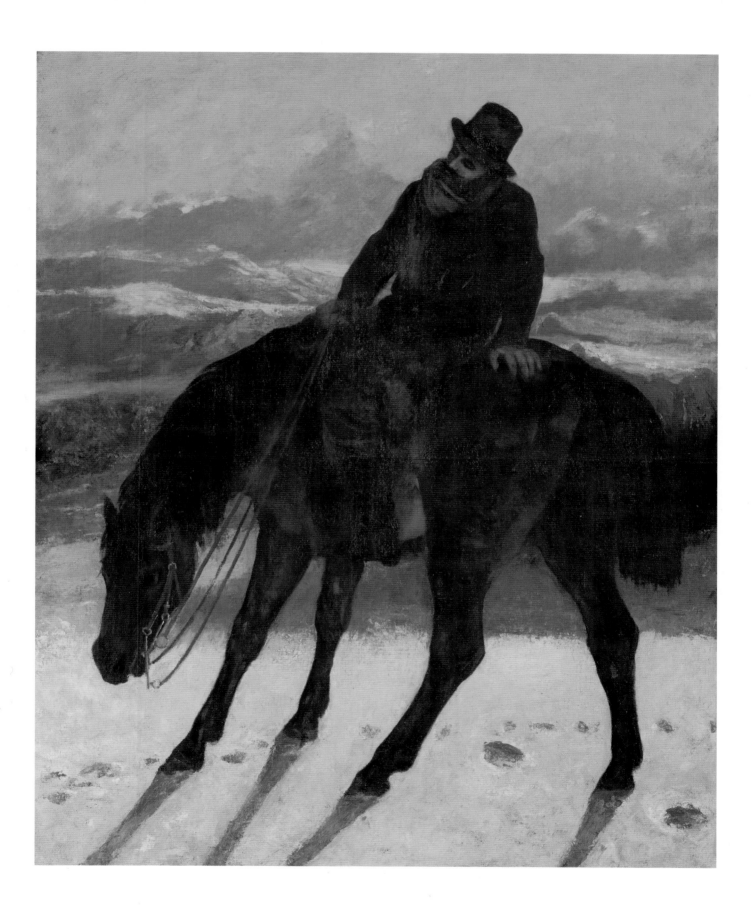

28. PORTRAIT OF P.-J. PROUDHON IN 1853

1865. Oil on canvas, 58 × 78" (147 × 198 cm).
Musée du Petit Palais, Paris

The death in January 1865 of the Socialist philosopher Proudhon moved Courbet to begin a painting in tribute to this fellow Franche-Comtois whom he had known and admired since his late twenties. To a mutual friend he wrote, "The nineteenth century has just lost its pilot and the man it has produced"—meaning its ideal man, its representative man. Proudhon's philosophy of democracy and human progress, developed out of the theories of Charles Fourier (himself a native of Besançon) and Saint Simon, were very important for the young Courbet in enabling him to work out a rationale for what he believed art should be and how it should relate to the life of its own time. Proudhon's anti-authoritarian and anti-clerical stance, together with the imprisonment and exile that he suffered as a result of his publications, aroused in Courbet the devotion of a disciple, which allowed him to overlook the writer's moralistic and indeed philistine views on art. Courbet had for many years wanted to paint a portrait of Proudhon, but the philosopher was an elusive and unwilling sitter. Thus he had to write from Ornans to his friend Castagnary in Paris, asking him to send him the photographs that had been made by Carjat and Reutlinger to use as models. In the letter he expressed his ambition to make a kind of monument for his mentor, so that "all that life of work, of probity and of luminous thought will finally emerge in all its brilliance in the midst of the shadows that surround us, the end of the nineteenth century will have its beacon which will rise above the crowds . . ." Behind the rather grandiose language lay the genuine intention to make an important painting in the tradition of the "real allegory," which like *The Meeting* and *The Painter's Studio* would use actual persons known to the artist to embody a whole cluster of ideas. The life-sized figure is presented in a domestic setting, seated on the back steps of his modest house, accompanied by his two daughters. His workman's tunic and soft hat, together with his books and writing materials and his thoughtful gaze, are the signs of his character: the working-class artisan turned intellectual. Though Courbet's family was a generation ahead of Proudhon's in terms of class development, they were close enough so that the artist felt the identity, which was in turn that of the emerging class whom he had given artistic existence in his paintings of the fifties. The intellectual portrayed here is not of the bohemian variety, but is rather the *père de famille*. His two small daughters are shown playing with the opposing elements of their future: one with the alphabet, the other with teacups and pitcher. They are constructed in a way remarkably similar to that of Géricault's portrait of Louise Vernet: large heads on stubby bodies, capable of a disquieting concentration. The absent wife/mother is figured by the sewing basket and pile of linen on the empty chair. The painting as it was shown at the Salon of 1865 included the figure of Madame Proudhon, seated on the chair and obviously pregnant. Among other changes Courbet subsequently made to the painting was the removal of this figure, apparently in response to objections made by the widow herself. In either stage, whether the wife is depicted in the background entirely in terms of childbearing, or is completely absent from the picture, Courbet invented an accurate image of Proudhon's harshly patriarchal view of women. On the top step at the left is clearly inscribed "P.J.P./1853." Courbet may have chosen that year for at least two reasons: it was the year when one of Proudhon's important books, *La philosophie du progrès*, was published (and banned); and it was a moment of domestic pride and contentment, with two children living and another on the way. The following year the middle child, shown playing with her cups, died of cholera.

29. THE WOMAN IN A PODOSCAPHE

1865. Oil on canvas, 67¼ × 82⅛" (170.8 × 208.6 cm).
Murauchi Art Museum, Tokyo

By 1865, the first summer that Courbet spent at Trouville, the harbor town and its close neighbor Deauville had become fashionable resorts for a Parisian and international clientele. Strolling and picnicking on the sands and even bathing in the sea had become stylish pastimes during the Second Empire; this was the life documented in the beach scenes by Courbet's older colleague Eugène Boudin. Sea bathing was still rather a decorous activity, however, and therefore the artist (and others) were much struck by the spectacle of a young woman who went out into the waves by herself, clothed only in a simple sleeveless shift and with her long hair blowing in the wind, propelling a kind of catamaran structure she called a "*podoscafe*." Courbet referred to her as the *Amphitrite moderne*, and set about making a large painting of her. Though it was never shown at the Salon, the ambitious scale of the work leads one to believe that it was originally conceived as a Salon painting. It was characteristic of Courbet to seize upon such a subject, unmistakably modern yet with classical overtones: a modern Venus not rising from the sea but dominating it. It is even possible that he might have initially conceived the painting as a kind of challenge or reproof to the trite pandering of Cabanel's *Birth of Venus*, shown at the Salon of 1863. This female figure is certainly not presented in terms of sexual passivity, but of independence and prowess. She fills the pictorial field, brought as close to the viewer as she can be without having her interesting vessel and her long, double-ended oar cut off by the edge of the painting. Her position on the structure is easy and confident. (Doubtless, it was quite impossible in actual fact without a harness of some kind, but she posed for him on land and Courbet was not concerned with literalism.) The loose, flowing hair, always so attractive to Courbet, was at the time a conventional signal of sexual availability, but seems here rather to rhyme with the waves through which this sea nymph plies her craft. The surface of the painting was not completely finished, and this fact together with restorations undergone sometime in this century, contributes to the unusual flatness of the figure. Nonetheless her conception and her placement in the vast space of the sea make this an unforgettable image, one that only Courbet would have had the bold naiveté to create.

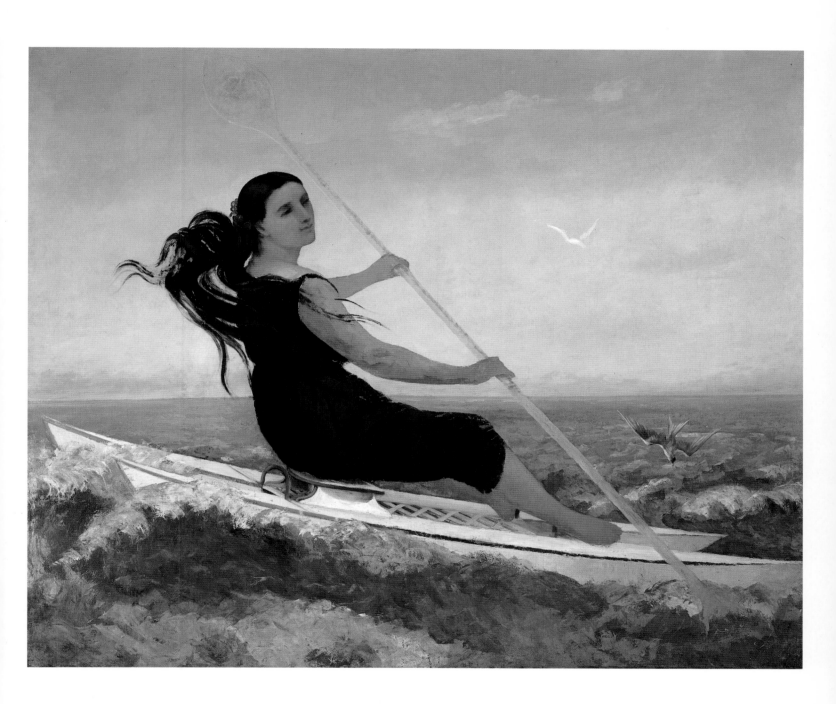

30. THE GIRL WITH SEAGULLS, TROUVILLE

1865. Oil on canvas, 31¾ × 25½" (81 × 65 cm).
Private collection

Like the *Woman in a Podoscaphe*, this painting was a "portrait" originating not in a commission from a vacationer but initiated by the painter himself as a result of his observations of the life of the year-round residents of the harbor resort. In it are combined in an extraordinary and unsettling way two of Courbet's obsessive themes: a woman's long wavy hair and the natural pelt of a wild creature, in this case the feathers of a trio of seagulls. Both themes here provide a bravura feast of painting: the thick, ruddy blonde curves of the girl's *chevelure* juxtaposed with the beautifully painted birds, their enormous range of subtly perceived tones of gray running between the white of their breasts and the black of their beaks. Courbet is clearly as fascinated by the plumage of these sea birds as he is by the more familiar fur of the fox and the coat of the deer. In this painting, as opposed to the paintings of the hunt, he has been given the welcome opportunity to put together the wild plumage of dead birds with the live, natural growth of a healthy young woman. The image is masterfully composed, the figure thrust right up against the picture plane and seen almost from the rear so that her burden becomes intensely close to the viewer. She is also nearly crowded into the right-hand side of the picture. This sense of powerful bulk on the right-hand two-thirds of the painting is dramatically in contrast to the left-hand side, where sand, sea, and sky provide a view of vast open space, a seascape in itself. The line of the pole articulates a corner into which the girl's face is fitted, turned to look over her shoulder in a cool and somewhat shuttered way. This geometric straight line rhymes and contrasts with the long organic lines of the dead birds' wings. The grouping of gulls is the emotional as well as physical focus of the painting. Heads and breasts converge at the center, two of the heads tenderly placed, as if grooming, on the outstretched breast of the third. From this center a vertical mass of wings rises to the pole, and from it radiate the sharp, angular forms of wings and tails, slicing through the space like knives.

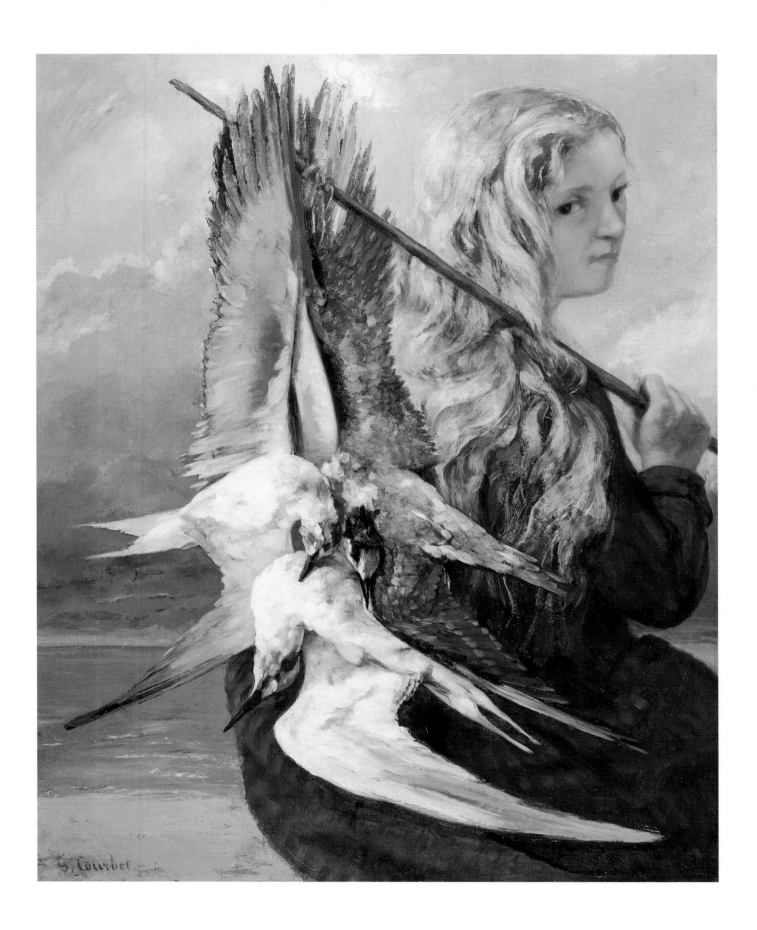

31. PORTRAIT OF JO, THE BEAUTIFUL IRISH GIRL

1865. Oil on canvas, 22 × 26" (55.9 × 66 cm). The Metropolitan Museum of Art, New York.
Bequest of Mrs. H. O. Havemeyer, 1929. The H. O. Havemeyer Collection

The model for this painting was Jo Heffernan, the "belle irlandaise" who was the model and mistress of Whistler in the 1860s. Courbet knew them both in Paris, but it was at Trouville, where Whistler and Jo were also staying, that he began this painting. Eventually he made four versions of the subject. Whistler's paintings modeled on Jo, such as *Symphony in White No. 1: the White Girl*, portray her as tall, slender, and ethereal; for Courbet she is broad and solid, and her hair is not merely long in a girlish, Pre-Raphaelite way, as in the Whistler, but is a mighty force, close to being the main subject of the painting. Courbet here transforms a traditional *Vanitas* theme that he had himself treated only a few years before in a more traditional way, in a *Lady with a Mirror* (now in Basel), in which the lady's décolletage and her self-satisfied smile are elements totally missing here. In this painting we are confronted—head on and up front—with a woman who is both beautiful and anxious. Her superb, vitally curling, copper-red hair cascades down over her shoulders and onto the dresser top; in a direct analogy with the flow of water, these tresses look as though they are still in the process of emergence, of moving and flowing even as we watch, as would falling water. Short tendrils fly up from her crown and over her brow. She lifts a handful of hair in her right hand, but hardly disturbs the thickness of the descending canopy. This living mass of hair, in action so like the rush of waters in the rising streams of Courbet's native countryside, becomes a powerful metaphor of female sexuality. In the art of his contemporaries, the Pre-Raphaelites, and of the later Symbolists this image of long thick women's hair was imbued with the idea of seductive danger and evil; for Courbet the link is with the natural landscape, for him the profoundest source of good. But if the hair is an image of female sexual energy, the face is inflected with uncertainty, figured in the tightening of the brow, the beginnings of a frown. Jo is not admiring her image, but questioning it. This mix of healthy eroticism and self-doubt is an important source of the painting's continuing fascination. Courbet was sufficiently attached to the image to have made three other versions and to have kept one of them all his life. It is difficult to know, based on the early documents in which distinctions are not made, which may be the original version. All four were shown together for the first time in the 1988 exhibition at The Brooklyn Museum. My choice, based on a comparative examination at that time, is the painting shown here, in part because it has a greater sense of completeness, especially in the hair and in the rendering of the lacy blouse. One also feels more of the tension in the face. Finally, the locks of hair falling over the dresser are full here, and more sketchily rendered in the other three versions.

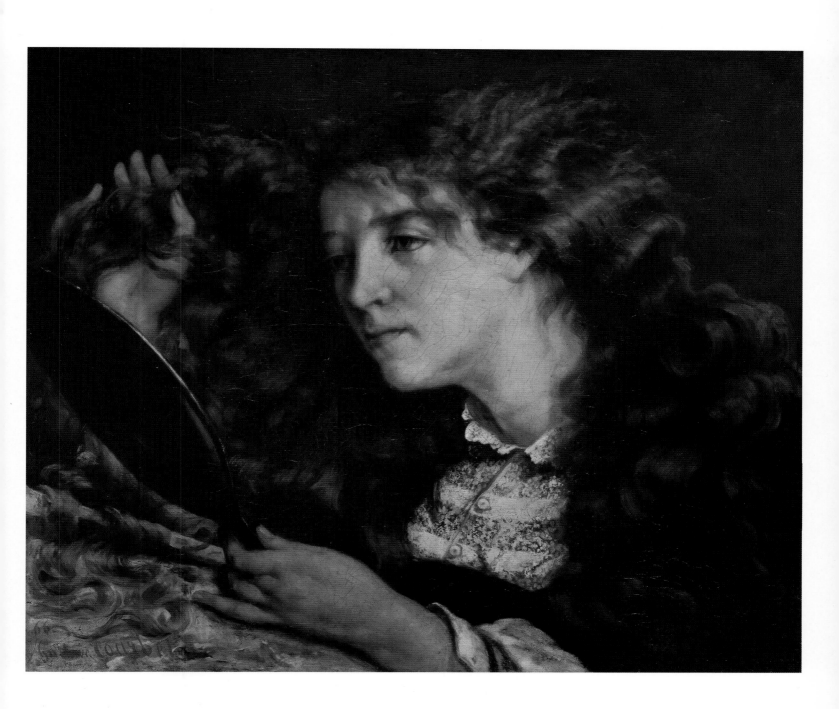

32. MARINE

1865 or 1866. Oil on canvas, 19¾ × 24" (50 × 61 cm).
The Norton Simon Foundation, Pasadena

Courbet was delighted with the society at Trouville, and at neighboring Deauville, where in 1866 he stayed with the Count de Choiseul. But although some members of the resort population are represented in his commissioned portraits, the summer public as a whole did not find its way into his paintings of the sea and shore. Almost without exception his seascapes are unpopulated, except by an occasional boat abandoned on the sand or sailing far away on the horizon. When he looked, as a relative newcomer to the painting of seascape, to the work of Boudin, he paid attention to the low horizons and the wide high skies rather than to the sociably grouped little figures along the shore. He was moved by the vast expanses of sea and sky and by the shifting, subtle luminosity of the Channel coast. This experience is at its most intense on this particular stretch of coast when the tide is low. The beach is very flat for a long way out, so that at low tide there is an expanse of wet, light-reflecting sand that merges into the line of the sea, and at certain times a wide stretch of very shallow water. The relations of color and tone between the three elements of earth, sea, and sky are close and constantly shifting. Courbet focused on this experience and made it the subject of one whole group of his Trouville seascapes, the Low Tides. In response to the experience he lightened his palette and worked directly with lighter pigments, rather than building up to light from dark, which had been his lifelong method. The painting shown here is one of the most brilliant of the series. The richly varied, dragged color defines the damp sand with its tidal pools, the mid-distant expanse of pale green shallow water moving to deep blue at the horizon, and the wide sky in which heavy white clouds filter the rays of a late sun. At the same time the tonal and coloristic play of the pigments create a structure of pure luminosity on the surface of the canvas. For the viewer, these two experiences of depth and surface are inextricable from one another. The result is an excellent example of how a painted surface that can be seen purely coloristically and tonally all on one plane can also convey, paradoxically, a vast depth of space. These Low Tide canvases are thus remarkably akin to later Impressionist painting, in particular that of Monet at Giverny, in that they convey an immediate visual response to a specific place and at the same time construct a web of paint that can be experienced for its own sake.

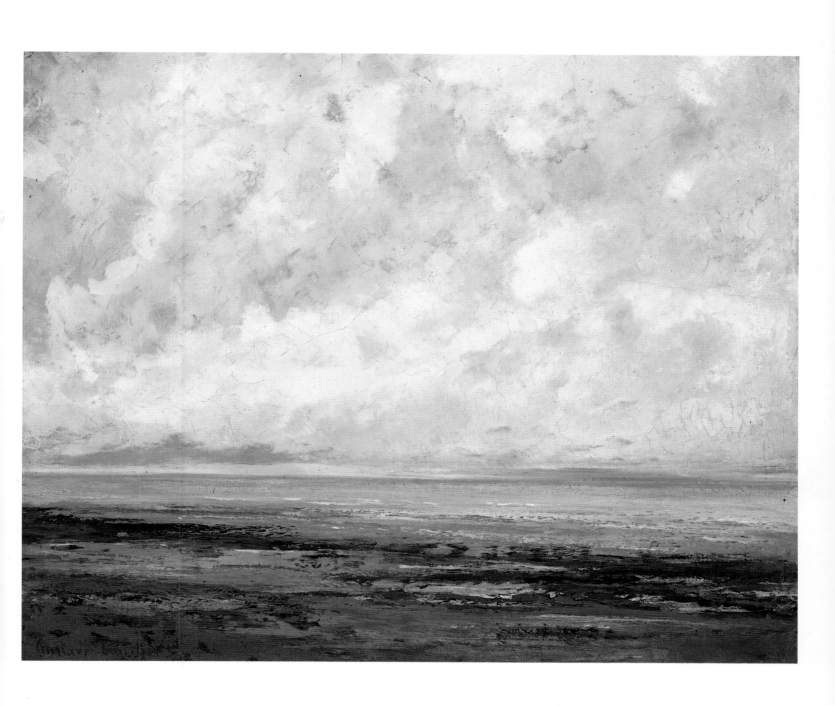

33. THE WAVE

*1869 (signed 1870). Oil on canvas, 44⅛ × 56¾″ (112 × 144 cm).
Nationalgalerie, Berlin*

A stay in the summer of 1869 at Etretat, on a different and more rocky part of the Channel coast to the northeast across the Seine estuary, engendered a series of paintings of the sea which differed greatly in mood and style from the Low Tide series made at Trouville. These are images of storm and tumult, in which the billowing, rising waves and the thick dark clouds above them seem to be made of the same solid, roiling material. Deep space is conveyed here by the narrow band of light beneath the clouds that allows a glimpse of tiny, faraway boats on the horizon, but the main effect of the painting is to create a sense of being virtually pursued and overwhelmed by these threatening clouds and these foaming waves. As Courbet had invented a whole vocabulary of touch in his landscapes, using the palette knife and other tools to construct the chalky fractured surfaces of rocks and the lush or dry foliage of the trees, so he adapted these methods to the paintings of the stormy sea. Here the paint is built up with myriad short strong strokes, with a basic color structure of grayed greens and blue-violets, whose pigmentation ranges through an extraordinary number of tones. The way in which the whites are applied, now solid, now transparent, always in motion between the two, conveys a vivid sense of the boiling foam in the same moment that it speaks of the activity of pure paint. This painting and the closely related *Stormy Sea* at the Musée d'Orsay in Paris are the strongest works of this series. They are not plein air paintings—their size alone would tell us that, apart from the fact that storms are not painted out of doors. Even more significant is the close relationship of the wave structure in the two works. These paintings are not studies of individual waves, nor descriptions of phenomena in their particularity. They are born of the experience of a violent coastal storm, yet they are meditations on the unleashing of immense natural force.

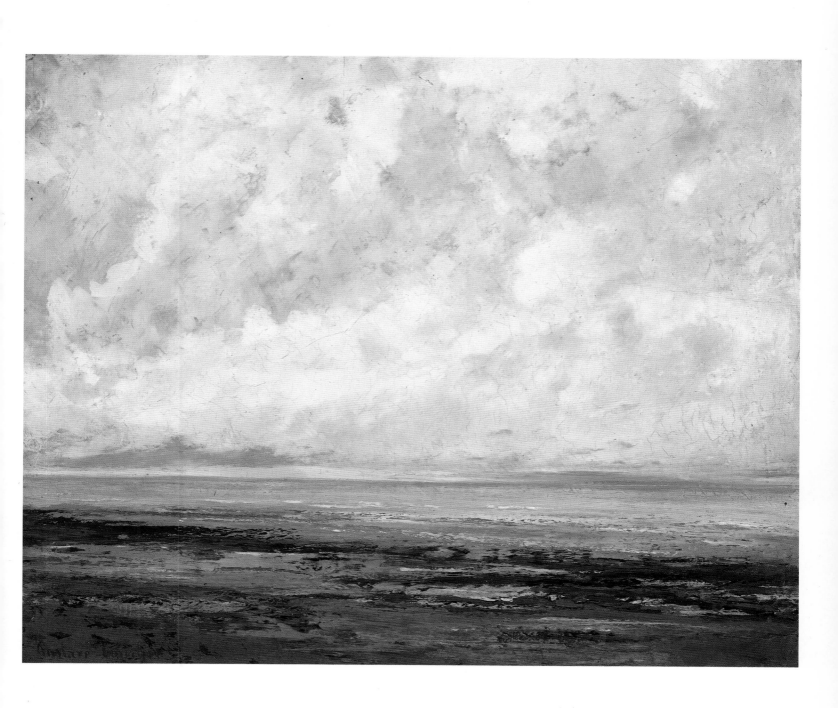

33. THE WAVE

*1869 (signed 1870). Oil on canvas, 44⅛ × 56¾" (112 × 144 cm).
Nationalgalerie, Berlin*

A stay in the summer of 1869 at Etretat, on a different and more rocky part of the Channel coast to the northeast across the Seine estuary, engendered a series of paintings of the sea which differed greatly in mood and style from the Low Tide series made at Trouville. These are images of storm and tumult, in which the billowing, rising waves and the thick dark clouds above them seem to be made of the same solid, roiling material. Deep space is conveyed here by the narrow band of light beneath the clouds that allows a glimpse of tiny, faraway boats on the horizon, but the main effect of the painting is to create a sense of being virtually pursued and overwhelmed by these threatening clouds and these foaming waves. As Courbet had invented a whole vocabulary of touch in his landscapes, using the palette knife and other tools to construct the chalky fractured surfaces of rocks and the lush or dry foliage of the trees, so he adapted these methods to the paintings of the stormy sea. Here the paint is built up with myriad short strong strokes, with a basic color structure of grayed greens and blue-violets, whose pigmentation ranges through an extraordinary number of tones. The way in which the whites are applied, now solid, now transparent, always in motion between the two, conveys a vivid sense of the boiling foam in the same moment that it speaks of the activity of pure paint. This painting and the closely related *Stormy Sea* at the Musée d'Orsay in Paris are the strongest works of this series. They are not plein air paintings—their size alone would tell us that, apart from the fact that storms are not painted out of doors. Even more significant is the close relationship of the wave structure in the two works. These paintings are not studies of individual waves, nor descriptions of phenomena in their particularity. They are born of the experience of a violent coastal storm, yet they are meditations on the unleashing of immense natural force.

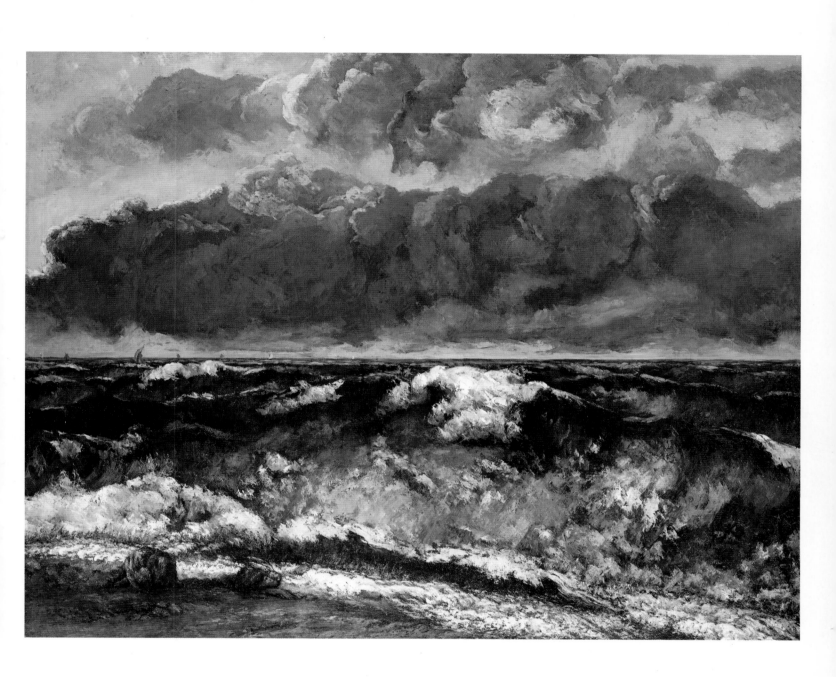

34. THE SHADED STREAM (THE STREAM OF THE PUITS NOIR)

1865. Oil on canvas, 37 × 53¼" (94 × 135 cm).
Musée d'Orsay, Paris

Le Puits Noir is a place in the forest near Ornans where the little Brême River flows between high rocks from whose cracks grow luxuriant vegetation, forming a kind of high canopy over the quiet pool in the river. It is a place of enclosure and secrecy, filled with the rocks, foliage, and water for which Courbet loved to find painterly equivalents, and it was one of his favorite landscape motifs. In terms of the pictorial structures of his landscapes, Courbet was certainly not part of the tradition of the picturesque, with its focus on landscape motifs that were conceived of as being intrinsically pictorial. But the motifs to which he was drawn in his native region were not anonymous corners; rather they were natural features such as specific rock formations, river sources, and hidden glades. These places were already well enough known to the local people to have acquired such names as Le Puits Noir, or The Black Well. What Courbet did, like other landscape painters of the nineteenth century, was to represent these sites in sufficiently powerful pictorial form that they acquired a new kind of existence in the visual imagination of the culture. Part of the force of Courbet's paintings comes from the metaphoric resonance with which he imbues specific landscape features. The fortresslike cliffs of the open highlands that the artist often chose to paint contrast sharply with the Puits Noir, a place of silence and seclusion in which secrecy and organic vitality combine to provide an analogue of sexual mystery. Courbet constructs the image in terms of a pure animation of pigment, just as foliage, dappled rock, and moving water are conjured up through an enormous variety of touches, scumbles, and strokes. It is a way of painting that produces a powerful paradox of solidity and verisimilitude coexisting with an overall network of purely painterly invention. The viewer is presented at the same time with the representation of an unmistakable place, a *there* in the world, and with a painting in which the processes of creation are open to view. This invitation to the viewer to participate imaginatively in the complex and varied manipulation of pigments that construct the painting is one of the earliest attributes of modernity. It is a way of painting that promises spontaneity and freshness of perception, and which in order to succeed demands that both these be genuinely present. These qualities are lost in followers and weakened by the pressure to paint to market demand. Understandably but perhaps unfortunately, the subject of the Puits Noir with its atmosphere of solitude and remoteness from urban cares became a popular one among collectors. Courbet, in fairly constant conflict with the juries of the Salon, looked increasingly to dealers, and through them to collectors, who ordered paintings by name and type, and this was a type they liked. In that period when the Salon system was dying and the dealer system being born, it was the artist and the art of painting that showed the strain. But when Courbet painted landscape at his best, as he very often did, he made a unique contribution both to the art of painting as such and to the repertory of those places that we can imaginatively enter through the art of landscape painting.

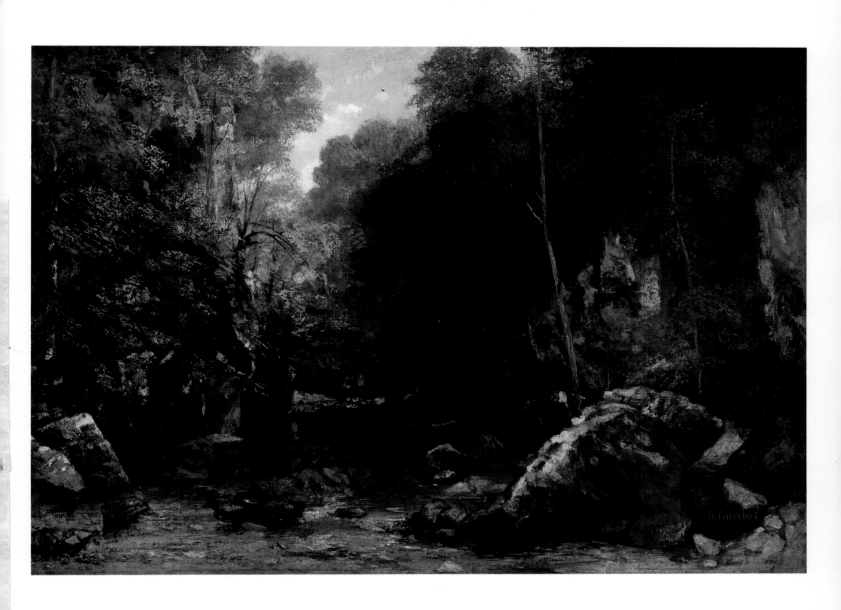

35. THE SHELTER OF THE ROE DEER AT THE STREAM OF PLAISIR-FONTAINE, DOUBS

1866. Oil on canvas, 68½ × 82¼" (174 × 209 cm).
Musée d'Orsay, Paris

During the course of the 1860s Courbet had achieved a particular reputation for his scenes of the hunt and of wild game. At the Salon of 1861 he had presented two works that were highly acclaimed, both drawn from his experience of stag hunting in the Black Forest in Germany: *The Stag at Bay* and *The Springtime Rut: Battle of the Stags* (fig. 39). Into the *Battle of the Stags* in particular he poured all of his admiration for the power and nobility of these great animals. The painting approached the scale of *A Burial at Ornans*, and indeed Courbet wrote of it to Francis Wey that "*Battle of the Stags* ought to have, in a different sense, the importance of *A Burial*." This massive image of fierce male struggle became, however, a source of great disappointment to the artist: despite critical acclaim and active interest in acquiring it for the State, the potential purchase and consequent prize was cancelled by Napoleon III. There was thus perhaps a certain irony involved in presenting to the Salon five years later a large (though not as large) painting on the theme of wild game that portrayed two gentle pairs of roe deer at their ease in a covert, or sheltered place, in the forest. Toussaint notes that when an acquaintance remarked that the "Members of the Institute" could not possibly see in the painting any kind of democratic manifesto, Courbet replied, "unless 'they' see in it a secret society of roe deer meeting in the woods to proclaim the Republic!" In fact the painting, immensely successful at the Salon, was already sold when the Minister of Fine Arts made his inquiries about a purchase. Together with *The Woman with a Parrot* (fig. 44), *The Shelter of the Roe Deer* made Courbet the surprising hero of the Salon. For the painter this inspired not gratitude but a sense of revenge taken, of having delivered to the authorities and establishment critics a "punch in the nose" (*coup de poing en pleine figure*). Avant-garde critics both at the time and today have seen this painting as a kind of sell-out to Second Empire taste, but this is to disregard both the complex politics of Courbet's relationship with the Salon, and the genuineness of his feeling for the theme. It is true that he made for the market too many reduced variations on the theme, which like the Puits Noir was much in demand. But that is a problem for connoisseurship, which cannot fail to recognize the quality of such paintings as this one. In characteristic fashion he has described in his title the specific location of the setting, near Ornans on a shaded tributary of the Brême not far from the Puits Noir. The painter evokes with great freshness the textures of rocks, trees, and water, the play of sunlight, and the atmosphere of silence. Into this natural habitat, their own living space, are delicately placed the four deer, the males alert, the females more relaxed. These creatures are not sentimentalized or made into toys; the painter simply shows us the facts of their grace and beauty. The image is one of nature in its own intrinsic dignity.

35. THE SHELTER OF THE ROE DEER AT THE STREAM OF PLAISIR-FONTAINE, DOUBS

1866. Oil on canvas, 68½ × 82¼" (174 × 209 cm).
Musée d'Orsay, Paris

During the course of the 1860s Courbet had achieved a particular reputation for his scenes of the hunt and of wild game. At the Salon of 1861 he had presented two works that were highly acclaimed, both drawn from his experience of stag hunting in the Black Forest in Germany: *The Stag at Bay* and *The Springtime Rut: Battle of the Stags* (fig. 39). Into the *Battle of the Stags* in particular he poured all of his admiration for the power and nobility of these great animals. The painting approached the scale of *A Burial at Ornans*, and indeed Courbet wrote of it to Francis Wey that "*Battle of the Stags* ought to have, in a different sense, the importance of *A Burial*." This massive image of fierce male struggle became, however, a source of great disappointment to the artist: despite critical acclaim and active interest in acquiring it for the State, the potential purchase and consequent prize was cancelled by Napoleon III. There was thus perhaps a certain irony involved in presenting to the Salon five years later a large (though not as large) painting on the theme of wild game that portrayed two gentle pairs of roe deer at their ease in a covert, or sheltered place, in the forest. Toussaint notes that when an acquaintance remarked that the "Members of the Institute" could not possibly see in the painting any kind of democratic manifesto, Courbet replied, "unless 'they' see in it a secret society of roe deer meeting in the woods to proclaim the Republic!" In fact the painting, immensely successful at the Salon, was already sold when the Minister of Fine Arts made his inquiries about a purchase. Together with *The Woman with a Parrot* (fig. 44), *The Shelter of the Roe Deer* made Courbet the surprising hero of the Salon. For the painter this inspired not gratitude but a sense of revenge taken, of having delivered to the authorities and establishment critics a "punch in the nose" (*coup de poing en pleine figure*). Avant-garde critics both at the time and today have seen this painting as a kind of sell-out to Second Empire taste, but this is to disregard both the complex politics of Courbet's relationship with the Salon, and the genuineness of his feeling for the theme. It is true that he made for the market too many reduced variations on the theme, which like the Puits Noir was much in demand. But that is a problem for connoisseurship, which cannot fail to recognize the quality of such paintings as this one. In characteristic fashion he has described in his title the specific location of the setting, near Ornans on a shaded tributary of the Brême not far from the Puits Noir. The painter evokes with great freshness the textures of rocks, trees, and water, the play of sunlight, and the atmosphere of silence. Into this natural habitat, their own living space, are delicately placed the four deer, the males alert, the females more relaxed. These creatures are not sentimentalized or made into toys; the painter simply shows us the facts of their grace and beauty. The image is one of nature in its own intrinsic dignity.

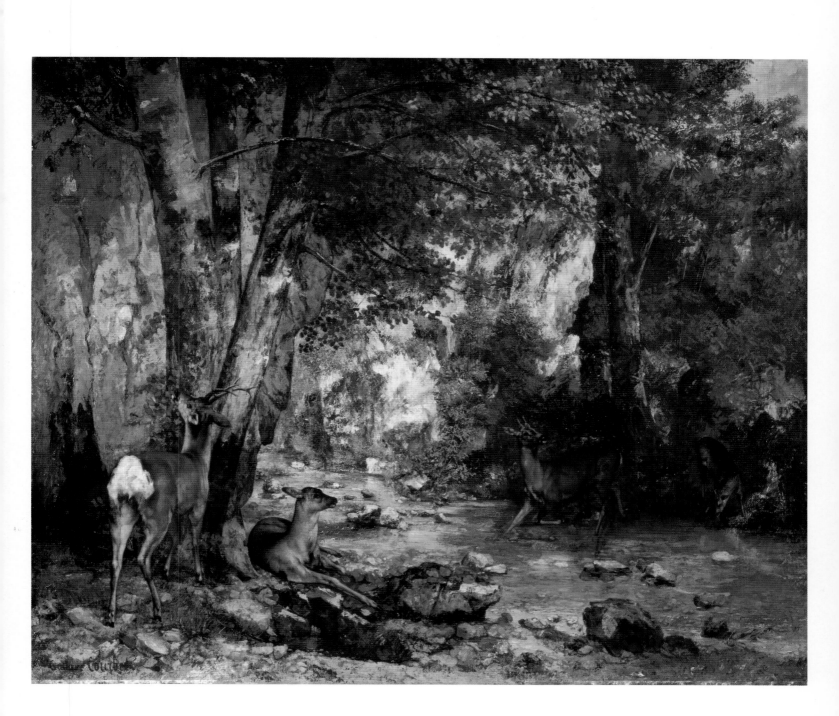

36. THE SLEEPERS, OR SLEEP

1866. Oil on canvas, 53⅛ × 78¾" (135 × 200 cm).
Musée du Petit Palais, Paris

This most sumptuous and magnificent of Courbet's painting of the nude was made not for the Salon public but for a private patron. Khalil Bey, former Turkish ambassador to the czar, had given up diplomacy for the life of a collector and bon vivant in Paris. He formed an important collection of contemporary French painting, which included the famous *Turkish Bath* by Ingres. Initially asked by Khalil Bey to paint for him another version of the *Venus and Psyche*, which had caused scandal by its refusal at the Salon of 1864, Courbet chose rather to paint an entirely new work, one in which the lesbian theme is not disguised by mythological narrative. The subject was far from unknown in nineteenth-century Paris, but it only existed in the form of popular prints and illustrations. Such a frank depiction of erotic connection between two women had not occurred in the tradition of high art before Courbet made this painting. As he had made paintings in the 1850s that raised provincial country people to the status of being serious subjects for artistic contemplation, so he took the opportunity to do the same thing for a kind of eroticism that conventional society did not wish to acknowledge and indeed condemned as wickedness. (When the painting was seen displayed in a dealer's window for sale in 1872, Khalil Bey by then having been financially ruined and forced to sell his collection, the police received a written denunciation of the artist's moral turpitude.) That Courbet also painted this theme for the delectation of its (male) owner is true; but that does not seem to alter the fact that he deliberately challenged cultural taboo by transforming a subject once confined to covert or vulgar imagery into a splendid work of art. The flesh is painted with a depth and resonance that makes it shine with life against the rich palette of whites and pale roses that make up the bedding. The white-on-white broken string of pearls is presumably a sign of headlong passion but it also joins the ornate matching decanter and goblet and the Sèvres flower vase as figures of Second Empire *grand luxe*. Indeed, one of the titles given to the painting at the time, *Paresse et Luxure*, attempted to divert moralistic attention from the sexual reality to the issue of self-indulgence. Perhaps the women too are portrayed here as objects of *grand luxe*, but if so they are not portrayed as having been fashioned by the hand of man, in questionable or any other kind of taste. Their bodies, and their bodies' capacities for feeling, are celebrated by this painter as gifts of the natural world.

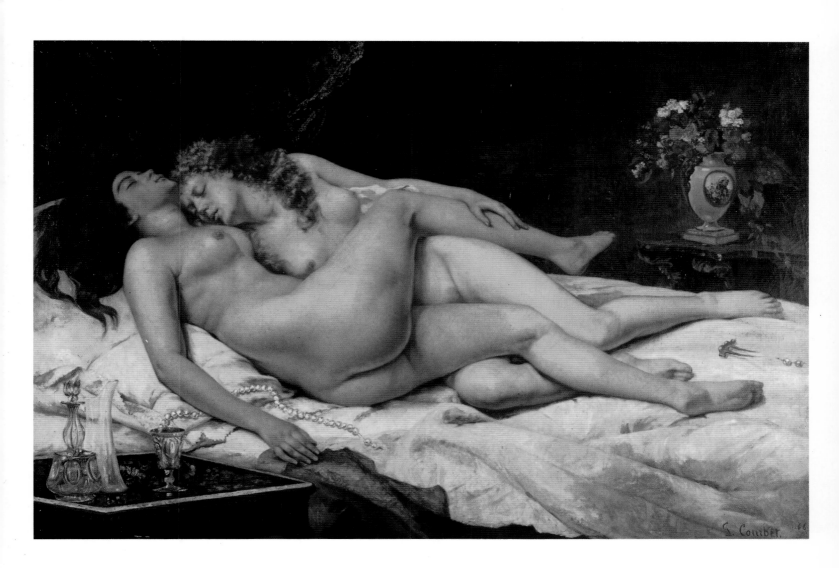

37. THE REST DURING THE HARVEST SEASON (MOUNTAINS OF THE DOUBS)

1867. Oil on canvas, 83½ × 107½" (212 × 273 cm).
Musée du Petit Palais, Paris

In 1869 Courbet presented to the Salon two large-scale paintings that demonstrated his remarkable gifts as a painter of animals. The largest of the two, the *Death of the Stag*, now in the museum in Besançon, is the artist's final major painting on the theme of the hunt; it is a winter scene depicting the climactic moment of the great stag's death, surrounded by hounds. The other painting, *The Rest*, is at the opposite pole from this: a scene of summer noontime in the pastureland, where working animals and human beings join in rest, an image of somnolence and contentment. Not since *The Peasants of Flagey* of 1850 (plate 7) had Courbet treated the theme of the local farming people in the midst of their domestic animals. Here the animals in fact take the leading role. They are not cows but bullocks, beasts of burden whose task it is to pull the loaded haywagons. Their heavy, blocky forms, their beautifully textured coats, their great patient heads and architectural hindquarters dominate the painting. The work as it was originally exhibited included the figure of an additional sleeping woman in the foreground. It is not known exactly when or for what reasons Courbet painted over it the rustic still life of wine barrel, blanket, rake, and even the straw hat of the vanished figure. The effect of the change is to transpose the theme of the sleeping woman—a theme of profound importance to Courbet throughout his career, from *The Hammock* (plate 1) through *The Sleeping Spinner* (plate 11) and *The Young Ladies on the Banks of the Seine* (plate 18) to *The Sleepers* (plate 36)—into a related but altered mode. The specifically sexual implications for the viewer of being a witness to the privacy and vulnerability of a woman asleep are subsumed into something more global. The fact that one of the sleeping harvesters is a woman is of little significance; they are figured as three human beings, three farm workers engaged in the same task and the same rest from that task. The significant difference-cum-relationship is that which exists between the human beings and the animals, and that relationship is one of union and interdependence. The two bullocks at the left seem to be acting as guardian figures, watching over the sleepers; the pair at the right perform a similar function through creating a kind of barrier with their massive bodies. It is the animals who benignly preside over this scene, while the human beings recede into smallness and vulnerability, dependent on their fellow creatures for their safety in rest. As is so often the case with Courbet, this painting at first glance might be seen in relation to a contemporary popular genre of cattle painting, as practiced by Troyon or Bonheur; in fact it has little in common with these naturalist exercises. Courbet's immense feeling for the lived life of these animals and for the land and those who work on it, together with his immense powers of representation, make of *The Rest* a kind of utopian vision.

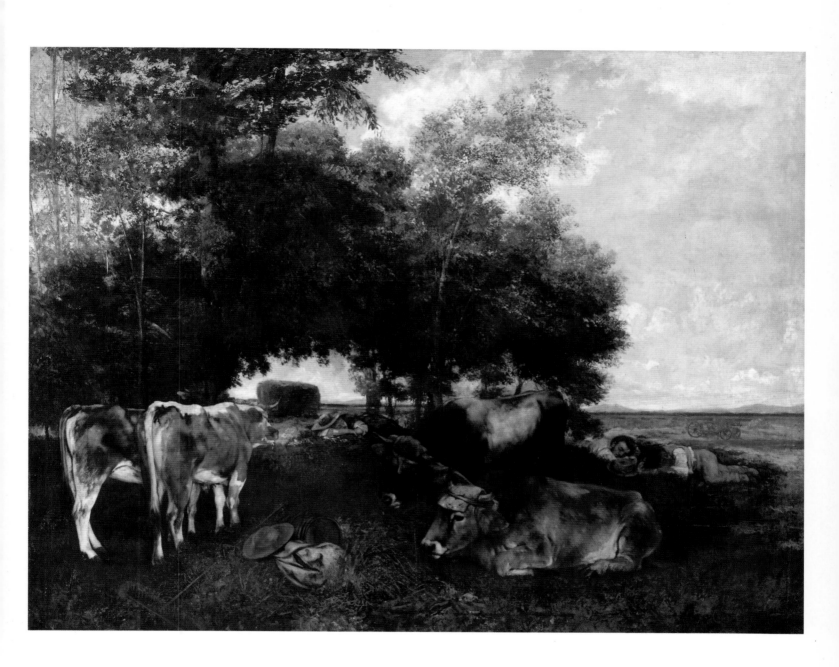

38. THE CLIFF AT ETRETAT AFTER THE STORM

1869–70 (signed 1870). Oil on canvas, 52⅜ × 63¾" (133 × 162 cm).
Musée d'Orsay, Paris

Courbet went to Etretat in the summer of 1869, drawn by its Channel beach and dramatic cliffs, as painters had been since early in the century. For this lifelong painter of the geological structures of the Franche-Comté there was a special attraction to these noted formations of natural archways made in the high rocks by centuries of water and wind. This view of one of these arched escarpments, called the Porte d'Aval, is painted with the same powerful attack and inventive brushwork that Courbet applied to the depiction of his own native cliffs. In fact the archway itself is not the focus of the painting: compared to Monet's later series at Etretat, which focuses on that structure in another of the cliffs known as La Manneport, the opening in the rock here is only a part of its larger mass. That solid yet fractured mass, which extends into the sea but also turns back along the shore to face the viewer, is visualized as a great architectural construction. This building-like quality is reinforced by the choice of viewpoint, which gives full attention to the opening in the rock wall, framed by stones and covered with wood like a door. The complex planar structure of this wall-like face of the cliff, the vertical clusters of rock that rise like towers in the promontory, and the thick mossy growth on the top combine to conjure up the idea of a great ruin, a kind of Hadrian's Villa of the Channel coast. The painting was presented at the Salon of 1870 together with a related painting of the same coast in a very different mood, *The Stormy Sea* (fig. 48), also at the Musée d'Orsay. The larger of the two, and indeed the largest uninhabited landscape that Courbet painted, *The Cliff at Etretat* has a magisterial air. It is bathed in a fresh, stormwashed light, emanating from the sky with its closely observed cloud patterns, moving from scattered whites down to the lavender mass along the horizon where the storm clouds move off. With the exception of the unfinished painting made in exile during his final year of life, *Grand Panorama of the Alps* (fig. 58) in the Cleveland Museum of Art, this would be Courbet's last monumental painting.

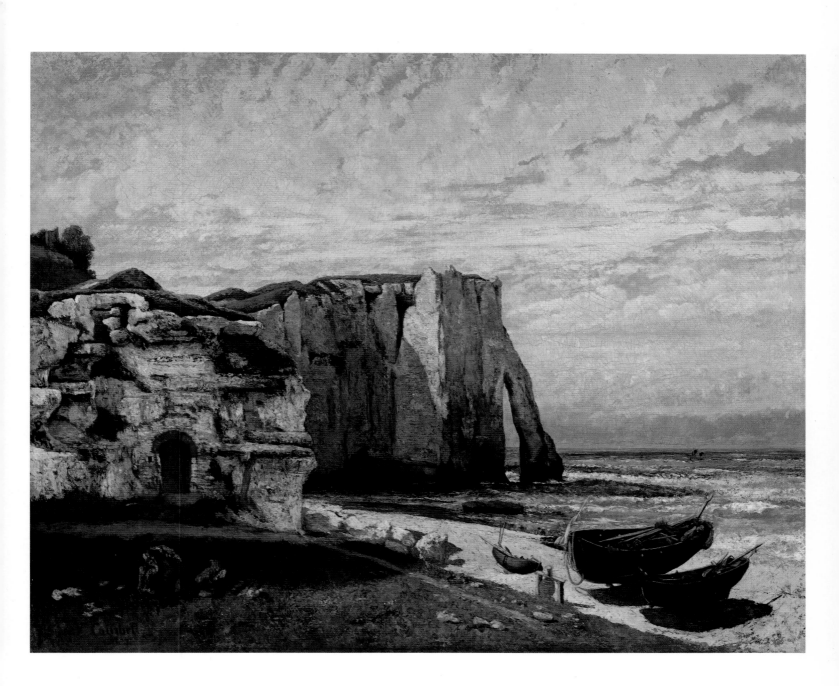

39. SELF-PORTRAIT AT STE.-PÉLAGIE

c. 1872–73. Oil on canvas, 36¼ × 28⅜" (92 × 72 cm).
Musée Gustave Courbet, Ornans

Courbet spent the summer of 1871 imprisoned together with other Communards in the stables of Versailles. Conditions were vile and terrifying as he spent weeks being interrogated and tried for his role in the destruction of the Vendôme column, while witnessing or hearing of the sentences of death and exile being inflicted upon many of his fellow prisoners. Given the number of people who came to testify on his behalf, such as former Minister Jules Simon, Louvre Director Barbet de Jouy, and the Comte de Choiseul, there was hope that he might be acquitted. But he was sentenced to six months' imprisonment at the Paris prison of Ste.-Pélagie. There conditions were marginally better, but feeling ran so high against the Communards that they were treated not as political prisoners but as common criminals, confined to dark cells and prison garb. It was not possible for Courbet to paint there; this painting could not have been made before early 1872, at the clinic where he was sent for health reasons to spend the remainder of his sentence. It was more probably done after his return to Ornans, and possibly even during his Swiss exile. In any case it is, like all of Courbet's self-portraits, not an examination of the biographical facts but a statement of specific meanings. He portrays himself with the black beard and country pipe of younger days, though in fact prison had left him sick and gray-haired. The strong note of the red scarf in the mud-colored gloom is an emphatic statement of his radical principles, still in place despite the disavowals of responsibility for the Column that he had allowed himself to make during the interrogation and trial. By dressing himself in ordinary clothes and providing the cell with the light, however dull, from a large window, he suppresses the actual facts of the prison in favor of an image that will demonstrate that he has succeeded in overcoming these painful and humiliating circumstances. Through the bars of the window, in the dreary courtyard, are the sickly trees that are the prisoner's only contact with the natural world so necessary to his spiritual sustenance.

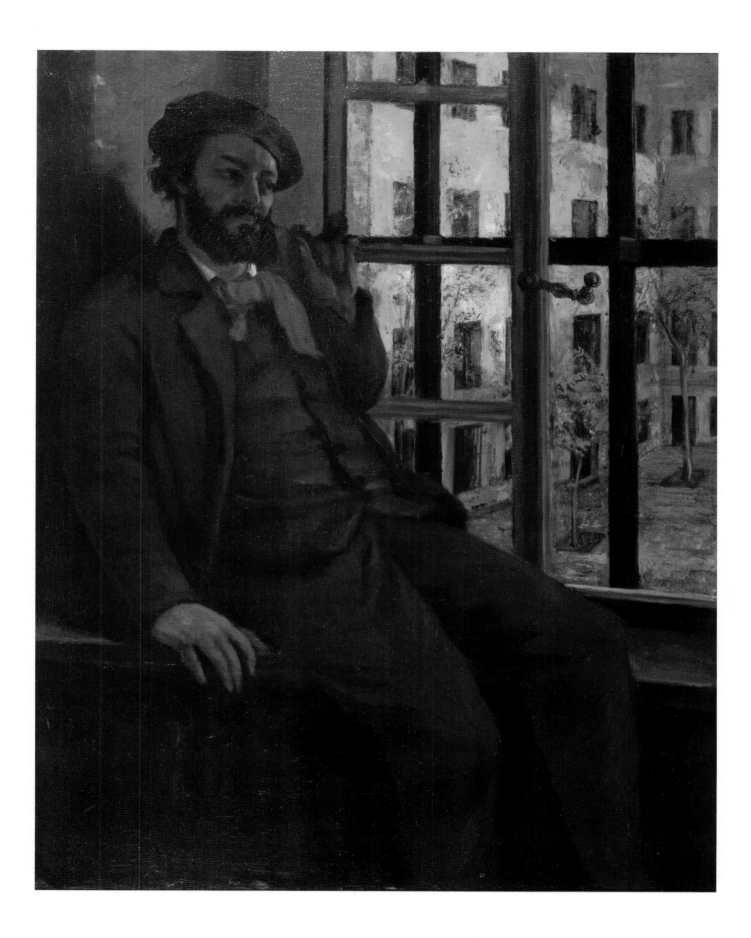

40. STILL LIFE: APPLES, PEARS AND PRIMROSES ON A TABLE

1872 (signed 71). Oil on canvas, 24 × 28¾" (61 × 73 cm).
The Norton Simon Foundation, Pasadena

At the end of 1871 Courbet was transferred from Ste.-Pélagie to the clinic of Dr. Duval in Neuilly, where he continued to be under arrest but in very different circumstances. Despite the discomfort of illness, here he could live as a human being and above all, here he could work. The series of still lifes he painted during these months, of flowers but especially of fruit, constitute an extraordinary outburst of painterly energy directed toward the representation of these marvelously simple and bountiful gifts of nature. From a tiny but monumental grouping of nine apples and a pear, a painting now in the Philadelphia Museum of Art (fig. 57), to the larger compositions such as this one, the paintings resonate with that primitive feeling of astonishment at the beauty of fruit which is experienced with special intensity by artists and victims of deprivation. In these paintings Courbet is both: the artist emerging out of the world of darkness, dirt, and death into the everyday world in which fruit may be taken for granted, but never by him. The connection between the experience of prison and his response to the fruits is made explicit by his inscription, on this and others of the series: "Ste Pélagie 71." The meaning of this is not that the paintings were literally made in prison, which was impossible, but that they must be understood in the light of the ordeal of prison. That ordeal involved everything that was diametrically opposed to the actuality and the meaning of these magnificent rounded objects, solid with flesh and juice, blissful in their colors and shapes. Toussaint has drawn attention to the artist's prodigal gifts as a painter of still life, often overlooked in the critical focus on the figure paintings. Indeed, these paintings of fruit take their place in the great tradition of French still life, some of them sharing the fresh radiance of Chardin, others, like this one, possessed of a more planar construction that looks forward to Cézanne, a great admirer of Courbet's work. Because of their special quality these paintings also illuminate Courbet's Realist project, his character as witness. In the historical trauma he was living through, this witnessing did not involve a literal description of conflict or imprisonment (apart from a few powerful sketchbook drawings). Instead, the human meaning of degradation is attested to by means of paintings which represent its polar opposite, yet are inscribed with the sign of incarceration.

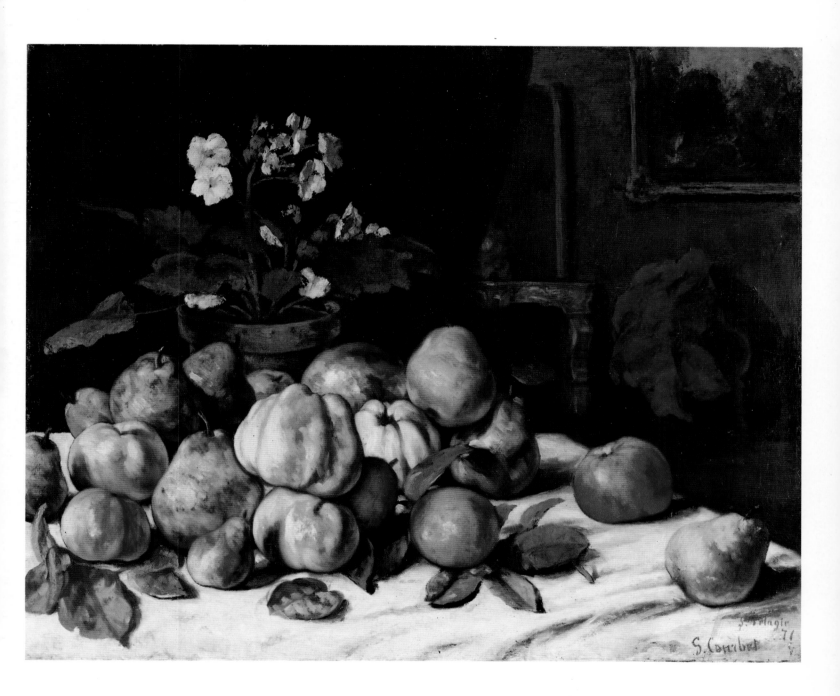

ACKNOWLEDGMENTS

This book is based upon the research, reading, and pictorial study that began in 1984 with the preparation of the exhibition *Courbet Reconsidered*, organized by Linda Nochlin and me, presented at The Brooklyn Museum in 1988. I am grateful to Brooklyn's Director, Robert T. Buck, for the opportunity both to work on that exhibition and its catalogue, and to further develop my observations about Courbet in the present book. As would anyone working on Courbet today, I have relied on the abundant scholarship of Hélène Toussaint and her colleagues at the Louvre contained in the catalogue of the centenary exhibition mounted at the Grand Palais in 1977. Interpretive studies over the past two decades, in particular those of T. J. Clark, Linda Nochlin, Michael Fried, and Klaus Herding, have shaped my understanding of the complexity of issues and meanings that are embodied in Courbet's paintings. Especially welcome has been the recent publication of Klaus Herding's studies, translated for the first time into English. Most recently, Petra Chu has made the essential contribution of publishing Courbet's correspondence, hitherto available only in small part and in scattered publications. (I have used her translations in three instances, on pp. 32, 40, and 86. Two other translated passages, one from Courbet, p. 42, and one from Dumas *fils*, p. 43, are borrowed from Lindsay. All other translations, from published and unpublished sources, are my own.)

I would like to express my appreciation to those I have worked with at Abrams: Margaret Kaplan, Executive Editor; Neil Ryder Hoos, Picture Editor; and Ruth Peltason, Senior Editor, who has been a most perceptive editor of the text. Thanks are due, as always, to my colleagues at the Brooklyn Museum for their support and encouragement, and in particular to Barbara Millstein.

—SARAH FAUNCE, 1992

SELECT BIBLIOGRAPHY

Castagnary, Jules. "Fragments d'un Livre sur Courbet." *Gazette des Beaux-Arts*, no. 5 (1911), pp. 5–20; no. 6 (1911), pp. 488–97; no. 7 (1912), pp. 19–30.

Chu, Petra ten-Doesschate, ed. and trans. *Letters of Gustave Courbet*. Chicago: University of Chicago Press, 1992.

Clark, T. J. *Image of the People: Gustave Courbet and the Second French Republic 1848–51*. London: Thames and Hudson, 1973.

Courbet à Montpellier. Exh. cat. by Philippe Bordes. Montpellier: Musée Fabre, 1985.

Courbet et la Suisse. Exh. cat. by Pierre Chessex. La Tour de Peilz: Le Château, 1982.

Courbet Reconsidered. Exh. cat. by Sarah Faunce and Linda Nochlin, with additional essays by Petra ten-Doesschate Chu, Douglas E. Edelson, Michael Fried, Claudette R. Mainzer. New York: The Brooklyn Museum, and Minneapolis: Minneapolis Institute of Art, 1988.

Courbet und Deutschland. Exh. cat. by Klaus Herding, Werner Hofmann, Margaret Stuffmann, et al. Hamburg: Kunsthalle, and Frankfurt: Städelsches Kunstinstitut, 1978.

Gustave Courbet (1819–1877). Exh. cat. by Hélène Toussaint. Paris: Grand Palais, and London: Royal Academy, 1977, 1978.

[Courbet papers]. "Documents sur Gustave Courbet réunis par Et. Moreau-Nélaton et Georges Riat (venus de Castagnary) et la Famille Courbet." Paris: Bibliothèque Nationale, Cabinet des Estampes.

Courthion, Pierre, ed. *Courbet raconté par lui-même et par ses amis*. 2 vols. Geneva: Pierre Cailler Editeur, 1948, 1950.

Fernier, Robert. *La Vie et l'oeuvre de Gustave Courbet: Catalogue raisonné*. 2 vols. Lausanne and Paris: Fondation Wildenstein, 1977.

de Forges, Marie-Thérèse. *Autoportraits de Courbet*. Les Dossiers du Département des Peintures, no. 6. Paris: The Louvre.

Fried, Michael. *Courbet's Realism*. Chicago: University of Chicago Press, 1990.

Haskell, Frances. "A Turk and his Pictures in Nineteenth-century Paris." *Oxford Art Review* 5, no. 1 (1982), pp. 40–47.

Herbert, Robert. "Courbet's *Mère Grégoire* and Béranger." In *Malerei und Theorie: Das Courbet-Colloquium 1979*, edited by Klaus Gallwitz and Klaus Herding. Frankfurt: Städelsches Kunstinstitut, 1980.

Herding, Klaus. *Courbet: To Venture Independence*. Translated by John William Gabriel. New Haven: Yale University Press, 1991.

Jammes, André, and Eugenia Parry Janis. *The Art of French Calotype*. Princeton: Princeton University Press, 1983.

Léger, Charles. *Courbet selon les caricatures et les images*. Paris: Galerie Paul Rosenberg, 1920.

Lindsay, Jack. *Gustave Courbet: His Life and Work*. London: Jupiter Press, 1973, 1977.

Mainzer, Claudette. "Une histoire du cimetière." In *Ornans à l'enterrement—Tableau historique des figures humaines*. Ornans: Musée Gustave Courbet, 1981.

Mayaud, Jean-Luc. "Courbet, peintre de notables à l'enterrement . . . de la République." In *Ornans à l'enterrement—Tableau historique des figures humaines*. Ornans: Musée Gustave Courbet, 1981.

Nochlin, Linda. *Gustave Courbet: A Study in Style and Society*. New York: Garland Publishing, 1976.

———. "Gustave Courbet's *Toilette de la Mariée*." *Art Quarterly* 34, no. 1 (1971), pp. 31–54.

Riat, Georges. *Gustave Courbet, peintre*. Paris: H. Floury, 1906.

Sabatier-Ungher, François. *Salon de 1851*. Paris: Librairie phalanstérienne, 1851.

Schapiro, Meyer. "Courbet and Popular Imagery: An Essay on Realism and Naiveté." 1941. Reprinted in Schapiro, *Modern Art: Nineteenth and Twentieth Centuries*. New York: Braziller, 1978.

Walter, Rodolphe. "Un dossier délicat: Courbet et la Colonne Vendôme." *Gazette des Beaux-Arts*, no. 81 (1973), pp. 173–84.